MFA
HIGHLIGHTS arts of **ANCIENT EGYPT**

Publications, a division of the Museum of Fine Arts, **BOSTON**

MFA
HIGHLIGHTS arts of **ANCIENT EGYPT**

RITA E. FREED

LAWRENCE M. BERMAN

DENISE M. DOXEY

MFA PUBLICATIONS *a division of*
the Museum of Fine Arts, Boston
465 Huntington Avenue
Boston, Massachusetts 02115
tel. 617 369 3438 fax 617 369 3459
www.mfa-publications.org

© 2003 by Museum of Fine Arts, Boston
Library of Congress Control Number:
2002115252
ISBN 0-87846-661-4

Manuscript edited by Emiko K. Usui
Copyedited by Denise Bergman
Design and composition
by Lucinda Hitchcock
Printed and bound at CS Graphics PTE
LTD, Singapore

Trade distribution:
Distributed Art Publishers/ D.A.P.
155 Sixth Avenue, 2nd floor
New York, New York 10013
Tel. 212 627 1999 Fax 212 627 9484

First edition

Contents

Foreword 7
Acknowledgments 8

Egypt Lost and Found in Boston
by Lawrence M. Berman 11

The Egyptian Expedition
by Rita E. Freed 25

The Collection:
by Lawrence M. Berman,
Denise M. Doxey, and Rita E. Freed

Predynastic and Early Dynastic Periods 39
Old Kingdom 65
First Intermediate Period and Middle Kingdom 105
Second Intermediate Period and New Kingdom 141
Third Intermediate, Late, and
Greco-Roman Periods 169

Chronology of Ancient Egypt 198
Glossary 200
Map 202
Index 203

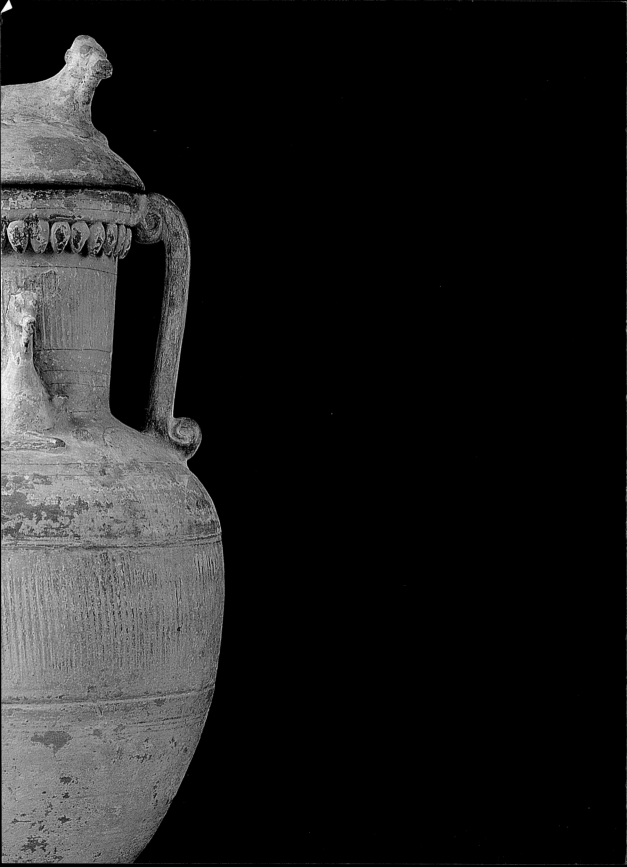

Foreword

Art is for everyone, and it is in this spirit that the MFA Highlights series was conceived. The series introduces some of the greatest works of art in a manner that is both approachable and stimulating. Each volume focuses on an individual collection, allowing fascinating themes — both visual and textual — to emerge. We aim, over time, to represent every one of the Museum of Fine Arts, Boston's major collections in the Highlights series, thus forming a library that will be a wonderful resource for the understanding and enjoyment of world art.

It is our goal to make the Museum's artworks accessible by every means possible. We hope that each volume of MFA Highlights will help you to know and understand our encyclopedic collections and to make your own discoveries among their riches.

Malcolm Rogers
Ann and Graham Gund Director

Acknowledgments

The Egyptian collection at the Museum of Fine Arts, Boston, ranks as one of the finest in the world, thanks in large measure to its thirty-seven years of archaeological excavation and the generous divisions it received from the Egyptian government. This volume represents the first time its key pieces have been published together in full color. For this opportunity, thanks are due the Museum's Director, Malcolm Rogers. Not only did he recognize the need to establish a series of volumes on the Museum's highlights, but also he selected the Egyptian collection for one of its premier volumes.

A work such as this one, of necessity, involves more than its three authors. Prior research by and assistance from the entire department staff, including Yvonne Markowitz, Joyce Haynes, and Peter Der Manuelian, greatly facilitated the writing of the entries. Photographers Thomas Lang, Gregory Hines, Damon Beal, and Gary Ruuska brought out the beauty of the objects. Conservators Pamela Hatchfield, Suzanne Gänsicke, and Marie Svoboda insured their safe transport to and from the photography studio. Assistant Curator Denise M. Doxey spent many hours coordinating with both departments. She, together with Giza Archives Project Director Peter Der Manuelian and Assistant Diane Flores, tracked down the many archival photographs that fill these pages. The task of coordinating the chronology and insuring consistency fell to Curator Lawrence M. Berman, who also acted as liaison with Editor Emiko K. Usui. Without both of their efforts, this volume would have been much less coherent and accessible. Interns B. J. Carrick and Russell Feldman provided invaluable assistance in fact-checking and other editorial issues. For coordinating all the manuscript's component parts and keeping its production on schedule we are grateful to Terry McAweeney. For its beautiful appearance we are indebted to designer Lucinda Hitchcock.

Regardless of the value of the idea or the quality of its execution, no project can come to fruition without funding. For making this project possible we are all grateful to the Norma-Jean Calderwood Curatorship Endowment and the foresight of Stanford Calderwood who arranged for it. Our only wish is that Norma-Jean and Stan could see and appreciate this fine volume today.

Rita E. Freed
Norma-Jean Calderwood Curator of Ancient Egyptian,
Nubian, and Near Eastern Art

Egypt Lost and Found in Boston Lawrence M. Berman

The Egyptian collection of the Museum of Fine Arts, Boston, with over sixty
thousand objects, is one of the largest and most comprehensive in the world.
Today, it is best known for the works excavated from 1905 to 1947 by the Harvard
University-Museum of Fine Arts, Boston, Expedition directed by George Andrew
Reisner (1867–1942). What is not generally known is that by the time the Egypt-
ian department formally came into being in 1902, the MFA's Egyptian collection
was already the largest in the United States. Its history is the story of collecting
Egyptian art in America.

Egyptology was bound to play an important role in the MFA from the begin-
ning. The Museum was incorporated in 1870; the first Egyptian objects were
acquired in 1872. In 1902 the MFA was one of the first museums in the United
States to establish a separate department of Egyptian art — but to place this
history in context we have to go back much farther than that.

In 31 B.C. the combined naval forces of Mark Antony and Cleopatra VII were
defeated by Octavian (later Augustus) at the battle of Actium off the coast of
western Greece (fig. 1). The following year the lovers committed suicide — first
he, then she — and Egypt became a province of the Roman Empire, the emperor's
private preserve. While in Egypt, Augustus and his successors represented
themselves as traditional pharaohs. As such they can be seen at Dendara and
Philae, and even in New York and Boston, for the temple of Dendur in the Met-
ropolitan Museum is the work of Augustus, while the MFA owns the column
drums of Augustus and Claudius, and a Ptolemaic gateway completed by Nero
(pp. 190–91).

Imperial support for the temples fell off abruptly, however, in the second cen-
tury, and practically disappeared with the rising popularity of the Christian
faith in the third century. Egypt then became a center of early Christianity, the
birthplace of monasticism and a hotbed of theological debate. Fanatical monks
and their followers roamed the countryside, ransacking the temples, murdering
the priests, and even breaking into people's homes in an effort to wipe out all

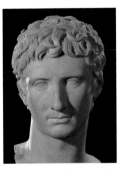

fig. 1 Augustus, Roman Period,
about A.D. 40, fine-grained
Italian marble, found in Ariccia
(near Rome), h. 43.3 cm (17 ¹⁄₁₆
in.), Henry Lillie Pierce Fund
99.344.

11

traces of paganism. At Philae the images of Pharaoh were mutilated and defaced (fig. 2), while the temples and tombs were converted into churches. With the formal division of the Roman Empire into eastern (Byzantine) and western halves in 395 (the traditional end of ancient Egyptian history), the fall of Rome to the barbarians in 476, and the Arab conquest of Egypt in 641, Egypt of the pharaohs was effectively cut off from western Europe.

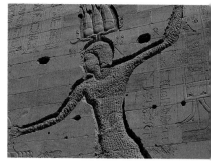

There were occasional encounters, such as the Crusades, and much trade, but neither Crusaders nor traders were interested in antiquities. They wanted luxury goods, for which Egypt had always been famous. Although a few intrepid travelers — notably Jesuit priests — made it to Egypt every now and then, it was not until Napoleon Bonaparte's Egyptian campaign of 1798–1801 that contact was reestablished for good. Egypt was in the news again. The eyes of Europe were focused on Egypt as they had not been since the days of Antony and Cleopatra.

Of course the Egyptian campaign did not occur in a vacuum. The seventeenth and eighteenth centuries, the Age of Enlightenment, had seen a renewal of European interest in Egypt. But Napoleon's Egyptian campaign is still regarded as the beginning of modern Egyptology. Militarily it was a fiasco. Shortly after arrival, British Admiral Horatio Nelson destroyed the French fleet in the Battle of Abuqir, leaving the French marooned in Egypt. Napoleon returned to France in secret in 1799, leaving his troops. Surrendering to the British in 1801, they relinquished their booty, including the famous Rosetta Stone. But it is not as a military campaign that the French expedition should be judged. For in addition to his regular army, Napoleon brought with him another squadron, of scholars, artists, engineers, and architects — the greatest young minds of France. The newly formed Commission for Arts and Sciences followed in the wake of the French army all the way from Alexandria to Aswan, recording — at great risk to themselves — everything they saw. The results were prodigious.

Two events stand out. The first was the discovery in 1799 of the Rosetta Stone. This granite slab now stands about 112.3 cm tall (3½ feet), but it is only a fragment of a much taller round-top stele that originally stood about 149 cm tall (5 feet). It was immediately recognized to be carved in three different scripts: the top portion in hieroglyphs (reserved for monumental inscriptions in stone), the middle in an unknown script later identified as Demotic (corresponding to the spoken language of the Egyptians), the bottom in Greek (the language of the Ptolemies). None of the Ptolemaic rulers of Egypt ever condescended to learn Egyptian except for the last, Cleopatra. (Cleopatra was fluent in nine languages: in addition to Egyptian, she spoke Greek, Aramaic, Hebrew, Syriac, Ethiopian,

fig. 2 Images of pharaohs were defaced when temples were converted into churches during the third century A.D. Pylon with relief of Ptolemy XII from the temple of Isis at Philae, Ptolemaic Dynasty, reign of Ptolemy XII, 80–51 B.C. Photo: Lawrence M. Berman

Median, Parthian, and Troglodite). The Greek, of course, could be read, and the
final lines of the Greek inscription confirmed what everyone had hoped:

[It has been decided]...to inscribe this decree on a stele of hard stone, in sacred and
native and Greek characters and to set it up in each of the first and second [and third
rank temples next to the image of the ever-living king].[1]

The three scripts were different versions of the same text: a decree issued in
196 B.C. by the Egyptian priesthood in honor of the reigning king, Ptolemy V. Here
finally was the key to the hieroglyphs, knowledge of which had been lost after
the fourth century A.D. It was not until twenty-three years later, however, in
1822, that a brilliant young Frenchman by the name of Jean-François Champol-
lion announced his discovery of the hieroglyphic alphabet to the Academy of
Inscriptions and Belles-Lettres in Paris in his famous *Lettre à M. Dacier.*

The second epochal event was the publication of the *Description de l'Egypte,*
presenting to the world the scientific results of Napoleon's Egyptian campaign.
The twenty-two volume set — nine volumes of text, ten volumes of plates, and
three atlases — took twelve years to produce (1810–22) and was a monument in
itself, truly worthy of its subject. The plates were so large that they required a
special printing press. Subscribers could also order a sumptuous mahogany
cabinet in the latest Egyptian Revival style specially designed to house the
enormous volumes. The first edition of one thousand copies sold out, and the
work went into a second edition in 1826. Harvard University got a copy in 1822,
the first in this country.

Napoleon's Egyptian campaign infused an entire generation of European
scholars, soldiers, and adventurers with a passion for the Orient, as the Middle
East was then known. And the political climate in Egypt itself had changed. The
evacuation of the French had created a power vacuum in Egypt — still nominally
a part of the Ottoman Empire, it was in effect governed by a local ruling caste,
the Mamelukes. An Albanian named Mohammed Ali emerged as pasha of Egypt
and founded the dynasty that ruled until 1952. Eager to modernize, Mohammed
Ali Pasha welcomed Europeans. European consuls stationed in Egypt in the
early nineteenth century amassed great holdings of antiquities that they sold to
European governments; the superb collections of Turin, Paris, and London were
formed at this time amid a hotbed of competition. European technicians in the
service of the pasha were allowed to collect as they pleased while independent
travelers of means sojourned along the banks of the Nile sketching and study-
ing the monuments.

Egypt was in the air, and America was ready. In 1802, the year of its founding,

the American Academy of the Arts in New York elected Napoleon and expedition artist Dominique-Vivant Denon honorary members. Denon's book, *Voyage dans la Basse et la Haute Égypte, pendant les campagnes du general Bonaparte* (Travels in Upper and Lower Egypt During the Campaigns of General Bonaparte) came out that same year and was an instant best-seller. An English translation appeared in 1803.

In the Boston area, returning ships' captains were donating Egyptian artifacts as early as 1803 to the East India Marine Society in Salem, the first being a mummified ibis presented by a Captain Althorp. As a result, the Peabody Essex Museum of Salem now holds the oldest public collection of Egyptian antiquities in the U.S. In 1823 Jacob van Lennep, a Dutch merchant residing in Smyrna, Turkey, presented an Egyptian mummy and its two coffins to the city of Boston. There being no better place to put it, the mummy was taken to the newly opened Massachusetts General Hospital, where it was examined by noted surgeon Dr. John Collins Warren and pronounced genuine. The mummy and coffins were promptly placed on exhibition at Mr. Doggett's Repository of the Arts on Market Street, eventually earning for the hospital the handsome sum of four thousand dollars in viewing fees.

Also in 1823 the orator Edward Everett published an article in the *North American Review* on the Zodiac of Dendara. The Zodiac, which formed part of the ceiling of the great Temple of Hathor at Dendara, had recently been removed from the temple and installed in Paris. Everett expresses himself eloquently on the subject of such "removals":

No one can behold with gratification the brick post erected by lord Elgin to support the corner of the temple of Erectheus at Athens, from which that nobleman removed (this is the term) one of the beautiful Caryatides; and we have strong doubts whether future travellers in Egypt will be particularly gratified with finding the roof of the temple of Denderah blown out by gunpowder and carved out with saws by M. Lelorrain.[2]

In 1831 Everett wrote another article for the *Review* on "Hieroglyphics" praising Champollion's achievement to the skies. For Everett, Champollion's discoveries ranked with those of Sir Isaac Newton (this comparison was made over and over again by other authors as well):

We hope our scientific readers will not disdain the comparison...for if the mathematical discoveries of...Newton are the most brilliant which the modern world has produced in exact science, those of...Champollion are entitled to the same rank in critical

learning; and are destined to throw, we doubt not, a flood of light on a chapter of the history of mankind, hitherto almost a blank.[3]

A wave of Egyptomania swept the country. In the 1830s Mount Auburn Cemetery in Cambridge, Massachusetts, was provided with an Egyptian Revival gateway inspired by views of Dendara and Karnak in the *Description de l'Egypte*. It was the first of many such cemetery gateways, including those of the Old Granary Burial-Ground in Boston (1840) and Grove Street Cemetery in New Haven, Connecticut (1844–48). The Egyptian Revival style was considered particularly appropriate for cemeteries on account of its gravity, solemnity, and associations with permanence (although some people objected to the use of pagan themes in a Christian context).

In 1842 and 1843 George R. Gliddon, former U.S. vice-consul in Egypt, gave a course of twelve lectures in Boston entitled "Early Egyptian History, Archaeology, and Other Subjects connected with Hieroglyphical Literature." It was the first public lecture series in America on ancient Egypt, and it was so successful that he repeated it in Boston the following year before the Lowell Institute, attracting over five thousand auditors. He then embarked on an extended tour of U.S. cities that brought him as far west as St. Louis. Europeans were amazed at this phenomenon, whereby educated people of leisure would forego the opera and other entertainments to attend illustrated lectures:

The experiment…of popularizing, through direct and oral address, independently of the patronage or aid of Governments or Academies, to the comprehension of the educated masses, themes so fraught with interest to the past history and future development of humanity, does not appear to have been tried, in any country, since the Olympic era of the Halicarnassian…In England, to this very hour, there are no public lectures whatever on Egyptian Archaeology: and the fact that many thousands of America's citizens have spontaneously attended Discourses upon Hieroglyphics, in some European circles is yet unbelieved, in others it is a topic of mingled wonder and applause…[4]

Was it not about time that America acquired an Egyptian collection worthy of its interest? There was in fact a movement already afoot to establish an Egyptian Museum in this country — in Boston — and an opportunity to acquire a first-rate collection. But Boston allowed it to pass.

In 1842 the American Oriental Society was founded in Boston "for the purpose of the cultivation of learning in the Asiatic, African, and Polynesian languages," with John Pickering of Boston as its first president. In his inaugural address,

Pickering elaborated the society's field of study as ancient and modern "history, languages, literature, and general characteristics of the various people, both civilized and barbarous, who are usually classed under the somewhat indefinite name of Orientals," including those of North Africa (including Egypt and the Sudan), all of Asia, and Polynesia. The time was ripe, he claimed, for such an enterprise: America's trade was second only to England's; American ships put in at the farthest, most exotic ports; American missionaries scattered over the globe were versed in more languages than those of any other nation. In order to contemplate this vast area, he added, one must rise to an elevated height, and from this elevated height, two countries stood out as the twin fountains of human wisdom and knowledge: Egypt and India. Like Everett, Pickering lauded Champollion's discovery of the key to hieroglyphic writing as the finest historical discovery of modern times. He assured his auditors that there was yet more to find, making an urgent plea for the continuation of this study. And he brought in the Biblical connection: If it was said that "Moses was instructed in all the wisdom of the Egyptians" (Acts 7:22) and that, furthermore, "Solomon's wisdom surpassed...all the wisdom of the Egyptians" (1 Kings 4:30), how could we hold back, now that the key to unlock that wisdom had been discovered?[5]

That very same year, Joseph Sams, a British bookseller and antiquities dealer who had already sold a number of Egyptian antiquities to the British Museum, let it be known that he had another collection for sale. It was seen in London by a number of Americans (one assumes they were influential men of business) who put Sams in touch with Everett, then serving as the U.S. ambassador to England, with a letter of introduction. Everett went to see the collection and was favorably impressed. So he wrote to Pickering:

...I am inclined to think that the value of Mr. Sam's collection in reference to completeness and antiquarian interest is not over-rated....I feel no hesitation in expressing the opinion, that this collection, if advantageously arranged, would form a very attractive public exhibition.[6]

Everett was also sensitive to the pecuniary advantages of such an acquisition:

You recollect that the exhibition of a single mummy in Boston yielded for the Massachusetts Hospital a sum (if I mistake not) of near four thousand dollars. This collection, besides so many other articles of rare curiosity and interest, contains seven mummies — some of which, (and one in particular most richly gilded and painted,) have never been opened.[7]

Pickering wrote back:

...I would take all practicable measures in my power in relation to the subject, being myself much interested in it, and being desirous to make a beginning of an Egyptian Museum in this place. At the same time, however, I expressed my fears, that the urgent calls for money at this time for other public objects, which were considered to be more necessary to meet the present wants of our country, would be a great obstacle to obtaining a contribution for the purchase of a Collection of this kind.[8]

Surprisingly, Everett concurred that Boston had more pressing needs at that time. Throughout the negotiations, Sams seems to have thought he was dealing directly with the United States government. But then as now government support of the arts was tenuous. The collection would go to a private institution, or none at all.

Another chance to acquire first-rate Egyptian objects, the property of Dr. Henry Abbott, presented itself in 1853. Abbott, an Englishman, had formed his collection during twenty years' residence in Egypt where he had served as a ship's surgeon and physician. Placing his holdings on view at the Stuyvesant Institute in New York, Abbott had hoped to find an American buyer and thus to provide for his family, who had moved to the United States. It consisted of some two thousand objects, among them some real treasures. An advertisement promoted the exhibition as "the greatest attraction in the city" (fig. 3). One frequent visitor was Walt Whitman, who wrote a review of the exhibition in *Life Illustrated* (December 8, 1855). Whitman was fascinated by ancient Egypt and particularly by Champollion's discovery of the key to the hieroglyphs, as were Ralph Waldo Emerson, Henry David Thoreau, Edgar Allen Poe, Nathaniel Hawthorne, and Herman Melville. Indeed, the decipherment made a profound impression on the writers of the American Renaissance, and the old trope of the mystery of the hieroglyphs — the hidden wisdom of the Egyptians — was recycled as a metaphor of the material world as symbol of the Creator's divine plan.[9]

But even with the endorsements of such literary lions, the exhibition was not a popular success, and the collection was still without a buyer at the time of Abbott's death in 1859. Rumors that the collection was to be offered to the British Museum, however, inspired an appeal for funds to save the collection for the United States. Everett headed the list of Bostonians who spoke out, followed by the president, professors, and tutors of Harvard College. This time the appeal was successful, and the collection went to the New York Historical Society. (In 1937 the New York Historical Society placed the Abbott Collection on loan to the Brooklyn Museum, which bought it outright in 1948.)

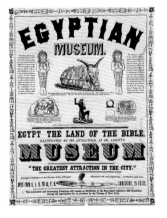

fig. 3 An advertisement promoting the exhibition of the Abbott collection of Egyptian antiquities, 1855.

In 1863 Elihu Vedder painted *The Questioner of the Sphinx*, perhaps his most famous work and an icon of American Egyptomania (fig. 4). Exhibited in New York that very year, it was bought by Martin Brimmer, one of the founding fathers and the first president of the MFA. In 1868 the painting was exhibited in the Boston Athenaeum, where no doubt many influential Bostonians had a chance to see it. So it is not surprising that in 1872, just two years after its founding, the Museum of Fine Arts, Boston, received as a gift of Charles Granville Way over 4,500 Egyptian antiquities his father had purchased in London the year before.

fig. 4 Elihu Vedder, American, 1836–1923, *The Questioner of the Sphinx*, 1863, oil on canvas, 92.1 x 107.3 cm (36 ¼ x 42 ¼ in.), Bequest of Mrs. Martin Brimmer 06.2430

The artifacts had come from the collection of Scottish nobleman Robert Hay (1799–1863), one of the great early travelers and our first, though by no means our only, connection with that great age of exploration and discovery. Hay initially visited Egypt in 1818 as a midshipman in the Royal Navy. As a fourth son he did not expect to inherit much, but as fate would have it, his older brothers all died young, and in 1819 Robert inherited the family estate. Thus a man of means, he abandoned his naval career and embarked on a Grand Tour, a long journey to historic and exotic locales customarily taken by British gentlemen since the eighteenth century. Hay led two expeditions to Egypt, 1824–28 and 1829–34, gathering about him an astounding constellation of artists and scholars. He shared a tomb on the west bank of Thebes with Gardner Wilkinson, the most famous of all the early travelers. Their circle included James Burton, Edward William Lane, Major Orlando Felix, and Lord Prudhoe, all men at the forefront of Egyptology at that time. Their method of operation might best be compared with a modern epigraphic survey: they did not dig, but rather, they copied everything they saw, meticulously and painstakingly, with as much knowledge of hieroglyphs as anyone but Champollion himself had at that time (and with greater respect for the monuments). Their notebooks, drawings, and sketches are all the more valuable today because so many of the monuments they recorded are now lost or destroyed or have substantially deteriorated. Unfortunately, little of the material was published. Today, Hay's papers are preserved in forty-nine volumes in the British Library.

While in Egypt, Hay assembled a large collection of antiquities, later aug-
menting it with purchases from various London sales. After Hay's death in 1863,
his son Robert James, in need of money, decided to dispose of the collection. To
publicize it, the collection was exhibited at the Crystal Palace. In the words of
Samuel Birch, curator of the Egyptian antiquities at the British Museum:

[It] comprises numerous specimens of each division of Egyptian antiquities, illustra-
tive of the arts, manners, and civilization and of the Pantheon, civil life, and funeral
rites of ancient Egypt. Its chief strength is in its mummies and coffins, some of which
are well preserved, and all would be valuable and important additions to any museum
which does not possess similar specimens.[10]

The British Museum indeed bought 529 objects in 1868, but the majority were
purchased in 1871 by Samuel Alds Way (1816–1872) of Boston and presented to the
MFA the following year.

Samuel Way was a wealthy banker and businessman. He and his wife, Sarah,
were great travelers, and it is said that while in Europe they were presented to
Napoleon III and Empress Eugenie of France. Their son Charles Granville Way
(1841–1912) studied art in Paris and exhibited at the international expositions in
Vienna, 1873, and Philadelphia, 1876. In 1866 Charles married Charlotte Forbes
and the bank accounts of the Way and Forbes families were united. Soon there-
after he gave up the artist's profession and settled down to the serious business
of managing the family properties. In 1872 he presented the entire collection of
Egyptian antiquities to the MFA. They consist mainly of objects of daily life as
well as funerary objects, including several mummies of the New Kingdom and
later periods. The Third Intermediate Period coffins are particularly ravishing
(see p. 176).

Few Americans journeyed to Egypt in the early 1800s. An exception was John
Lowell, Jr. (1799–1836), of Boston, who was born the same year as Robert Hay.
Lowell's family had been prominent in the Boston area for generations. His
father, John Cabot Lowell, had revolutionized the textile industry in the United
States with the introduction of the power loom, which he had reconstructed
from memory after seeing it in England. As a young man, Lowell had enjoyed
traveling abroad with his father, and he himself had made two trips to India.
His Egyptian excursion was, alas, prompted by grief. In 1831 and 1832 his wife
and two daughters — his entire family — all died from scarlet fever. Miserable at
home, he embarked on a trip around the world. Setting sail from New York to Le
Havre, he began his journal despondently:

But what shall I do in this world? What object have I to live for? No one depends upon me; no one loves me as I am wont to be loved! I have lived in vain. Monotony and listlessness remain in store if I live; and if I die, am I prepared for the next world?[11]

Following in the tradition of the Grand Tour, Lowell engaged the young Swiss artist Charles Gleyre as artist and traveling companion. As an artist Gleyre was wonderfully successful; as a traveling companion he was not, for the two could hardly have been more dissimilar. Lowell, the scion of a prominent Boston family, was a high-minded and puritanical Yankee (though one would hardly know it from a portrait of him in Turkish dress, fig. 5) while Gleyre, the penniless orphan, melancholy, self-indulgent, and resentful of his employer's wealth and station, personified the romantic young artist. But in all fairness it must be said that Lowell had a romantic streak too. (After all, it was the Romantic Age.) The poets Byron, Keats, and Shelley, the composers Beethoven and Schubert, were Lowell's contemporaries. En route to Egypt, Lowell even passed through Malta and Corfu and then traveled across the Albanian mountains into Greece, following in the footsteps of Byron's hero Childe Harold.

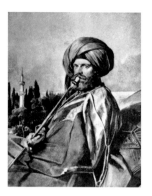

fig. 5 Charles Gleyre, Swiss, active in France, 1806–1874, *Portrait of John Lowell, Jr.*, Alexandria, 1834, watercolor and pencil on paper, 33.5 x 26.5 cm (10 ³⁄₁₆ x 10 ⁷⁄₁₆ in.), Collection of Mr. and Mrs. Ralph Lowell.

Lowell and Gleyre arrived in Alexandria on December 27, 1834. (They just missed Robert Hay.) Lowell intended to make only a brief stay in Egypt, just long enough to see Cairo, the pyramids, and Thebes. In the end he stayed in Egypt a year and a half. From Cairo he proceeded upriver to Thebes. There again, he did not intend to go farther, but rumors of plague (probably cholera—the early travelers are vague about the plague) in Cairo induced him to change his mind. So he sailed farther upstream, stopping at Esna and Philae. At Wadi Halfa (the border between Egypt and the Sudan) he exchanged his boat for a horse, and proceeded by land through Upper Nubia, arriving in Meroe in September 1835, then in Khartoum in November.

It was in Thebes that Lowell fell seriously ill for the first time during his journey—so ill that he added a codicil to his will establishing the Lowell Institute. Thereafter he suffered with stoicism periodic bouts of dysentery and conjunctivitis. Gleyre suffered too, though without stoicism. As Lowell writes:

Mr. Gleyre detests the desert and is much annoyed by the inconveniences of travel. He can work when he has a sufficient inducement, but it is difficult to find one for him. He is commonly in a state of apathy, which is always too great to permit him to exert himself....He has good talents, and on questions that he is well informed upon, good sense; but he is so deficient in energy and perseverance that it is doubtful if he will ever turn them to good account....Everything goes hard with him, and he knows not how to smooth the passage over unavoidable obstacles.[12]

The two men parted company in Khartoum and Lowell crossed the desert to the Red Sea. From there he traveled by ship along the coast to Massawa (Eritrea), where he was shipwrecked; eventually he arrived in Mocha (Yemen), and from there traveled to Bombay, where, sick and exhausted, he died on March 4, 1836. Gleyre stayed in Khartoum for another two years, still suffering from conjunctivitis, before finally returning to Paris in 1838. Afterward he had a successful career as an artist. Among his students were James Abbott McNeill Whistler, Claude Monet, and Auguste Renoir.

While convalescing at Thebes, Lowell occupied himself with making a collection of antiquities. So as not to be encumbered on his journey, he shipped these home to Boston. In 1875 the Museum received from Lowell's heirs its first monumental sculpture: two fragments of Hatshepsut's fallen obelisk at Karnak (fig. 26, p. 142), two statues of the lioness-headed goddess Sekhmet from the Mut precinct at Karnak, a colossal head of Ramesses III, which was also from the Mut precinct, fragments of Philip Arrhidaeus's bark shrine at Karnak, and two composite column capital fragments from the temple of Isis at Philae. (The MFA also has Lowell's travel diaries and Gleyre's drawings and watercolors on loan from the Lowell Institute.) Thus, within the space of three years (and only five years after its founding), the MFA found itself in possession of the largest and most important collection of Egyptian art in the United States. Its only serious rival was the New York Historical Society, which in 1860 had acquired the Abbott collection.

There being no professionally trained Egyptologists at that time in the United States, Honorary Director Charles C. Perkins engaged an amateur, Charles Greely Loring (1828–1902), to install the objects in the Boston Athen-aeum, where the collection was then housed. (Like the New York Historical Society, the Boston Athenaeum served as an art repository until local museums were built.) Loring had traveled to Egypt as a young man and returned in 1868 and 1869 after having served as an army general in the Civil War, with a taste for Egyptian art. So it was, in a way, natural for the Museum's trustees to turn to him when the first Egyptian objects from the Way collection arrived in 1872. The following year, Loring was elected as a trustee and, three years later, in 1876, he was made the Museum's first curator, responsible for the entire collection. When Loring became the Museum's first full-time director in 1886, a post that he held until his death in 1902, Egypt's place in the MFA was assured.

Eager to augment its Egyptian collection, the Museum subscribed to the London-based Egypt Exploration Fund (EEF), which had been founded in 1882. This was an excellent way to acquire genuine and well-provenanced antiquities excavated by the leading archaeologists of the day, Edouard Naville and

Flinders Petrie. An American branch was promptly opened in 1884, with its headquarters in Boston. "Most of the early subscribers were New Englanders, and the first museum to benefit materially from the Fund's discoveries was, naturally, Boston's Museum of Fine Arts. After the British Museum, the largest and best collection of antiquities was shipped there from Egypt every year."[13] From 1885 to 1911, therefore, the Museum received over three thousand objects from the EEF's excavations. From Herakleopolis came an exquisite gold statuette of the ram-headed god Harsaphes, and from Tell Nabasha came a colossal seated statue of Ramesses II (p. 2). The finds from Bubastis are particularly impressive: they include an even larger statue of Ramesses II (p. 163) and the block statue of his fifth son, Mentuherkhepeshef (p. 164), as well as architectural elements of great scale such as an enormous granite papyrus-bundle column (which at roughly 18 metric tons [20 tons] remains the single largest object in the collection; see p. 132), a column capital with the fetish of the goddess Hathor (p. 173), and four relief-decorated granite blocks from the temples of Osorkon II and Nectanebo II (p. 170). From Abydos came the scepter of King Khasekhemwy (p. 58). Promoted as the oldest royal scepter in existence, this object inspired an almost mystic reverence in Boston at that time.

General Loring died in 1902 and was succeeded as director by Edward Robinson, who had been Boston's first curator of classical art since 1887. That same year, a separate Department of Egyptian Art was created with Albert M. Lythgoe (1868–1934) as curator. Lythgoe was the first professional Egyptologist employed at the MFA. He started his career in Greek archaeology but also studied Egyptian language with George Andrew Reisner at Harvard, and later studied Egyptology in Bonn, Germany, with Alfred Wiedemann. After Germany, Lythgoe spent three years in Egypt with Reisner, who at the time was excavating on behalf of the University of California at Berkeley with funds provided by Phoebe Apperson Hearst, mother of the newspaper publisher William Randolph Hearst and herself in possession of a considerable fortune.

Lythgoe's tenure at the MFA was brief but significant. After his appointment as the Museum's first curator of Egyptian art in 1902, he made important purchases for the Museum, including two complete tomb chapels from Saqqara (which the Egyptian government was selling off), a wooden statue of Wepwawetemhat (p. 114) from the French excavations at Asyut, and a group of polychrome faience tiles from the palace of Ramesses III at Medinet Habu, Thebes (p. 165). Additionally, he secured through his influence with Theodore M. Davis several important objects from Davis's excavations at Thebes. Davis, a retired American businessman from New York, held the right to excavate—called a concession—in the Valley of the Kings from 1903 to 1912. As an excavator Davis was

incredibly lucky: his discoveries included the tombs of Hatshepsut and Thutmose IV, the tomb of Yuya and Tuya (in-laws of Amenhotep III), and many others. Of course he was no excavator himself, but he financed the excavations and he had able men working for him, such as Howard Carter (who was later to gain worldwide fame as the discoverer of the tomb of Tutankhamen), James Quibell (future head of the Egyptian Antiquities Service), Edward Ayrton, Harold Jones, and Harry Burton.

Thus in 1903 and 1904 the Museum received as gifts of Theodore Davis fifty-four objects from the tomb of Thutmose IV in the Valley of the Kings, including a panther "exhibiting wonderful power and action"[14] (p. 151) and a red quartzite sarcophagus of Hatshepsut recut for Thutmose I — the only Eighteenth Dynasty royal sarcophagus outside of Egypt — from the tomb of Hatshepsut (pp. 146–47). But the object that attracted the most attention at that time was a meshed garment of leather cut from a single gazelle skin and somewhat resembling a Roman Catholic chasuble. It was suggested at the time that this garment might be the prototype of the Biblical ephod, described in the Book of Exodus as the vestment worn by the Israelite high priests. It is really a loincloth (p. 150). The Davis gifts are all the more important today because the Museum would never excavate an important New Kingdom site.

Meanwhile, in 1903, Reisner had obtained for the Hearst Expedition the American concession to excavate at the Giza pyramids. When Mrs. Hearst announced that she would have to withdraw her funding — one of her gold mines had gone bad and she was forced to economize — Reisner and Lythgoe got the whole operation, lock, stock, and barrel — staff, concessions, and all — for Boston. An agreement was reached whereby the MFA would receive and exhibit the finds and Harvard would pay for the scholarly publications.

The Joint Egyptian Expedition of Harvard University and the Museum of Fine Arts, Boston (later shortened to the Harvard-Boston Expedition) began operations in 1905 with Reisner as director and Lythgoe as field director. Lythgoe resigned in 1906 to become New York's Metropolitan Museum of Art's first curator of Egyptian Art, and to head the Metropolitan's newly formed Egyptian expeditions. He was spectacularly successful, but in Reisner, Boston retained the greatest excavator of the day. As a result Boston's collection grew by leaps and bounds. In fact, no one — not the trustees, not even Reisner himself — could ever have anticipated how rapidly it would grow year by year with original works of art of the highest quality and importance, with impeccable provenance, acquired with relatively little expense. Reisner's excavations for the Museum would bring Boston's long-standing interest in ancient Egypt to fruition.

1 Stephen Quirke and Carol Andrews, *The Rosetta Stone: Facsimile Drawing* (New York: Harry N. Abrams, 1989), 22.

2 Edward Everett, "Zodiac of Denderah," *North American Review* 17, no. 41 (October 1823): 234.

3 Everett, "Hieroglyphics," *North American Review* 32, no. 70 (January 1831): 113.

4 George R. Gliddon, *Ancient Egypt,* 12th ed. (Philadelphia: T. B. Peterson, 1848), appendix, 2.

5 John Pickering, "Address," *Journal of the American Oriental Society* 1 (1849): 1–60.

6 Edward Everett to John Pickering, December 30, 1843. Department of Art of the Ancient World, Museum of Fine Arts, Boston.

7 Ibid.

8 John Pickering to Edward Everett, April 30, 1844. Department of Art of the Ancient World, Museum of Fine Arts, Boston.

9 See John T. Irwin, *American Hieroglyphics: The Symbol of the Egyptian Hieroglyphics in the American Renaissance* (Baltimore and London: Johns Hopkins University Press, 1983).

10 *Third Catalogue of the Collection of Ancient and Modern Works of Art given or loaned to the Trustees of the Museum of Fine Arts, at Boston, now on Exhibition in the Picture Gallery of the Athenaeum* (Boston: Museum of Fine Arts, 1874), 3.

11 John Lowell, November 21, 1832, cited by Nancy Scott Newhouse, "From Rome to Khartoum: Gleyre, Lowell, and the Evidence of the Boston Watercolors and Drawings," in *Charles Gleyre: 1906–1874*, exh. cat. (New York: Grey Art Gallery and Study Center, 1980), 80.

12 John Lowell, October 31, 1835, cited by Newhouse, 87.

13 T. G. H. James, ed., *Excavating in Egypt: The Egypt Exploration Society 1882–1982* (Chicago and London: University of Chicago Press, 1982), 22.

14 *Museum of Fine Arts Bulletin* 1, no. 5 (November 1903): 31.

The Egyptian Expedition Rita E. Freed

Fascination with ancient civilizations had a long history in both the city of Boston and the New England region at large by the time the Museum of Fine Arts was established in 1870. The citizens of the city that was called the "Athens of America," a great center of learning, regarded Greek civilization as the origin of Western art and culture. Moreover, since the Puritans lay the foundations for the country in the seventeenth century, many thought of America, especially New England, as a sort of "New Jerusalem." Their ideals and moral code were those of the Bible; every child studied the Scriptures.

By the nineteenth century, additional factors generated even greater interest in the past. The widespread dissemination of printed material on ancient cultures, made possible by cheaper printing methods, inspired more and more people to visit ancient sites. Travel was easier than it had ever been, and European influence in the Middle East made it seem safer. By the late nineteenth century, escape to the past must have been a comforting antidote for a society in the midst of the Industrial Revolution, and perhaps more importantly, it was fashionable. Archaeologists and entrepreneurs were unearthing treasures of ancient civilizations throughout the Classical World and Middle East, and filling museums with those riches in such cultural capitals as London, Paris, and Berlin. Boston was eager to have its share.

This phenomenon related particularly to Egypt. After Napoleon's Egyptian expedition in 1798, increasing numbers of people had access to its splendors, thanks to the highly acclaimed and widely available publication, *Description de l'Egypte*, produced under his auspices. This multivolume, copiously illustrated work helped inspire the Egyptian revival movement in architecture and the minor arts. Then there were the biblical connections. In Egypt, it was fervently hoped, explorers might find documents relating to one of the least-known and most significant periods of biblical history: the four-hundred-year Hebrew sojourn and oppression in the land of Goshen, specifically the Egyptian Delta.

Investigation of biblical lands would help document the Bible and counter Darwin's radical theory of evolution.

Accordingly, the Museum of Fine Arts, Boston, was founded with the twin goals of improving all humankind by providing a familiarity with great artistic masterpieces, and of "illustrating the fine arts by archaeology." As strange as it may seem today, the way to achieve the first objective, it was thought, was to acquire plaster casts of famous works. Although Boston possessed a small collection of European and American paintings as well as eleven full-size plaster casts of classical sculptures at the time, as a rule, real objects were thought to be beyond the financial means of the new museum. It was also widely believed that good quality originals were unavailable; meanwhile, casts of the best of the world's sculptures were attainable at a reasonable cost. So in addition to the more philosophical reasons behind the support for archaeology in the Museum's early years, it was an important means by which the young institution could acquire genuine objects.

fig. 6 George Andrew Reisner, June 26, 1933. Harvard University-Museum of Fine Arts Expedition Photograph.

The Museum's first and only direct sponsorship of an Egyptian expedition did not begin until 1905, but it lasted until 1947 and resulted in the MFA becoming one of the world's great repositories of Egyptian art and material culture. Known as the Harvard University-Museum of Fine Arts, Boston, Expedition (Harvard-Boston Expedition) because the original intention was for Harvard to publish the scientific results and for the Museum to receive and exhibit the finds, it was led by George Andrew Reisner (1867–1942; fig. 6), who in turn would become the single most influential person in the development of the MFA's Egyptian collection. His excavation methods and scientific insights would also earn him the title "Father of American Egyptology."

Born in 1867 in Indianapolis, Reisner graduated from Harvard in 1899 and completed his Ph.D. in Semitic languages and history there in 1893. Hired by the Berlin Museum where he published a number of cuneiform texts, he worked beside Kurt Sethe who taught him hieroglyphs. That would determine the future of his career. He returned to the U.S. in 1896 to teach Harvard's first hieroglyphs course. A year later, the Egyptian Government appointed Reisner as a member of a committee of five to catalogue the objects in the Egyptian Museum in Cairo. Between 1897 and 1899, he authored three volumes. It was in Cairo that he met Mrs. Phoebe Hearst, who hired Reisner in 1899 to excavate for her on behalf of the University of California. He continued to work under her auspices until 1905, when the failure of her goldmining operations reduced her income and forced her to retrench. It was then that the first curator of the newly formed Egyptian Department at the Museum of Fine Arts, Albert Lythgoe, was seeking to augment the collection by means of archaeological excavation.

When the Harvard-Boston Expedition was established, Reisner and his team of assistants and native workers were digging primarily at Giza, one of the most important sites in all of Egypt and renowned for its material from the Old Kingdom (also known as the Pyramid Age), including the famous pyramids themselves. Prior to that time, permission to excavate this prized site had been reserved by the Egyptian government, although no excavations had been conducted. Then, under pressure from Lord Cromer, the British Agent, it was given to a member of the British Parliament, who soon tired of what Reisner called his "looting operation." Finally acknowledging its inability to protect the area, the Antiquities Service agreed to accept applications from foreign institutions. Three stepped forward in 1902: Georg Steindorff on behalf of Leipzig University in Germany, Ernesto Schiaparelli on behalf of the Turin Museum in Italy, and Reisner on behalf of the University of California for the U.S. All three permissions were granted, with the pyramids and the extensive cemeteries to the east and west of the Great Pyramid to be divided by mutual agreement. Half the finds would go to the sponsoring organization, and the other half to the Egyptian Museum in Cairo.

In December of that same year, the three men met on the veranda of the Mena House hotel under the shadow of the Great Pyramid at Giza to draw lots. Reisner described what happened:

Everybody wanted a portion of the great Western Cemetery. It was divided in three strips east to west. Three bits of paper were marked 1, 2, and 3 and put in a hat. Mrs. Reisner drew the papers and presented one to each of us. The southern strip fell to the Italians, the middle to the Germans and the northern strip to me.

Then we proceeded to divide the pyramids. I perceived that the Italians were interested in the First Pyramid and the Germans in the Second. I kept my mouth shut and let them wrangle. When they had adjusted the line between the First and Second Pyramid, the Italians, thinking that I might insist on a ballot, resigned to me the northern part of the area east of the First Pyramid, if I would accept the Third Pyramid. I was perfectly willing to have the Third Pyramid, but of course I accepted his offer. [1]

Reisner was so accommodating because, unbeknownst to the others, he had sent his assistant to examine Giza. According to his report, Giza's most promising area was the Third Pyramid and its associated temples, the very area allotted to him. Reisner and his assistant proved to be right. Moreover, the Eastern Cemetery given to Reisner for his acquiescence would produce some of the most fascinating results. During the first year of its sponsorship of the expedition, the Museum received some beautifully preserved and unusual sculptures, including the brightly painted pair statue of Ptahkhenuwy and his wife (pp. 88–89), and

fig. 7 Working at Bersha briefly in 1915, Reisner made many important Middle Kingdom finds. Harvard University-Museum of Fine Arts Expedition Photograph.

a "reserve head" (p. 77) described as "probably the most important piece of Egyptian sculpture in America."[2]

But Reisner was not just lucky. He had an archaeologist's sixth sense for recognizing the potential of a site through careful examination. Even more importantly, he developed a methodology for scientific recording that is still followed today. Among the first to recognize that the context in which an object was found could shed light not only on the meaning of the item itself, but also on its date and the culture from which it came, he had each day's events recorded in meticulous detail. (He even included the names of those who dropped by for tea.) When an object was found, it was photographed in situ and then brought for additional photography to the excavation house, a rambling series of unpretentious mudbrick structures to the far west of the Great Pyramid, fondly known as Harvard Camp. There the object was measured, described, drawn, and given a number corresponding to the date and order in which it was found. Tomb walls were also drawn and photographed. Reisner's goal each year was not only to excavate at Giza where he was sure to make discoveries that would please the Museum because of their artistic value, but also to spend time at other sites where he could flesh out the archaeological record of periods other than the Old Kingdom. In all, he would excavate twenty-two additional sites in Egypt (fig. 7), the Sudan (also known as Nubia), and what is now Israel.

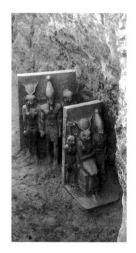

fig. 8 Menkaure triads as they were found in the Menkaure Valley Temple. The one in the foreground was awarded to the MFA. Harvard University-Museum of Fine Arts Expedition Photograph.

Beginning in 1906, Reisner focused on the Third Pyramid at Giza and its temples. Within a year, in the mortuary temple at the base of the pyramid, he discovered several statues of King Menkaure, builder of the Third Pyramid, and his family, including fragments of a colossal statue of the king (p. 80). Two triads of Menkaure, Hathor, and a nome deity from the Menkaure Valley Temple (fig. 8 and pp. 83–85), as well as other royal statues were awarded to the Museum in 1909. Eventually, work there had to stop, because, as Reisner reported, "the value of the finds had been so great that the payment of the *bakshish* to the workers exhausted our resources."[3]

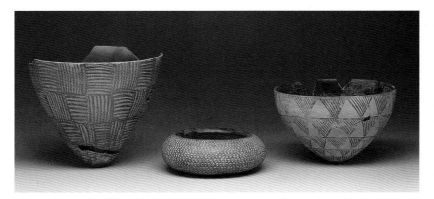

fig. 9 Conical bowls painted in imitation of basketry and incised wares were among Reisner's finds in Nubia. Nubian bowls, about 3100–2900 B.C., pottery, h. 6.5–19 x diam. 10.8–21 cm (h. 2 9/16–7 1/2 x diam. 4 1/4–8 1/4 in.); left and right: Gift of Dr. George A. Reisner 19.1540 and 19.1543, middle: Emily Esther Sears Fund 03.1613.

In 1907, other projects intervened for Reisner. When Egyptian government authorities recognized that the heightening of the first Aswan dam built in the late 1890s would flood the area below it, they requested Reisner's services to document what would be lost. From 1907 to 1909, he transferred his staff and workers to the south, where his First Archaeological Survey of Nubia excavated some eight thousand tombs in more than one hundred-fifty different cemeteries and established a framework for Nubian history that is still in use today (see fig. 9). Fascinated with the area and its potential, he would later return for further work. Although previously scholars and travelers had documented some of Nubia's main monuments, and treasure seekers had removed what they could carry, prior to Reisner there had been no scientific excavation of the area.

fig. 10 The heads of King Menkaure and a queen emerge from a robber's pit in the Menkaure Valley Temple. Harvard University-Museum of Fine Arts Expedition Photograph.

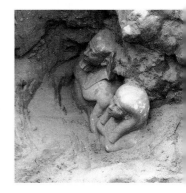

Reisner also continued his work at Giza, where an interesting problem presented itself in 1910. The year before, tossed aside in a robber's hole in the Mycerinus Valley Temple, Reisner had found the magnificent dyad of Menkaure and a queen (fig. 10 and p. 86). Upon finishing the excavation of that area, Reisner brought what he had excavated to Cairo for the division of finds. By contract, he was entitled to half. However, the pair statue had no equal among his objects, and he argued that Boston would be shortchanged should the statue go to Cairo. Sensitive to the needs of both parties, Reisner proposed that he be given a duplicative statue already in the Egyptian Museum. In principle the head of the Antiquities Service, Gaston Maspero, agreed, but each piece Reisner suggested was rejected. Maspero countered with his own proposal. He suggested Boston return one of the triads the Museum had received earlier, thought to represent half the value of the dyad, and accept the pair statue in exchange. Wasting no time, Reisner telexed Boston and received approval for this proposal the next day.

Today, the dyad is the icon of the Egyptian Department and one of the Museum's priceless treasures. No survey of world art is complete without it. Never again did Reisner have to worry about funding. He was also rewarded

personally by being made Curator of the Museum's Egyptian Department and Assistant Professor of Egyptology at Harvard.

In 1912, when the Italians withdrew from their concession at Giza, Reisner took that on as well, and a slightly petulant note in that year's annual report mentions that no work was done in the Museum's Egyptian department because the entire staff was in the field. The situation only got worse the next year when Reisner began excavations in the Sudan as well. However, with the discovery of the spectacular statue of Lady Sennuwy (fig. 11 and pp. 126–27) shortly afterwards, the

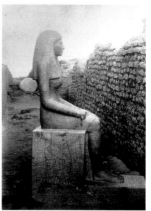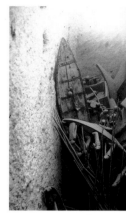

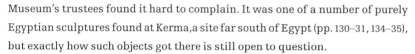

fig. 11 Originally placed in her husband's tomb in Assiut, Egypt, the magnificent statue of Sennuwy was plundered in antiquity and reburied in Kerma, Nubia. Harvard University-Museum of Fine Arts Expedition Photograph.

fig. 12 Jumbled models of boats and other objects left behind by robbers in the tomb of the nomarch Djehutynakht at Bersha. Harvard University-Museum of Fine Arts Expedition Photograph.

Museum's trustees found it hard to complain. It was one of a number of purely Egyptian sculptures found at Kerma, a site far south of Egypt (pp. 130–31, 134–35), but exactly how such objects got there is still open to question.

The Harvard-Boston Expedition soon experienced other problems. When World War I broke out in 1914, the indomitable Reisner made the decision to continue excavating and to keep his trained and trusted Egyptian staff together, although his American assistants went off to serve their country. They worked extensively in the Sudan. In Egypt, the Expedition excavated not only at Giza, but also at Bersha, where they discovered the Middle Kingdom tomb of the provincial ruler Djehutynakht, packed with coffins and models of boats and items of daily life (see figs. 7 and 12). In view of the danger of traveling by sea during the War years, the decision was made to keep the finds in Egypt.

Wartime turbulence had quieted down enough by 1919 for Reisner, with some trepidation, to send a shipment home that included Djehutynakht's outer coffin (pp. 118–19). "It is the finest Middle Kingdom coffin in the world," he noted in that year's report, while annotating the packing list, "I shall die of anxiety while it is at sea." His fears were well founded. Not only did the politics of the time create problems, but also weather conditions and other hazards presented constant threats. A fire that had broken out on the ship bearing the results of his 1913–14 season largely spared the objects, but the water used to extinguish the fire caused significant damage to a painted inner room from the chapel of Akhetmerynyswt. There was also a fire aboard the ship carrying the Djehutynakht material, but fortunately it escaped virtually unscathed.

After the war, with ships once again safe from attack, a deluge of another type occurred. The year 1921 saw the arrival of more than 90 metric tons (100 tons) of sculpture at the Museum, the accumulated results of the war years. With the objects came Reisner — his first visit in ten years — to oversee the rearrangement

of the galleries. Seventy-eight more cases arrived the next year, and fifty-five more were shipped in 1924. Not surprisingly, the Egyptian Department soon found itself seriously short of space and unable to show some of its major new acquisitions. Thanks to the completion of the Evans Wing for its paintings collection, the Museum was able to respond by dedicating the large gallery off the Upper Rotunda to the finds from Giza, a space that remains as of this writing as the finest exhibition of Old Kingdom art outside Cairo.

Ironically, the Expedition's best moment occurred when Reisner was on one of his rare trips to Boston, in February 1925. At the time, his assistant Alan Rowe was in charge at Giza. The staff, as per Reisner's instructions, was engaged in some cleaning and recording in the Eastern Cemetery prior to excavation and did not expect to find anything. However, when photographer Mohammed Ibrahim's tripod leg sank a bit too far into the ground, they discovered that he was standing above a flight of steps that led to a vertical shaft of 27.4 meters (90 feet). At the bottom was a sealed door. Reisner later described what his staff saw inside on March 7, after digging out the plaster, masonry, and stone that had blocked the area: "Mr. Rowe withdrew a single block of stone . . . and looked in. It was then late in the afternoon and sunlight had gone. By the light of a candle, he saw only dimly a chamber, a sarcophagus, and a glitter of gold."[4]

A cartouche read "Sneferu," so Rowe told the press that the Expedition had discovered the tomb of the father of the king who built the Great Pyramid. The next thing he did was to telex Reisner on March 9 describing what they had found. Reisner's response was clipped, "Close tomb to await my arrival," and he instantly denied the tomb owner's identity in an article in the London Times. Reisner was right to be cautious. What the Expedition had found was the tomb of Queen Hetepheres, wife of Sneferu and mother of the king who built the Great Pyramid.

It took more than four months for Reisner to arrive in Cairo. Once there, he realized the glittery mess he saw was the remains of wood furniture covered in gold foil. Over the millennia, the wood had decayed, leaving only the casing. Scattered fragments filled every available space. By all accounts, it looked to be an unplundered royal tomb, with a sealed alabaster sarcophagus in the corner. He knew his only hope for reconstructing the tomb's contents was the systematic removal of every scrap.

First, however, there were logistical problems. The underground burial chamber was small, dark, and hot. A light bulb suspended from an electrical generator above ground brought more heat, so a fan was installed. But the fan blew the objects around. The solution was to move the fan to the top of the shaft and blow air down a long pipe. For the constant fleas and flies, they suspended

flypaper. Only then was a staff member, by lying on a mattress at the door, able to work (fig. 13).

Fragment after fragment was given a number, photographed in situ, and marked on a general plan. Then each piece was moved to Harvard Camp, registered into a ledger, drawn, measured, and described. Finally, after two seasons of work, 1,701 pages of notes, plans and sketches, and 1,057 photographs (all of which may still be consulted in the Museum's archives), the tomb was clear, except for the large sealed sarcophagus. On March 3, 1927, two years after the tomb was opened, a crowd of dignitaries assembled in the burial chamber to witness its opening. With staff members Dows Dunham and Noel Wheeler on either side, slowly the heavy lid was raised. A moment went by before the excavation's artist Joseph Lindon Smith was heard to exclaim, "George, she's a dud!" The sarcophagus was empty. Reisner slowly turned to his distinguished guests and said solemnly, "Gentlemen, I regret Queen Hetepheres is not receiving." All too late, on the basis of the order of the tomb's contents and the empty sarcophagus, Reisner concluded that the tomb was a reburial. The original interment may have been near Sneferu's pyramid at Dahshur, and was probably robbed in antiquity. It was most likely the queen's son, Khufu, who arranged for the reburial near his own pyramid at Giza.

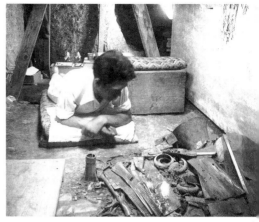

fig. 13 Amid the flies and fleas, Lt. Commander Noel Wheeler lay on a mattress near the door as he catalogued fragments from the tomb of Queen Hetepheres. Harvard University-Museum of Fine Arts Expedition Photograph.

Later that year Reisner delivered the tomb's contents to the Egyptian Museum, recognizing that according to his agreement with the Antiquities Service, any unplundered royal tomb belonged in its entirety to Cairo. However, because by contract the Expedition was supposed to receive half of what was found, the Museum received in compensation the spectacular painted bust of Ankhhaf (p. 78), discovered the same year as the tomb of Hetepheres.

Work at Giza, as well as at sites in the Sudan, continued throughout the rest of that decade and into the 1930s, but Reisner's primary focus largely shifted by 1930 from excavation to publication. Even failing eyesight and two unsuccessful operations for a detached retina did not stop him. He dictated his manuscripts to his devoted secretary, Evelyn Perkins, and reported with pride, "I have not ceased work for a single day after the first week following the second operation." [5] He demanded the same dedication from his assistants.

Back at the Museum, registration, analysis, and restoration occupied the staff, particularly with the arrival in 1928 of the archaeological conservator, William Young. He, together with assistant curator Dows Dunham, who had returned to Boston to run the department following the completion of work on the tomb of Hetepheres in 1925, restored treasure after treasure and pioneered

the development of scientific techniques for the examination and treatment of antiquities. These included ultraviolet light for revealing faint traces of paint on limestone, electrolytic reduction for the cleaning of metals, and, with the help of Massachusetts General Hospital and Eastman Kodak, x-rays for nondestructive analyses of mummies.

In Egypt, meanwhile, Reisner had become an institution (fig. 14). For years, distinguished visitors and young archaeologists alike went for tea to meet him and hear his stories. In his later years they called him "Papa George." During the infrequent hours he was not at work, he read detective novels, played with his twenty dogs, and attended Rotary Club meetings in Cairo. The year Reisner turned 70, the president of the MFA's Board of Trustees visited him in Egypt with a view toward planning for the future. In view of Reisner's age, increasing nationalism in Egypt, the economy during the Depression years, and what must have been a gargantuan backlog of excavated material in the Museum's storerooms, it is not surprising that the annual report for that year states, "There is still a tremendous amount of work for Dr. Reisner to do in publication, but how much more actual excavation should be undertaken is a problem which soon must be decided."[6] Sixteen additional crates arrived that year from Giza.

In 1939, after a hiatus of ten years, Reisner returned to Boston to attend his fiftieth Harvard reunion and accept an honorary doctorate of letters. After a month, he returned to Egypt, and his timing was none too soon. World War II broke out shortly thereafter. He acknowledged the possible danger by sending his wife and daughter home, and moving headquarters for the Expedition from Harvard Camp into a rock-cut tomb not far away. By establishing his bedroom in the same tomb, not only did he never have to leave, but also he could ignore air

fig. 14 The workroom at Harvard Camp, Giza. Reisner is second from the left. Harvard University-Museum of Fine Arts Expedition Photograph.

raid sirens. Bedrooms and workrooms for his staff were likewise relocated there. "His quarters are well ventilated," the Museum director relayed, "and . . . his work is proceeding at the normal rate."[7]

However, an era was about to end. On June 6, 1942, with both his beloved Egyptian and American staffs in attendance, Reisner died peacefully at Giza. He was buried in Cairo, and his obituary dubbed him "Saint of the Desert." Dows Dunham, who had long maintained the Egyptian department in Boston and who became curator upon Reisner's death, best summed up his contributions:

During more than thirty-five years of service to the Museum, principally in Egypt, he had built up this Department until it ranks high among the few greatest collections of Egyptian art and archaeology in the world; he had set scientific standards which had powerfully influenced the practice of excavation by workmen of many nationalities not only in Egypt but throughout the Near East, and he had added whole chapters to our knowledge of ancient Egyptian civilization.[8]

Then came the inevitable problem of what to do about the Expedition. War was still raging in Europe, so nothing could be decided immediately. Finally, in 1946 Dunham and Assistant Curator William Stevenson Smith went to Egypt to inventory, sort, and pack the accumulation of nearly forty years' work. In the end, sixteen thousand glass negatives and twenty-eight cases containing Reisner's books and the Expedition's records were packed and shipped back to Boston. Final divisions of archaeological material with the Egyptian government yielded an additional five cases of antiquities.

The moment for a difficult decision had come. A shortage of funds combined with rising nationalism threatened to make continued excavation difficult and the likelihood of major additions to the collection unlikely. So after thirty-seven years of continuous work in the field, the Museum's trustees closed the Harvard-Boston Expedition in 1947. Giving up Harvard Camp was difficult enough, but dismissing the staff of Egyptian workers — they averaged more than thirty years of service — was devastating. When Dunham returned to Egypt for a visit nearly twenty-five years later, one of these workers greeted him like a member of his family.

Today the expedition material remains both a precious legacy and a weighty responsibility. After Reisner's death, excavation largely shifted from the Nile Valley to the Museum's basement storerooms, as the department focused on the

reinstallation of galleries, restoration and conservation of objects, and augmentation of the collection through exchanges with other institutions. Publication became a major focus. Eventually, Museum staff returned to the field, this time not to excavate, but to complete the task of photographing and recording its tombs under the able leadership of curator William Kelly Simpson (born 1928) and others. In 1974 the first volume appeared in the ongoing *Giza Mastabas* series, a set of books devoted to the detailed publication of the Giza tombs. Today, a major grant from the Mellon Foundation makes it possible to scan all the Giza photographs and digitize the archival material. This not only preserves these resources for future generations, but also allows them to be made available to all via the Internet.

The collection continues to grow, albeit at a much slower pace than in Reisner's day. The recent discovery by French scholar Olivier Perdu of the base of a statue of Osiris in a French family estate, where it had been since the time of Napoleon, is just one example (p. 183). The addition of the superbly modeled head of a Twelfth Dynasty sphinx, a partial gift in honor of the department's centenary, filled a major lacuna in a way hardly dreamed possible (p. 128). The Museum and department today eagerly look forward to expanding into larger, state-of-the-art gallery spaces that will showcase this world-class collection to best advantage.

1 George Andrew Reisner, unpublished autobiographical notes, Department of Art of the Ancient World, Museum of Fine Arts, Boston.

2 Oric Bates, "Report on the Department of Egyptian Art," *Museum of Fine Arts, Boston, Thirty-first Annual Report for the Year 1906* (Boston: Museum of Fine Arts, 1907), 75.

3 George Andrew Reisner, "The Harvard University-Museum of Fine Arts Egyptian Expedition," *Museum of Fine Arts Bulletin* 9, no. 50 (April 1911): 18.

4 George Andrew Reisner, "The Tomb of Queen Hetep-heres," *Bulletin of the Museum of Fine Arts,* special number, supplement to vol. 5 (May 1927): 8.

5 George Andrew Reisner, unpublished biographical statement, Department of Art of the Ancient World, Museum of Fine Arts, Boston.

6 G. H. Edgell, "Report of the Director," *Museum of Fine Arts, Boston, Sixty-second Annual Report for the Year 1937* (Boston: Museum of Fine Arts, 1938), 14.

7 G. H. Edgell, "Report of the Director," *Museum of Fine Arts, Boston, Sixty-fifth Annual Report for the Year 1940* (Boston: Museum of Fine Arts, 1941), 13.

8 Dows Dunham, "Department of Egyptian Art, Letter to the Director," *Museum of Fine Arts, Boston, Sixty-seventh Annual Report for the Year 1942* (Boston: Museum of Fine Arts, 1943), 36.

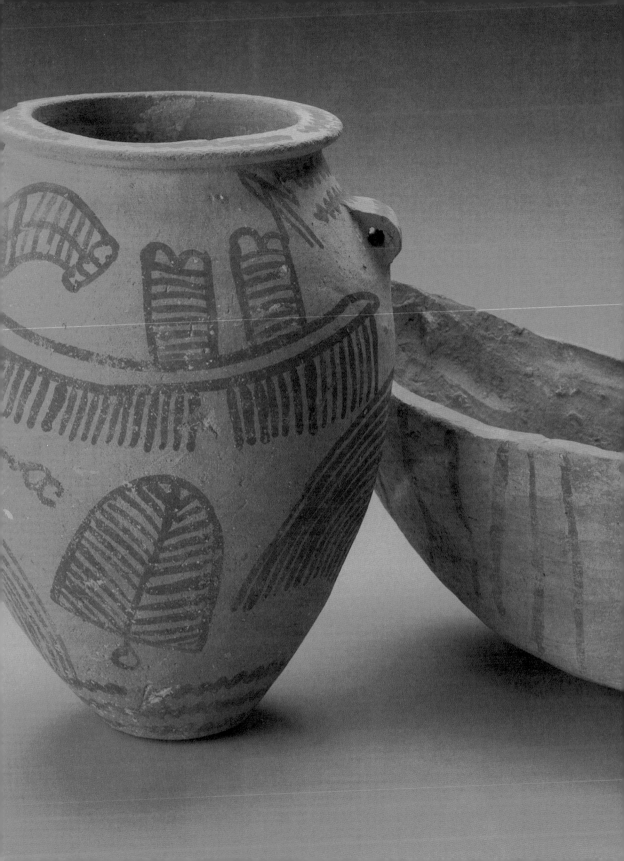

1

PREDYNASTIC and early dynastic periods before 3850–2649 B.C.

Predynastic and Early Dynastic Periods [before 3850–2649 B.C.]

The Egyptians laid the foundation for their complex and remarkable civilization in the millennia before their first kings came to the throne. Ideas about gods, rulers, and society formed at this time would influence culture for the next five thousand years, and by the end of the era, many of the distinctive and recognizable features of Egyptian art would be firmly in place. Shortly after forming communities, the people of the Nile valley began to bury their dead with grave goods to provide physical and spiritual sustenance for the afterlife, thus setting the stage for the elaborate burial customs and offerings that would later characterize their society and by which we are able to know them today.

In the early Predynastic Period, prior to about 3650 B.C., settlements in Lower (northern) Egypt retained their own distinctive cultures, customs, burial practices, and styles of tools and pottery, while in Upper (southern) Egypt a culture known as the Badarian appears to have flourished at a number of different locations. Throughout the land, people lived in small round or oval huts and were buried in a contracted position, wrapped in mats or animal skins. The economy relied on farming and animal husbandry, heavily supplemented by hunting and in some areas by fishing. Elaborate offerings have been found in the Badarian cemeteries in Upper Egypt, gifts that included pottery, tools, weapons, amulets, beads, combs, bracelets, cosmetic implements, and the earliest pottery boat models. The culture known as Naqada I, which originally coincided with and later succeeded the Badarian, featured even richer burials (fig. 15). Large elite graves at the important site of Hierakonpolis may have belonged to local rulers.

The middle years of the Predynastic, also known as the Naqada II Period, witnessed the increasing unification of Egyptian material culture as Naqada pottery and other objects began to appear at sites in the north and quickly supplanted the local styles. Relatively few settlement sites have been excavated to date, but the grave goods discovered at cemeteries reflect growing social stratification and the emergence of an elite ruling class. At Hierakonpolis, by then Upper Egypt's major center, one such leader was buried in Egypt's earliest-

fig. 15 Artists of the Predynastic Period transformed functional objects into lively and innovative works of art, often incorporating animal and plant motifs. Cross-lined beaker with two cows and a calf modeled on the rim, Naqada I, 3850–3650 B.C., Nile silt clay, from Abadiya, h. 16 cm (6 ⁵⁄₁₆ in.), Emily Esther Sears Fund 04.1814.

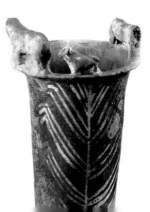

known painted tomb. Its decoration, which included scenes of sailing vessels, hunts, and military activities, parallels some of the scenes on the fine decorated pottery of the period. Gold and other precious materials entered the Nile Valley through trade during this time, and highly skilled and specialized artisans based at sites like Hierakonpolis, Naqada, and Abydos produced superb stone and pottery vessels, jewelry of semiprecious stone, ivory, and bone, hard stone palettes in the form of animals, and magnificent ripple-flaked knives. (fig. 16)

The closing years of the Predynastic era, referred to as Naqada III, along with the following phase known as Dynasty 0, witnessed striking and rapid developments: a single ruler established control over all of Egypt; monumental funerary structures were built; the first cult statues of divinities were carved; and hieroglyphic writing emerged. Copper also replaced stone for the manufacture of knives and other tools, while trade for gold and semiprecious stones, sometimes covering long distances, expanded dramatically.

By about 3000 B.C., Egypt was a unified state. The exact mechanism by which the unification came about remains unknown, but scenes on contemporary stone palettes and mace heads of victorious kings with vanquished and decapitated enemies suggest that warfare played a role. Symbols of royal authority that would endure for millennia are already present on these objects, including the heraldic plants and crowns of Upper and Lower Egypt and the pose of the smiting king on the verge of dispatching a conquered enemy. The ruler was also identified with powerful and aggressive creatures such as the bull, lion, and falcon. It is likely that the pharaohs at this time were perceived as divine.

With the formation of a centralized administration in Dynasty 1, Egypt's capital moved to Memphis. It would remain the royal residence for much of Egypt's later history. While preserved texts from the time are generally brief and fragmentary, enough historical information survives to indicate that the early pharaohs were engaged in the same activities that would characterize later reigns — building temples, trading and battling with Egypt's neighbors, and celebrating religious festivals. The longest reigning king of Dynasty 1, Den, enjoyed a prosperous tenure, during which he reorganized and expanded the state bureaucracy to solidify royal authority, and conquered enemies to the north and south. Warfare served both to secure Egypt's borders and to ensure access to precious commodities such as Nubian gold. The First Dynasty kings were so successful in their quest for the latter that by the end of the dynasty, northern Nubia had been entirely depopulated.

The kings of Dynasty 1 prepared multiroomed subterranean tombs at Abydos in southern Egypt, while also erecting temples honoring both themselves and the gods at sites in the vicinity of Memphis in the north. Large, mud-brick enclo-

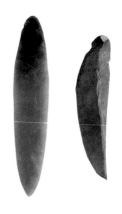

fig. 16 Predynastic knives, Naqada II, 3650–3300 B.C., flint, from Mesaid, l. 22 cm (8⅔ in.) and 17.7 cm (7 in.), Harvard University-Museum of Fine Arts Expedition 11.233 and 11.782.

fig. 17 Mudbrick funerary enclosure of Khasekhemwy at Abydos, Dynasty 2, about 2675–2649 B.C. Photo: Denise M. Doxey.

sures near the tombs at Abydos probably also served as memorial temples, setting the precedent for the royal pyramid temples and valley temples of the Old Kingdom. Excavations carried out there by the Egypt Exploration Fund provided the Museum of Fine Arts with an unusually fine collection of material from these early royal burial sites.

Less historical evidence survives from Dynasty 2. Early in the dynasty, Egypt may have suffered from social unrest, perhaps including renewed conflict between Upper and Lower Egypt. The powerful king Khasekhem put an end to these troubles, and apparently marked the event by changing his name to Khasekhemwy, meaning "the two powers appear in glory." His tomb at Abydos, lined with limestone blocks, is the oldest large-scale stone structure preserved from this early date, and his massive mud-brick enclosures at Abydos (fig. 17) and Hierakonpolis are the most prominent buildings to survive from the Early Dynastic Period. Memphis remained Egypt's capital, however, and the rich tombs of Egypt's highest-ranking officials have been discovered nearby at Saqqara. Large tombs unearthed at the site may also have belonged to other Dynasty 2 kings, and in the following dynasty, Saqqara would emerge as the principal royal cemetery.

With the death of Khasekhemwy, Dynasty 2 came to an end. By the reign of the early Dynasty 3 king Netjerikhet Djoser, Egypt's kingship, administration, economy, and foreign policy were firmly established, setting the stage for the glorious period of the Old Kingdom. Under Djoser, it would witness the emergence of monumental stone architecture, and the age of the pyramids would begin.

Denise M. Doxey

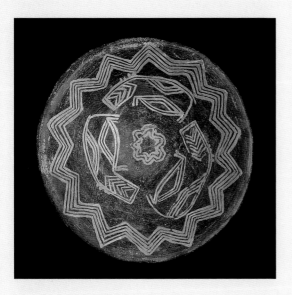

Bowl with hippopotami
Naqada I, 3850–3650 B.C.

The scene on this early bowl already displays many of the qualities that would become canonical in Egyptian art. Stylized hippopotami are depicted in profile, with their essential features—mouths, eyes, ears, legs, and tails—shown as discrete symbols rather than realistically; yet combined they form a visually coherent and aesthetically pleasing whole. A landscape setting is indicated both by the wavy, concentric lines of the central rosette representing a pool of water or perhaps the Nile, and by the zigzag lines around the border of the bowl that suggest cliffs on the horizon. The three hippopotami wade peacefully in the intervening space.

This bowl is one of the finest examples of what is known as "cross-lined ware." It was handmade of reddish Nile silt clay, burnished, coated with a thin red slip, and then decorated with linear patterns in thick, creamy white paint. The cross-hatching for which the ware is named may initially have imitated basketry. The best artisans, however, added figures and created unique narrative scenes, many of which portray animals, such as the hippopotami seen here.

The hippopotamus motif was destined to recur throughout Egyptian art, serving both as a symbol of the destructive god of chaos, Seth, and as a protective amulet to ward off danger. Other dangerous animals also occur on cross-lined pottery, particularly crocodiles, which are sometimes shown being hunted with nets. It is possible that these vessels were intended to impart the creatures' power to the vessels' owners, granting them success in the hunt and safety from danger. Most of the best examples come from tombs, and may have been made specifically as funerary offerings.

Nile silt clay
Mesaid, probably tomb 26/6
H. 6.8 cm, diam. 19.4 cm (H. 2$^{11}/_{16}$ in., diam. 7$^5/_8$ in.)
Harvard University-Museum of Fine Arts Expedition 11.312

Comb

Naqada I, 3850–3650 B.C.

Some of the earliest three-dimensional representations of humans and animals in Egyptian art appear on small, utilitarian items such as combs, pins, and cosmetic implements. Bone and ivory combs with long teeth and handles topped by birds, giraffes, gazelles, and other animals were probably worn as hair ornaments. They occur from the end of the Neolithic era, and reached the height of their popularity in the earliest phases of the Predynastic Period. The artisans of such objects displayed a talent for observing and representing nature that would persist throughout the history of Egyptian art.

Ivory
Naga el-Hai
H. 14 cm, w. 3.7 cm (H. 5½ in., w. 1½ in.)
Harvard University-Museum of Fine Arts Expedition 13.3509

Figurine of a man

Naqada II, 3650–3300 B.C.

Human figures sometimes take the form of rectangular ivory tags with incised and inlaid decoration. This schematically rendered tag-type figure with a pointed beard portrays a man or possibly a deity, and may have served as an idol or amulet. The man's only garment is a simple belt or loincloth, carefully indicated by means of incision. Similar attire appears on some of the earliest large-scale cult statues of gods, who otherwise appear to be nude. The massive eyes of this figure were once inlaid with semiprecious materials or beads. There is no loop for suspension, but the deeply carved groove at the bottom, a common feature of these tags, suggests that it may have been suspended on a leather thong (fastened around the groove). Statuettes of this type have been discovered in burials, often lying beside the arm of the deceased, with fragments of leather still attached. Some scholars have suggested that they were worn as amulets, while others propose that they were purely practical, serving as stoppers or plugs for water skins.

Ivory
Abadiya
H. 6 cm, w. 1.9 cm (H. 2⅜ in., w. ¾ in.)
Emily Esther Sears Fund, 1904 04.1946

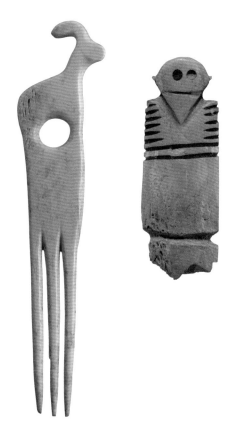

Turtle-shaped palette, Naqada II, 3650–3300 B.C.

Graywacke, shell

Naga el-Hai, tomb K 362

L. 16 cm, w. 13 cm (L. 6�5/16 in., w. 5⅛ in.)

Harvard University-Museum of Fine Arts Expedition 13.349

Fish-shaped palette, Naqada II, 3650–3300 B.C.

Graywacke, shell

Naga el-Hai, tomb K 527

L. 12.3 cm (L. 4³/16 in.)

Harvard University-Museum of Fine Arts Expedition 13.3494

Bird-shaped palette, Naqada I–II, 3850–3300 B.C.

Graywacke, shell

Said to be from Naqada

H. 14 cm, w. 9 cm (H. 5½ in., w. 3⁵/16 in.)

Emily Esther Sears Fund 03.1473

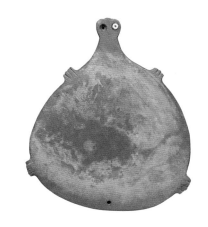

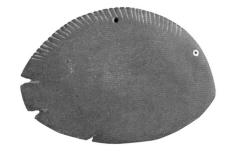

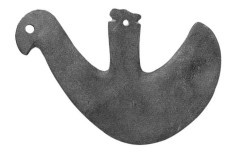

Hard stone palettes were used to grind malachite (a green copper ore) for eye paint, and were buried as offerings in the graves of both men and women from the end of the Neolithic period. They were usually placed near the head of the deceased, or perhaps suspended on a cord or leather thong around the neck. The earliest examples are flat and geometric, usually rectangular, but in the earliest phase of the Predynastic era (known as Naqada I), new shapes emerged, including representations of fish, birds, and turtles.

Some animal-shaped palettes are very large, suggesting that they may have had a ritual significance beyond their function of grinding eye paint.

The animals here — a turtle, a fish, and a bird — are portrayed from the perspective that best conveys their distinguishing characteristics. The fish and bird appear in profile, while the turtle is seen from above. Details such as the dorsal fins of the fish and the claws of the turtle are incised, and the eyes are inlaid with shell. The skill with which the early sculptors manipulated the exceedingly hard stone points to further advancements that would follow. By the Early Dynastic Period, Egyptian artists would be producing massive ceremonial palettes with narrative scenes in exquisite raised relief. By the Old Kingdom, however, these carved palettes would disappear completely.

Black-topped jar with incised figure of a ram
Naqada I, 3850–3650 B.C.

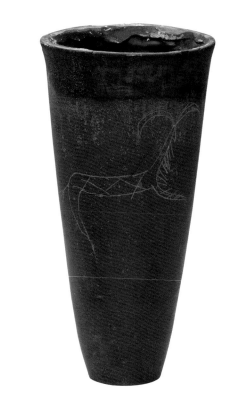

The finest pottery wares to have survived from the Predynastic Period were not utilitarian items designed for use in the home, but rather seem to have been made specifically as burial offerings for an emerging elite class. The beauty and technical quality of the finest among them would remain unsurpassed in the long history of Egyptian ceramics.

"Black-topped ware" is handmade of red clay and burnished to a high sheen by rubbing with a smooth stone or pebble. Standing the vessel upside-down in ashes in the kiln during the firing process formed the distinctive black rim. The tall beaker shown here bears an unusual incised image of a ram. The impressionistic rendering of the animal, with its massive curved horns, successfully conveys a sense of movement and grace, foreshadowing the superb representations of animals that would appear later in Egyptian art.

Nile silt clay
Abadiya, tomb B 83
H. 23.2 cm, diam. 11.5 cm (H. 9 ⅛ in., diam. 4 ½ in.)
Gift of the Egypt Exploration Fund 99.710

Bowl in the form of a bird
Naqada I–II, 3850–3300 B.C.

Potters used the same type of highly polished red Nile clay to create lively and appealing vessels incorporating human or animal elements. Here, a semicircular bowl takes the form of a bird. The modeled head of a duck extends gracefully from one side of the bowl, while the body approximates the shape of a waterfowl with an upright tail. The Egyptians would continue to produce vessels in the form of plants and animals for the next three millennia.

Nile silt clay
El Mahasna, tomb H 39
H. 9 cm, l. 15.7 cm, w. 11 cm (H. 2 ³/₁₆ in., l. 6 ³/₁₆ in., w. 4 ⁵/₁₆ in.)
Gift of the Egypt Exploration Fund 09.379

Wavy-handled jar with spatter decoration
Naqada II, 3650–3300 B.C.

As the Predynastic Period progressed, a new style of pottery emerged, made of hard, buff-colored desert clay and decorated with reddish brown paint. The spatter pattern on the jar seen here imitates the mottling of a hard stone such as diorite. The shape of this jar was widely popular, featuring a tall, ovoid body and characteristic wavy, horizontal ledge handles. Wavy-handled jars continued to be produced in both stone and pottery well into the Early Dynastic Period, but they gradually lost their shouldered or ovoid shape, developing into the elegant cylindrical jars of Dynasties 1 and 2.

Marl clay
Mesaid
H. 12.7 cm, diam. 12.7 cm (H. 5 in., diam. 5 in.)
Harvard University-Museum of Fine Arts Expedition
11.313

Figurine of a man

Naqada II, 3650–3300 B.C.

Highly stylized clay figures featuring abstract, beaklike faces, long necks, gracefully upraised arms, and legs abbreviated to conical pegs without any indication of feet were probably made to accompany their owners to the grave. Female figurines of this type are far more common than those portraying men, so this well-preserved representation of a man is of particular interest. The lower part of the body is painted white to represent a kilt, while the skin is rendered in red and the schematic facial features are outlined in black.

At present, it is uncertain whom these appealing and enigmatic figures represent. Excavated examples, which are rare, all come from graves. The figures' peglike lower bodies enabled them to stand erect in the sandy bottom of the shallow, oval burial pits that were popular at the time. Because female figurines sometimes accompany male burials, they clearly do not represent the deceased. The emphasis placed on the breasts of the female figures and the genitalia of the male figures suggests an association with fertility and rebirth in the afterlife. The pose, with upswept arms, may also be a position of mourning, appropriate to the funerary context. Figures with identical poses and conical lower bodies sometimes occupy prominent positions in painted scenes on pottery, leading some scholars to suggest that they may even be gods and goddesses. This interpretation seems unlikely, however, because deities in this period usually take animal forms, and representations of gods and goddesses do not begin to appear in nonroyal graves before the New Kingdom.

Terracotta
H. 18 cm (H. 7 1/16 in.)
Emily Esther Sears Fund, 1904 04.1802

Amulet

Naqada II, 3650–3300 B.C.

Carnelian

Mesaid

H. 1.8 cm, l. 2.6 cm (H. ¹¹⁄₁₆ in., l. 1 in.)

Harvard University-Museum of Fine Arts Expedition

11.1086

Group of amulets

Naqada II, 3650–3300 B.C.

Green feldspar

Naga el-Hai, tomb K 128

H. 0.7–1.5 cm, l. 0.8–1.2 cm (H. ¼–⁹⁄₁₆ in., l. ⁵⁄₁₆–½ in.)

Harvard University-Museum of Fine Arts Expedition

13.3499a–b, d

The Egyptians wore amulets both as jewelry and as protective devices to avert the many threats they faced in daily existence, such as illness, injury, and attack by an animal. Although the repertoire of amulets increased in scope as time progressed, a considerable variety was available even in the Predynastic era. Animals were favorite subjects. Representations of fierce and dangerous creatures may have been intended to defend against hostile forces or to impart to the wearer their strength, speed, and agility. Some animals, such as cattle and falcons, may already have represented deities, as they would later.

Often carved in hard stone, early animal amulets tend to be highly stylized and can sometimes be difficult to identify with certainty. This endearing quadruped of bright red carnelian with an inlaid eye may be a pig or a hippopotamus. The latter is perhaps more likely, because hippopotami are featured in contemporary slate palettes and on painted pottery. Pigs are uncommon in Egyptian art, although Predynastic figurines of both hippopotami and pigs have survived. The animals were known for their aggressiveness, and would later be symbols of chaotic forces that threatened Egypt. The creator of this large amulet may have chosen the creature so that its ferocious temperament could avert such forces. The inlay technique used for the eye resembles that of contemporary stone palettes.

The group of flat, dark stone amulets were found together in a tomb and are probably elements of the same necklace. Included are a vulture, birds that are likely falcons, and schematic bovine heads with curved horns. Cattle played a prominent role in Predynastic and Early Dynastic religion. One of Egypt's earliest attested deities was a solar cow goddess, while the bull became a symbol of power directly associated with the king. The vulture would eventually become one of Egypt's most popular protective symbols. In pharaonic times, vulture goddesses appear flying above the king as he rides in his chariot and enveloping coffins to defend the dead on the dangerous route to eternity. Interestingly, when suspended on a cord, most of these amulets would have hung upside down. It seems, therefore, that the artist meant for them to be viewed from the perspective of the deceased.

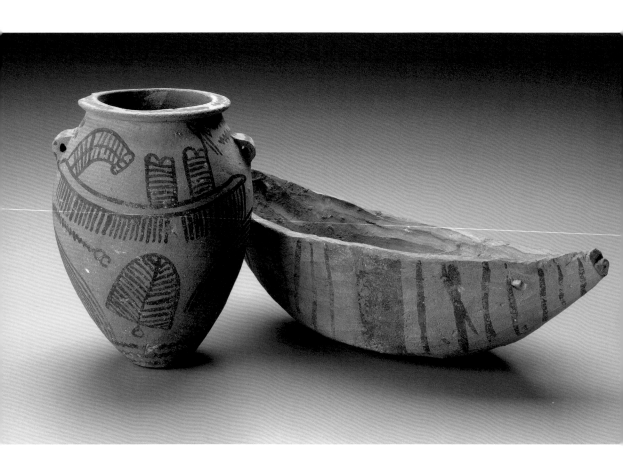

Jar with painted boats
Naqada II, 3650–3300 B.C.

The second half of the Predynastic Period witnessed
the emergence of one of ancient Egypt's most distinc-
tive and beautiful pottery styles, known today as
"decorated ware." This unusually large jar is one of
the best examples of the type. Handmade of fine, buff
clay, it features decoration in brownish red paint, an
attractive contrast to the light beige background.
Each side bears a narrative scene in which a long,
narrow ship navigates through a river landscape,
providing us with a glimpse of life on the Nile nearly
half a millennium before Egypt's first king took the
throne. The ships are equipped with two banks of
multiple oars and a pair of cabins or portable
shrines. Atop the first cabin is a pole bearing a stan-
dard and a pair of blowing streamers. These stan-
dards are a regular feature of early nautical scenes,
and may have served as emblems — divine or tribal —
or as indicators of the vessel's port of origin. Below
the ship, atop wavy lines representing the water, is
a series of large tropical plants, evoking the lush
landscape of a marsh. Because pots decorated with
boat scenes have been found almost exclusively
in burial contexts, they may have served a ritual func-
tion, as processions by boat would play an important
role in funerary iconography throughout Egyptian
history. In later periods, they often represent the
journey of the deceased to the afterlife. If these early
scenes have the same significance, it would suggest
that the Egyptians' conception of the afterlife as
a riverine land (much like Egypt) had already been
established by this early date.

Marl clay
Mesaid, tomb 877
H. 19.1 cm, diam. 15.8 cm (H. 7½ in., diam. 6¼ in.)
Harvard University-Museum of Fine Arts Expedition 13.3952

Boat model
Naqada II, 3650–3300 B.C.

The pottery boat model was manufactured using
the same technique as the jar. Made of pinkish clay
and decorated on the hull with vertical lines in
reddish paint, it represents a flat-bottomed boat of
reeds or papyrus bundles lashed together. The tall
prow and stern are now missing. Models like this one,
relatively uncommon in the Predynastic Period,
have been found in burials at important early ceme-
teries such as Naqada and Abydos. They may have
been intended to transport the deceased symbolically
to the afterlife, making them the precursors of the
magnificent wooden boat models that came into use
beginning in the Old Kingdom (see pp.122–23).

Marl clay
Naqada
H. 11 cm, l. 37 cm, w. 16.4 cm
(H. 4⁵⁄₁₆ in., l. 14⁹⁄₁₆ in., w. 6⁷⁄₁₆ in.)
Emily Esther Sears Fund, 1903 03.1381

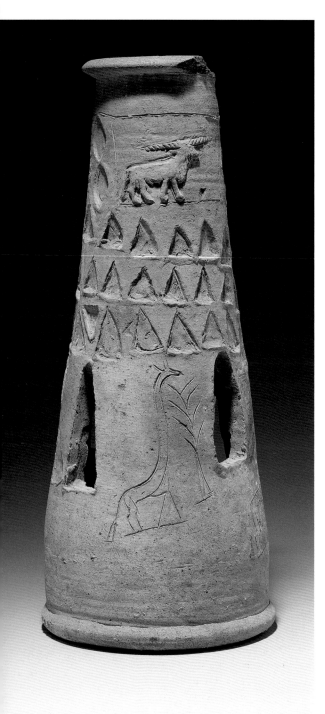

Cult stand with animal decoration

Naqada III to Dynasty 0, 3300–about 2960 B.C.

Temple furnishings from the earliest days of the Egyptian state, like this well-preserved pottery stand, are extremely rare. The stand was excavated at the site of Abydos, near the temple of the funerary god Khentiamentiu (a precursor of Osiris). The temple context suggests that it served in the presentation of offerings, perhaps in the cult of the unidentified ram deity represented at the top in raised relief.

The powerful ram with heavy, straight horns is the most important element in the stand's decoration. Placed within a rectangular frame at the uppermost part of the stand, this figure was stamped out of a separate piece of clay and applied to the surface before firing. The remainder of the upper part is decorated with recessed triangles, a pattern found in contemporary pottery from elsewhere in Egypt as well as Nubia.

Large, triangular openings divide the lower part of the stand into a series of four fields, two of which continue the geometric patterning found above. The other two fields bear incised giraffes standing beside palm trees, a motif that also occurs on other Early Dynastic items such as stone palettes, but becomes rare after Dynasty 1. The plant-with-animal symbol may designate a particular plantation or domain. If so, the figures would be examples of early hieroglyphic writing. Another inscription appears in a rectangular frame along the neck of one giraffe, but the exact meaning of the text remains unclear.

Pottery
Abydos, temple of Osiris
H. 65.5 cm, diam. 30.5 cm (H. 25 ¹³⁄₁₆ in., diam. 12 in.)
Gift of the Egypt Exploration Fund 03.1959

Cylindrical jar (right)
Dynasty 1, reign of Den, 2873–2859 B.C.
Tuff
Abydos, tomb of King Den
H. 15.5 cm (H. 6 ⅛ in.)
Gift of the Egypt Exploration Fund 01.7283

Cylindrical jar (left)
Dynasties 2–3, about 2750–2575 B.C.
Travertine (Egyptian alabaster)
H. 33.2 cm (H. 13 ⅟₁₆ in.)
Gift of Miss Nina H. Burnham 56.170

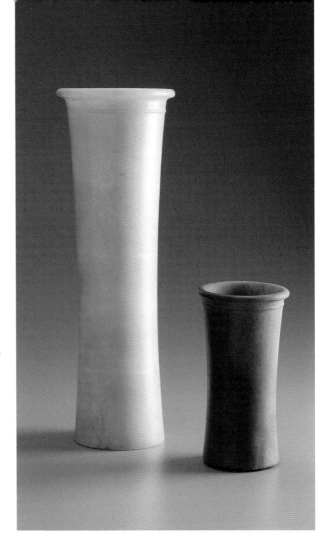

Superbly crafted stone vessels are among the most impressive products of Early Dynastic art. Artists chose and shaped their stone carefully to maximize the decorative effect of the natural color and banding. Travertine was the most popular choice, because it is soft and relatively easy to work, as well as beautifully translucent. Harder stones such as the rare, green volcanic tuff were prized for their color, fine grain, and smooth surface. To manufacture jars, artisans first produced a smooth, solid stone cylinder. Then they carefully drilled out the interior and polished both the interior and exterior with an abrasive such as sand. Tubular drills were made of copper or flint, and by the Early Dynastic Period craftspeople had access to a new type of drill, tipped with stone and turned by means of a crank.

These two tall cylindrical jars demonstrate the skill of the era's best stone workers. The smaller one was discovered in the tomb of the First Dynasty king Den, at Abydos, and must be the product of a royal workshop. The original context of the larger one is unknown. The design of both vessels is clean and elegant, the sole decoration consisting of a line of rope patterning, enhanced by incised hatching, just below the rim. Although the rope motif originally derived from the wavy ledge handles of Predynastic pottery jars, it had become purely ornamental by this time.

Forepart of a recumbent lion
Dynasty 1, 2960–2770 B.C.

This small yet imposing lion, dating to the very beginning of the pharaonic age, marks a crucial point in the development of Egyptian sculpture. While retaining the rectangular form of the block from which it was made, the hard stone was skillfully carved to convey the curves of the animal's body, the tension of its muscles, and the texture of its ruff and mane. The statuette is carved of hard andesite porphyry, a material otherwise known primarily in stone vessels, suggesting that the artist or his workshop may have emerged from that tradition. Figures of animals such as this one were probably dedicated as votive offerings in temples.

Although only the upper forepart of the lion has survived, his pose is clearly discernable. Like other lion figures of the period, he is crouched as if about to spring, with his head extended upward and forward and his snout curled back in a snarl. The ears poke up through the gently rounded mane. By contrast, the sculptor has rendered the bared teeth simply by means of crudely incised lines. Similarly stylized teeth are found on other contemporary lions, and despite their simple execution, they effectively convey the animal's ferocity. Originally, the deeply carved eyes were inlaid with another material, an unusual feature for animal sculptures of this date. The effect would surely have added both realism and intensity. The tail lies flat against the lion's back, and the curving tip remains visible behind the line of the mane.

Andesite porphyry
Possibly from Gebelein
H. 13 cm, l. 13 cm (H. 5⅛ in., l. 5⅛ in.)
Egyptian Special Purchase Fund 1980.73

Stela of a woman

Dynasty 1, reign of Djer, 2926–2880 B.C.

The First Dynasty royal tombs and funerary enclo-
sures at Abydos are surrounded by hundreds of
subsidiary burials, some richly furnished, belonging
to members of the rulers' households. Because
the burials appear to have taken place at the same
time the king was interred, and because so many
of the deceased appear to have been quite young,
excavators concluded that royal retainers, officials,
and others had been killed to accompany the ruler
into the afterlife. This practice is believed to have
occurred at other Early Dynastic royal cemeteries
as well, but it appears to have been followed for only
a short time. It is attested nowhere after the end of
Dynasty 1.

Each of the subsidiary graves at Abydos, like the
tombs of the kings, was marked by a round-topped
stela. While the royal tombs featured large stelae
of hard stone with sharply carved decoration in
raised relief, those of the retainers are small and
generally made of crudely carved limestone. This
fragmentary example comes from the grave of a
woman who was buried alongside the tomb of King
Djer. Its raised relief is largely devoid of contour and
the surface is uneven. Although much has been
broken away, the missing lower portion can be
reconstructed based upon other known examples.
The figure, shown kneeling and facing to the right,
without visible arms, is not intended to be a portrait
of any specific woman, but is instead merely a
symbol for a female. Later, the same hieroglyphic
sign would serve as a determinative for female
personal names. The inscription, "the *ka* of …" may
be an abbreviated request for funerary offerings
with the name itself omitted. Alternatively, it might
be the deceased woman's name.

Limestone

Abydos, Umm el-Qaab, tomb of King Djer

H. 21 cm, l. 31 cm, d. 7.5 cm (H. 8¼ in., l. 12³/₁₆ in., d. 2¹⁵/₁₆ in.)

Gift of the Egypt Exploration Fund 01.7294

Face from a composite statue
Dynasty 1, 2960–2770 B.C.

Because ancient wood rarely survives, very little large-scale wooden sculpture remains from any period in Egyptian history. Thus, this remarkably well-preserved face from such an early date is unparalleled. While its exact context is unknown, it probably came from Abydos, the most important cult center of the Early Dynastic Period, which housed the sanctuary of the funerary god Khentiamentiu, a precursor of Osiris, as well as the royal cemetery. The concave, masklike face was probably attached to a core made of a different material, possibly a less valuable type of wood. The eyes and eyebrows, now missing, were once inlaid with crystal or stone, which would have given the face a lifelike appearance. This inlay technique continued to be used for wooden statuary in later periods as well (see p. 94 and p. 114). Although some scholars have suggested that the sculpture represents a foreigner, the identity of the individual portrayed cannot be determined with certainty, and the facial features resemble those found on First Dynasty ivory statuettes. The wig or hair is rendered as a series of overlapping cylindrical coils, while the beard and moustache are composed of rows of neat, stylized curls. Fragments of similar wooden statues have been found in the royal and elite tombs in cemeteries at both Abydos and Saqqara. In addition, surviving groups of cylindrical locks of hair made of faience (a self-glazing, non-clay ceramic composed of quartz, lime, and alkali) may also come from similar composite statues.

Wood
Probably from Abydos
H. 16.3 cm, w. 9.7 cm (H. 6 ⁷/₁₆ in., w. 3 ¹³/₁₆ in.)
Gift of J. J. Klejman 60.1181

Leg from a piece of furniture
Dynasty 1, reign of Djet, 2880–2873 B.C.

Discovered in First Dynasty king Djet's luxuriously appointed tomb in the royal cemetery at Abydos, this diminutive and delicately crafted leg from a piece of furniture demonstrates the sophistication and technical ability achieved by royal workshops at an early date. Carved from hippopotamus ivory, it takes the form of the rear leg of a bull or cow atop a horizontally ribbed cylinder. Legs of this type are known from a variety of furnishings, including beds and stools, but the small size and material of this example suggest that it was part of a box or chest made of wood inlaid with ivory. Typically, the front and back legs would be carved to represent the fore and rear legs, respectively, of the animal. This leg must therefore come from the back of the chest. Whether it was used in the royal palace or made specifically for use in the tomb is uncertain.

Ivory
Abydos, Umm el-Qaab,
tomb of King Djet
H. 3 cm (H. 1³/₁₆ in.)
Gift of the Egypt Exploration Fund
01.7366

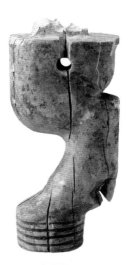

Box with sliding lid
Dynasties 1–2
2960–2649 B.C.

As the rulers of the first two dynasties extended Egyptian domination southward into Nubia, gold and other precious commodities flowed into Egypt. The nation's wealth during this time was reflected in the richness, beauty, and diversity of decorative objects made not only for the ruler, but for wealthy individuals as well. This small limestone box is a superb example of such an object, and demonstrates the Early Dynastic stone workers' skill and innovation. It is composed of thin slices of pale pinkish-white limestone joined with delicate gold rivets, set into drilled holes. The slightly convex lid slides in a carefully slotted groove, with a raised ridge at the front that allows it to move back and forth with ease. Similar boxes were also made in ivory and probably wood.

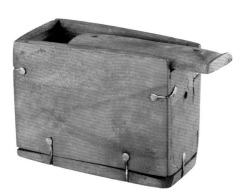

Limestone, gold
Probably from Naqada
H. 8.5 cm, w. 5 cm, d. 12 cm
(H. 3⅜ in., w. 1⅞ in., d. 4 in.)
Emily Esther Sears Fund 04.1837a–b

Scepter of King Khasekhemwy
Dynasty 2, reign of Khasekhemwy,
2676–2649 B.C.

Items of royal insignia, such as crowns, scepters, maces, and distinctive kilts, were established in Egypt's earliest dynasties to identify the king. They would continue to serve as potent symbols of royal authority and as protective implements to ward off hostile forces throughout Egyptian history. Although such regalia appear often in artistic representations, few actual examples, like this scepter made in late Dynasty 2 for King Khasekhemwy and discovered in his tomb at Abydos, have survived.

The scepter is composed of highly polished tubular beads of veined brown-red sardonyx held together by a copper rod. A thick band of gold surrounds every fourth bead, giving the appearance of horizontal stripes. The delicate construction of this object indicates that it was made for ceremonial use only. When found, it was broken in two pieces, the larger one seen here and a 12.7 cm (five-inch) segment now in the Cairo Museum.

Sardonyx, gold, bronze
Abydos, Umm el-Qaab, tomb of
King Khasekhemwy
L. 60 cm (L. 23 ⅝ in.)
Gift of the Egypt Exploration Fund 01.7285

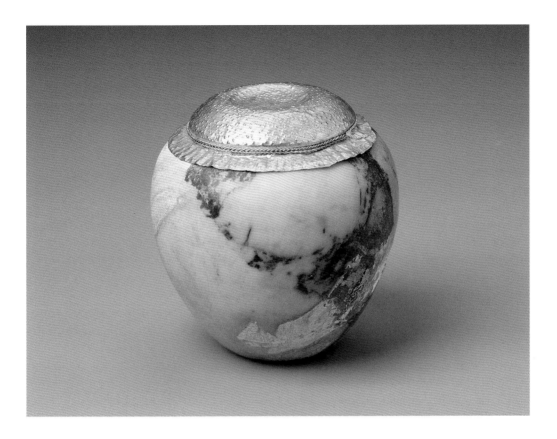

Vessel with lid

Dynasty 2, reign of Khasekhemwy, 2676–2649 B.C.

This graceful little ointment jar, one of several from the tomb of Second Dynasty king Khasekhemwy, demonstrates both the wealth of the early royal tombs and the superb craft of the Early Dynastic royal workshops. To produce the set of gold-topped vessels, Khasekhemwy's artists selected distinctive and beautiful stone in a wide range of colors, such as this unusual black-veined variety of limestone. The circular gold-foil cover, held in place by a delicate gold wire, imitates a piece of cloth or leather tied with a string. Tiny repoussé dots effectively convey the texture of the material. The technique of manufacturing the tie is particularly impressive — thin bands of gold have been painstakingly twisted to resemble a cord and are wound twice around the neck of the jar. A ball of clay at the end of the wire would have served as a seal. The interior of the jar was carefully hollowed out using a simple stone-tipped drill with abrasive sand. Like several other stone vessels from the tomb, this one has a hole through the base, which would have been closed in ancient times with a stone plug.

Dolomite, gold

Abydos, Umm el-Qaab, tomb of

King Khasekhemwy

H. 6.3 cm, diam. 6.1 cm (H. 24 ¹³⁄₁₆ in., diam 24 in.)

Gift of the Egypt Exploration Fund 01.7287

Necklace (larger)

Dynasties 1–2, 2960–2649 B.C.

Carnelian, limestone, quartz

Zawiyet el-Aryan, tomb Z 116

L. 63 cm (L. 24 ⅞ in.)

Harvard University-Museum of Fine Arts

Expedition 11.2564

Necklace (smaller)

Dynasties 1–2, 2960–2649 B.C.

Carnelian, limestone, quartz, faience

Zawiyet el-Aryan, tomb Z 118

L. 24.8 cm (L. 9 ¾ in.)

Harvard University-Museum of Fine Arts

Expedition 11.255

These two beautifully colored necklaces attest to the relatively wide availability of fine raw materials in Early Dynastic Egypt, for they belonged not to members of the ruling class, but rather to individuals of moderate social standing. They come from the Early Dynastic cemetery at the site of Zawiyet el-Aryan near the capital city of Memphis. The owner of the longer of these necklaces, a woman who must have died in childbirth and was buried with her newborn baby, was a relatively wealthy individual. In addition to the necklace she was wearing, her grave goods included stone vessels, ceramic jars containing food offerings, a slate cosmetic palette, stone bracelets, and ivory pins. The smaller necklace belonged to a child who was buried in a well-equipped grave nearby. Along with the necklace found on the child's body, the burial included a set of nine ivory bracelets, a slate palette, a stone dish and cups, a spherical pot, and a well-preserved wooden coffin.

The woman's necklace is composed of truncated barrel-shaped beads of carnelian highlighted by stones of other colors. A central pendant takes the form of a bivalve shell, a relatively common form of amulet.

The child's necklace is made up primarily of truncated barrel beads of carnelian and cylindrical beads of carnelian and limestone, surrounding a finely carved pendant in the shape of a lioness or panther head. The exact function of such an amulet is uncertain. Perhaps the fierce creature was intended to ward off potential harm. Alternatively, it may have been hoped that the animal's strength and speed would be transferred to the wearer. Perhaps it appealed to its owner simply for its beauty.

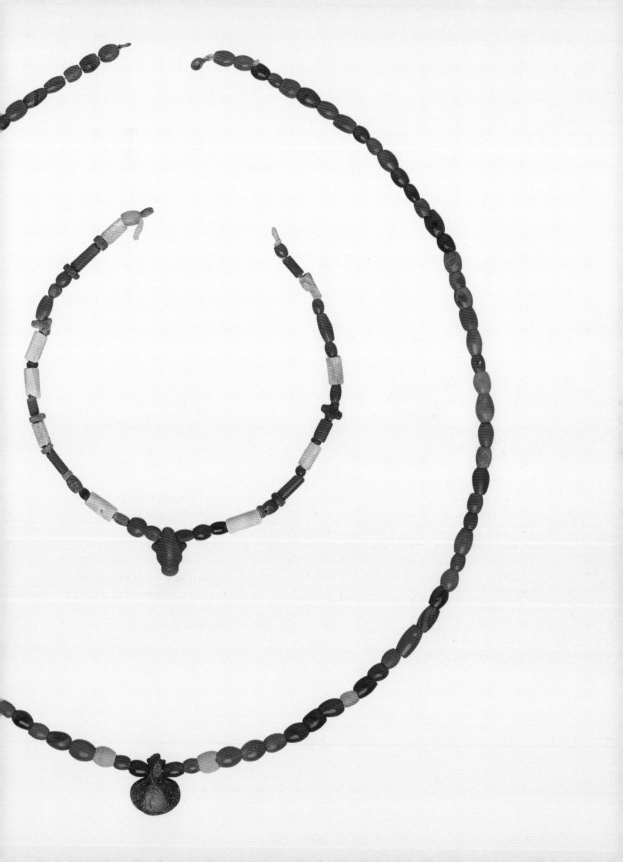

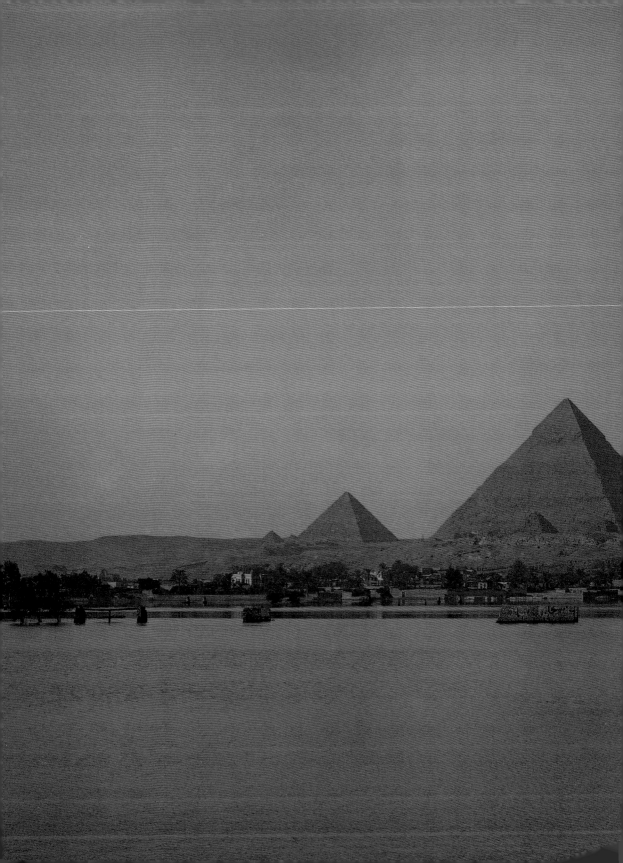

Old Kingdom [2649–about 2100 B.C.]

Egypt is synonymous with pyramids, and the Old Kingdom (2649–about 2100 B.C.) was the golden age of pyramid construction. It was also a time when Egypt traded with neighbors perhaps as far away as Ethiopia, built ships capable of sailing the Mediterranean, and quarried exotic materials in Sinai and Nubia. In Dynasty 3, sculpture increased in both quantity and scale. By Dynasty 4, artists achieved a harmonious and reproducible canon of proportion for depicting the human figure based on ratios between different parts of the body. They also perfected the art of carving hard stone and tested its limitations. At the beginning, the Old Kingdom was a time of prosperity, with power centered on the king, whose office was considered divine. Later, as the complexity of administering the country grew, so too did the bureaucracy and the number of people involved. The era ended with a fragmentation of power shortly after the long reign of an ultimately ineffectual king, combined with unstable weather conditions.

Many questions remain about Dynasty 3, including the number and sequence of its rulers. However, it is clear that it was a time of prosperity and growth, particularly in the economic and administrative spheres. Djoser, the second and greatest king of the dynasty, is best known for his assemblage of mortuary cult structures at Saqqara, including the Step Pyramid, a soaring six-stepped edifice surrounded by a rectangular enclosure wall measuring 274.3 by 548.6 meters (900 by 1,800 feet). The component parts were made of finely dressed limestone that reproduced structures of less permanent materials such as wood, reed, and mudbrick. The Step Pyramid marks the first time a project in stone was undertaken on such a monumental scale. Djoser's son and successor Sekhemkhet attempted an even larger structure, but died before its completion. Imhotep, Djoser's vizier and possibly son, is credited with the building of both pyramids. Later dynasties remembered and revered the two kings to a certain extent, but it was Imhotep who was deified by the Late Period and worshiped as the god of scribes, wisdom, and medicine, as well as architecture.

fig. 18 Pyramid of Khafre at Giza, seen from the Western Cemetery looking south, Dynasty 4, reign of Khafre, 2520–2494 B.C. Harvard University-Museum of Fine Arts Expedition Photograph.

The first king of Dynasty 4, Sneferu, was also revered by later generations as well as in his own time. Our knowledge of him as a warrior, innovator, and statesman, like most kings of the Old Kingdom, comes primarily from his tomb rather than from the cities he and his successors erected, which have not survived to any great extent. It was Sneferu who built the first true pyramid, at Dahshur, just south of Saqqara, after first building a stepped structure as his Dynasty 3 predecessors had done. The first pyramid temple, built against the east face of the pyramid, and the first valley temple, further east at the desert edge, were built during his reign as well. These structures, together with the causeway that connected them, became standard components of all later pyramid complexes. It was in these temples that aspects of the burial rituals and continuing cult of the king were celebrated.

Sneferu's son and successor, Khufu, chose the Giza plateau as the site of his funerary precinct and erected the Great Pyramid, which originally soared to a height of 146.6 meters (481 feet) and consisted of some 2.3 million limestone blocks with an average weight of 2.3 metric tons (2.5 tons). Khufu's son and grandson, Khafre and Menkaure respectively, also erected pyramids at Giza, although theirs were smaller (see figs. 18, 19). Exactly how pyramids were made, how many people were involved in their construction, and how long they took to build, all remain matters of dispute, but it is clear that they required a tremendous organization of labor coupled with superior engineering skills.

Rulers of Dynasties 5 and 6 built pyramids of even lesser scale and quality at Dahshur and Abusir. In addition, a number of Dynasty 5 rulers built temples to the sun god Re near their pyramids, reflecting the rising importance of that cult. Another great change at the end of Dynasty 5 was the inclusion of the Pyramid Texts on the walls of the king's burial chamber. These series of almost one thousand spells expressed a view of the afterlife and provided a path to achieve it. They stated that the deceased would follow the direction of the setting sun below the western horizon and travel eastward to be reborn and rejuvenated at the start of each new day.

Throughout the Old Kingdom, those closest to the king, including members of his family and the highest officials, were given the privilege of burial near the ruler. Their tombs followed the tradition of earlier dynasties and took the form of *mastabas*, rectangular constructions with chapels attached to their east sides. Actual burial was in a chamber below ground, accessed via a vertical shaft cut into the core of the mastaba superstructure. For the body, the essential elements of mummification were already in place by the beginning of Dynasty 4:

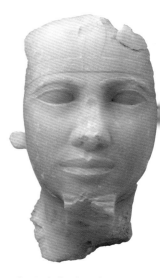

fig. 19 Khafre, shown here, not only built the second pyramid complex at Giza, but also the sphinx and original sphinx temple as well. Head of King Khafre, Dynasty 4, 2520–2494 B.C., travertine (Egyptian alabaster), 20.4 x 12.5 x 10 cm (8 ¹/₁₆ x 4 ¹⁵/₁₆ x 3 ¹⁵/₁₆ in.), Harvard University-Museum of Fine Arts Expedition 21.351.

internal organs were removed and the body was artificially desiccated, wrapped in linen, and placed in a coffin.

Tombs needed to be properly equipped in order for their owners to achieve rebirth and to be sustained appropriately in the afterlife. The most important item was a statue of the deceased that could serve as a substitute for the body and provide sanctuary for the soul or life force, known as the *ka*. For this purpose, a representation of the tomb owner was created, which, more often than not, showed him or her in an idealized manner, in the prime of life, and gazing into a timeless eternity. It was personalized by means of an inscription on the base or back pillar that identified the owner and the most important office held. Such statues were placed in a niche, called the *serdab*, behind a false door, a door with no opening through which only the soul could pass to magically partake of offerings of food or drink left in front of it (see p. 96). The false door was located on the western wall because that was the direction of the setting sun and the start of the journey to the afterlife. Carved in relief or painted on the chapel's walls were scenes from the life of the tomb owner and his family.

As the administration of the country grew more complicated, the king delegated authority beyond his immediate family and thereby created a large official class. With the growing bureaucracy came an increase in the number of private tombs. From Dynasty 4 to Dynasty 5, the number of statues included in the *serdab*, the number of rooms in the chapel, and the complexity of its decoration grew as well, reflecting the greater resources in private hands (see fig. 20). Some officials answerable to the king were delegated to regional centers, known today as *nomes*, and in time these areas grew in size and prosperity. Descendants of the original appointees displayed greater loyalty to their home district than to the capital.

The tendency toward decentralization continued in Dynasty 6, as kings curried favor with the nomes by donating land to local cults. Their temples were granted exemptions from paying taxes or from providing labor to the king. Simultaneously, the ability of the central authority to command resources declined, and soon after the lengthy reign of Pepy II (up to ninety years according to one source), the central government all but ceased to exist. A sense of hopelessness permeated literature, and in the absence of state sponsorship, the quality and quantity of artistic production plummeted. The era of the king's absolute authority had ended, never to return.

Rita E. Freed

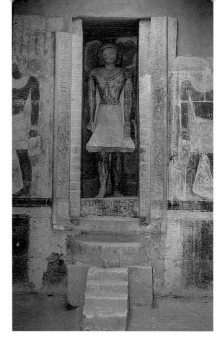

fig. 20 Mereruka, a vizier of King Teti, Dynasty 6, constructed one of the largest mastabas at Saqqara. He is shown here ready to receive offerings left by priests and family members. Photo: Rita E. Freed.

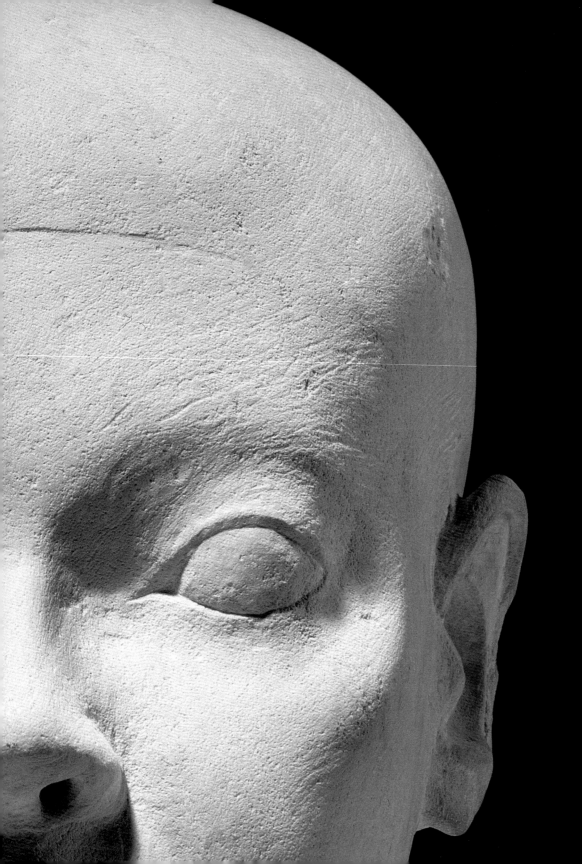

Head and upper torso of a man
Dynasty 3, 2649–2575 B.C.

Although Egyptian artists created colossal sculptures of deities by late Predynastic times and large-scale royal sculptures during Dynasties 1 and 2, it was not until Dynasty 3 that private sculpture of any size was produced. At that point, artists had not yet fully perfected a method for rendering their ideal human figure, but were close to it. This head and upper torso of a man probably from the Third Dynasty shows this penultimate stage.

Sculptors of Dynasty 3 were still exploring the capabilities of stone and often sacrificed realism for practicality. Accordingly, the neck (an area vulnerable to breakage) is short and thick. The artist, however, cleverly used the wig to mask the transition between head and torso, thereby minimizing the deficiency.

Compared to the schematically rendered body, the head is rich in detail. The heavy enveloping wig with horizontal rows of individually rendered curls frames the unidentified man's round face. An extra line outlines the eyes, and triangular notches mark their inner and outer corners, giving them further emphasis. Faintly modeled furrows running diagonally from the corn-ers of the nose to the straight mouth contribute to his expression of strength and impassivity.

On the back, shoulder blades are rendered as stylized curls, another hallmark of early sculpture. The man's left arm is slightly forward, indicating that what is now a bust was originally part of a complete figure standing in the traditional left-foot-forward pose (see p. 86). A name and titles on the base would have identified him. Like the vast majority of Old Kingdom sculptures, he was probably placed in his owner's tomb chapel, where he could receive offerings and serve as a repository for the soul.

Limestone
H. 75.5 cm, w. 19 cm, d. 24 cm
(H. 29¾ in., w. 7½ in., d. 9⁷⁄₁₆ in.)
Marilyn M. Simpson Fund 1999.507

Furniture from the tomb of Queen Hetepheres [reproduction]
Dynasty 4, reigns of Sneferu to Khufu, 2575–2528 B.C.

Those who could afford it equipped their tombs with all the necessities and comforts of life on earth, so that they could continue to enjoy them in the afterlife. For Queen Hetepheres, wife of King Sneferu and mother of King Khufu, these necessities included her entire bedroom suite: her portable canopy, bed with headrest, armchair, and curtain box, all designed of wood overlaid with gold.

The canopy was cleverly designed so that it disassembled easily and without damage, thanks to the copper sheathing reinforcing the joins. Sheets of fabric anchored to the top and sides by copper staples afforded privacy and protection from insects. When not in use, they might be stored in the elaborately inlaid box, whose long sides, like the endposts of the canopy, bear the name and titles of the queen's husband, Sneferu.

On her bed, which was a mere 177 centimeters (5 feet 9 inches) long, the queen would have slept on her side with her cheek resting on the headrest. A foot-rest, decorated with a gold and faience design of stylized plant motifs, both served as decoration and

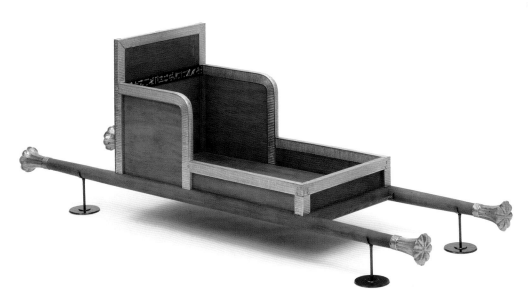

prevented her from slipping down. The legs mimic those of a lion, a symbol of royal power.

The combination of plant and animal motifs is also found on the low chair, the armrests of which are decorated with bound papyrus plants. Cushions would have padded the hard seat. A second armchair adorned with an even more complex motif awaits reconstruction. For traveling, the queen sat in her carrying chair, whose long poles would have been hoisted on the shoulders of her attendants. Gold hieroglyphs inlaid into ebony strips at the back identify her as the mother of Khufu, indicating that her son gave her this piece of furniture.

All of the furniture is noteworthy for its austerity of line and selective use of detail. The seeming simplicity masks sophisticated joinery. The beauty and technical achievement of these objects are matched only by the amazing story of their accidental discovery in 1925 and subsequent excavation and restoration (see pp. 31–32). Because it was an unplundered royal tomb, the original contents remained in Cairo, as stipulated in the Expedition contract. The set in the Museum is an exact duplicate.

Wood, gold, copper, silver, leather, faience, ebony
Giza, tomb G 7000X

Bed: H. 43.5 cm, l. 177 cm, w. 97.5 cm
(H. 17 ⅛ in., l. 69 ¹/₁₆ in., w. 38 ⅜ in.)
Headrest: H. 20.5 cm, w. 17.2 cm, d. 7.8 cm
(H. 8 ¹/₁₆ in., w. 6 ¾ in., d. 3 ¹/₁₆ in.)
Canopy: H. 221.5 cm, l. 313.7 cm, w. 258.8 cm
(H. 87 ³/₁₆ in., l. 123 ½ in., w. 101 ⅞ in.)
Carrying chair: H. 79.5 cm, w. 70.7 cm, d. 66 cm
(H. 31 ⅝ in., w. 27 ¹³/₁₆ in., d. 26 in.)
Armchair: H. 79.5 cm, w. 70.7 cm, d. 66 cm
(H. 31 ⅝ in., w. 2 ¹³/₁₆ in., d. 26 in.)
Curtain box: H. 18.5 cm, l. 157.5 cm, w. 21.5 cm
(H: 7 ⁵/₁₆ in., l. 62 in., w. 8 ⁷/₁₆ in.)

Harvard University-Museum of
Fine Arts Expedition
29.1858–9, 38.873–4, 38.957, 39.746

Relief from the tomb of Prince Kawab

Dynasty 4, reign of Khufu, 2551–2528 B.C.

This figure's informal pose, balding pate, and small scale relative to the heron perched on top of the caged birds leave little doubt that it is not Kawab, the prince and owner of the tomb from which the relief came. Instead, he must be one of the overseers of Kawab's estate. The birds — pintail ducks in the top cage and what may be wigeons below — represent the yield of a day's fowling in the marshes. This stellar catch was undoubtedly achieved with the help of the heron, shown at rest with his neck curled into his shoulder. The ancient Egyptians domesticated herons and used them as decoys to attract other birds, a practice that continues today. The slightly curved line below the overseer's feet indicates that he is on a small boat. Although this is all that remains, the entire scene may

be reconstructed to include the capture of birds with a clapnet in the marshes, and a large-scale standing figure of Kawab, toward whom the skiff is heading.

Kawab's tomb was one of the largest in the East Cemetery at Giza and was prominently located near the Great Pyramid built by his father, Khufu. The many tiny fragments that remain indicate that its exterior chapel was once decorated with a variety of scenes of life on the owner's estate, including fowling and the herding and butchering of animals. Although this piece was executed in rather bold raised relief, others were cut in much lower relief. In all cases, subtle detail would have been added in paint, which unfortunately has not survived. Whoever destroyed the reliefs probably smashed the ten or twenty stone statues that were originally in the tomb as well.

It is likely that both Kawab's father and wife outlived him. Although a space was prepared for Kawab's mate in his mastaba, she was buried instead in the tomb of her next husband.

Limestone
Giza, tomb G 7120
H. 55.2 cm, w. 36.8 cm, d. 20.9 cm
(H. 21 ¾ in., w. 14 ½ in., d. 8 ¼ in.)
Harvard University-Museum of Fine Arts Expedition
34.59

Slab stela of Meretites

Dynasty 4, reign of Khufu, 2551–2528 B.C.

A commemorative tablet, or stela, featuring the deceased tomb owner seated beside a table laden with food was frequently installed in a chapel outside the tomb. Relatives and friends could leave offerings in front of it in order to sustain the tomb's occupant in the afterlife. This example depicts a woman named Meretites, who, the hieroglyphs tell us, was the king's daughter. Women enjoyed considerable prominence in all periods in Egypt, so it is not surprising that Meretites had her own stela. While women were certainly responsible for household maintenance and childrearing, they also held administrative positions and served as priestesses during the Old Kingdom. At the end of the period, a female ruled the country.

Items either depicted or mentioned on the stela provide a glimpse into what the ancient Egyptians considered necessary for the afterlife. Certainly Meretites had a large appetite for gourmet food, as her stela lists one thousand of each of the following delicacies: bulls, oryxes, calves, oxen, cranes, geese, pigeons, loaves of bread, and jugs of beer. She also required a container of cold water, three natron pellets (a naturally occurring salt used in mummification), and an assortment of cakes, fruit, and wine.

Appearance in the afterlife was important too, as one thousand items of clothing, one thousand alabaster containers (for cosmetic unguents?), and both black and green eye-paint are mentioned. Fully four different types of linen, graded on the basis of fineness of weave, are also listed. Because Meretites's burial was plundered, we cannot be sure whether the tomb actually contained these items.

The relief is wafer-thin and reveals exquisitely carved details. Its style, together with the horizontal format and the enumeration of different types of linens in chart form at the far right, identify it as a slab stela. The similarity between the relief style and that found in Khufu's mortuary complex suggests that Meretites's piece was made by a royal workshop. To date, just 15 slab stelae are known, all of which come from the great Western Cemetery at Giza. All appear to date to the reign of Khufu, and all served as the only decorative element in the tomb chapels in which they were found. (Of the thirteen slab stelae where sex may be determined, five belonged to women.)

Limestone

H. 51 cm, w. 82.5 cm, d. 8.3 cm

(H. 20 ¹/₁₆ in., w. 32 ½ in., d. 3 ¼ in.)

Harvard University-Museum of Fine Arts Expedition

12.1510

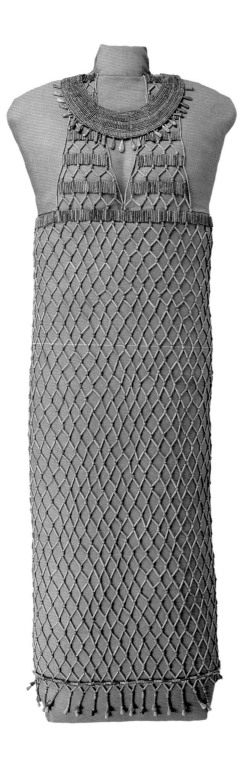

Bead-net dress
Dynasty 4, reign of Khufu, 2551–2528 B.C.

When the female rowers of the king's boat tossed away their regular clothing and slipped on bead-net dresses instead, "the heart of His Majesty was happy at the sight of their rowing," according to an ancient author. The tale is about magic performed by one of the priests of Khufu, the builder of the Great Pyramid and the king under whom the owner of this dress probably lived. The woman's occupation is not known because she was found in an uninscribed coffin. Nothing remained inside except bones, a few scraps of linen, a headrest, and approximately seven thousand beads.

Because of meticulous note taking and photography at the time of their discovery, the original position of the beads was recovered, and some of the original stringing preserved. With clues provided by relief representations, the shape of the bodice and the floral-pendant fringes at the bottom could be reconstructed. These fringes would have jingled seductively as the wearer walked. The faience's vivid dark blue, light blue, and green hues have faded, but a hint of their original brilliance may still be seen. Although only the front part of the dress has been restrung, sufficient beads were found to indicate that the dress would have covered the back of the mummy as well. It is the earliest known bead-net dress, and one of very few from the Old Kingdom. Prior to its reconstruction, this type of dress was known only from representations painted on relief or statuary.

Faience
Giza, tomb G 7440
L. 113 cm, w. 44 cm (L. 44 ½ in., w. 17 ⁵⁄₁₆ in.)
Harvard University-Museum of Fine Arts Expedition
27.1548

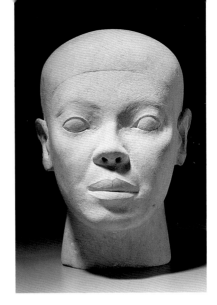

Reserve head

Dynasty 4, reigns of Khufu to Khafre,

2551–2494 B.C.

This striking head represents one of the rare instances in which Egyptian artists sculpted a partial figure. Slightly over life-size, it is noteworthy for its austere beauty and serene gaze. Although perhaps not a true portrait like that of Ankhhaf (p. 78), it nevertheless exhibits a number of distinctive traits. Because of its round face, pronounced cheekbones and full, sensuous lips, George Reisner called it a "Negroid princess." He found it at the bottom of a tomb shaft in the Western Cemetery at Giza, where robbers most likely tossed it after plundering the burial chamber. A second head with a much more elongated face and facial features was found beside it, and Reisner considered that to be her Egyptian husband. Unfortunately the tomb itself provides no clues as to the racial identity or sex of either head. However, a touch of red paint remaining on the ear of this head hints that the subject was male rather than female, because red is the traditional male skin color on sculptures (see p. 88). To further complicate matters, the tomb only contained space for a single burial, so exactly which head belonged there is not clear.

The function of this piece also remains enigmatic. Just over thirty such heads have been found, mostly at Giza, and mostly datable to the brief period in Dynasty 4 spanning the reigns of Khufu and Khafre. Although all are approximately the same size, each is distinctive. All have been found either in the burial chamber or at the bottom of the shaft leading to it. In contrast, other types of Old Kingdom sculptures have most often been found in chapels above ground attached to tombs, where they could magically partake of food offerings. Upon excavating one of these heads at the beginning of the twentieth century, a German archaeologist postulated that its purpose was to replace the head of the deceased should anything happen to it. Since that time, these sculptures have been known as "reserve heads."

Over the years others have suggested different functions for these heads. Several archaeologists believe that they served as models or molds for other sculptures. The fact that many, excepting the present example, show signs of deliberate mutilation, led another scholar to theorize that they served a magical function during the burial ceremonies but were ritually "killed" to prevent them from subsequently harming the deceased. Whatever their purpose, they were in vogue for a very brief period, until they were superseded by face and body coverings in plaster and then *cartonnage,* a material consisting of layers of linen stiffened with gesso (see p. 117).

Limestone

Giza, tomb G 4440 A

H. 30 cm, w. 21 cm, d. 26 cm (H. 11 ¹³/₁₆ in., w. 8 ¼ in., d. 10 ¼ in.)

Harvard University-Museum of Fine Arts Expedition 14.719

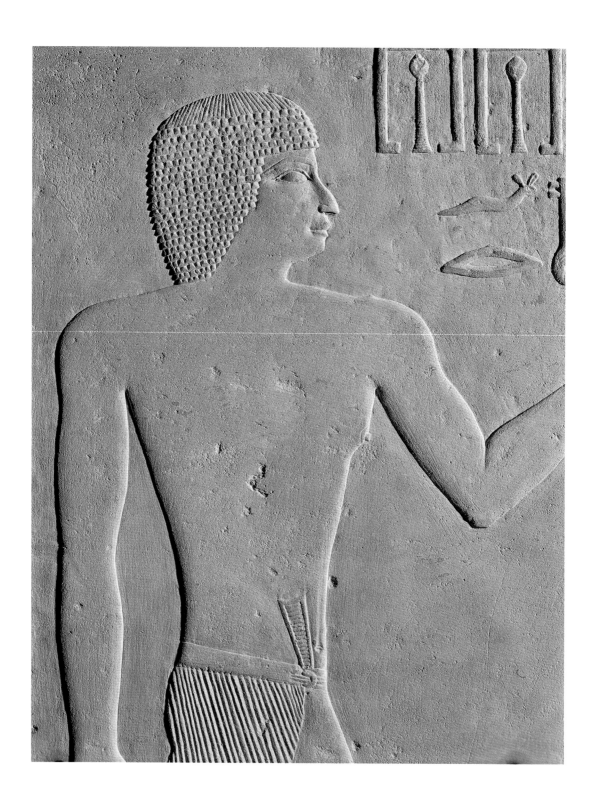

Doorjamb

Dynasty 4, reigns of Khufu to Khafre, 2551–2494 B.C.

Limestone

Giza, tomb G 2110

H. 95 cm, w. 109.5 cm (H. 37⅜ in., w. 43⅛ in.)

Harvard University-Museum of Fine Arts Expedition 07.1002

Reserve head of Nofer

Dynasty 4, reigns of Khufu to Khafre, 2551–2494 B.C.

Limestone

Giza, tomb G 2110

H. 17.4 cm (H. 6¾ in.)

Harvard University-Museum
of Fine Arts Expedition 06.1886

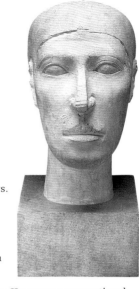

We may not know exactly what Nofer looked like, but we can be sure that he had a large aquiline nose. This aspect is featured prominently on the north door jamb from his chapel as well as on the reserve head found at the bottom of the tomb's shaft. The scale with which Nofer is represented on the walls — three times bigger than other figures — and the fourteen different offices enumerated there demonstrate that he was a prominent official in Dynasty 4. Among his titles, both real and honorary, were overseer of the treasury, overseer of the king's regalia, overseer of the arsenal, secretary of all the secrets of the king, estate manager, and royal scribe.

The exquisitely carved relief figure of Nofer on the doorjamb exhibits the traditional combination of profile and frontal views. Subtle modeling calls attention to the area under the eye and the bridge of the nose. Each individual curl of the wig is cut with precision. He wears a conventional kilt and holds a walking stick and baton of office as he faces out from inside the tomb toward the entrance. A row of scribes carrying the tools of their trade face into the tomb to meet him.

While Nofer's relief is idealized, his reserve head offers a much more portraitlike representation of how he must have looked, with a somewhat elongated face, high cheekbones, and a square chin, in addition to his prominent nose. The rough cutting of the nose, ears, and hairline suggest that in this case, finer detailing might have been executed in plaster. Alternatively, it may represent intentional damage inflicted for reasons that remain unknown.

George Reisner was not the first to enter Nofer's tomb in modern times when he excavated it in 1905. August Mariette, the first director of antiquities, found the tomb in 1857, and in the following year he presented the other (southern) doorjamb of the tomb chapel to the viceroy of Egypt, who, in turn, presented it to Prince Napoleon of France. From there it entered another French collection before it was purchased by the Louvre in 1868. Other relief-decorated blocks were plundered from the tomb prior to the MFA excavations and are currently in Rome, Copenhagen, and Birmingham (England).

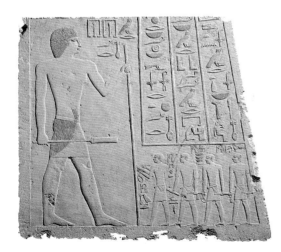

Bust of Prince Ankhhaf
Dynasty 4, reign of Khafre, 2520–2494 B.C.

In ancient Egypt, artists almost never created true portraits. This bust of Ankhhaf, therefore, breaks the rule. It is made of limestone covered with a thin layer of plaster, into which details have been modeled by the hand of a master. Rather than a stylized representation, the face is of an individual. From inscriptions in his tomb, we know that Ankhhaf was the son of a king, probably Sneferu, brother of another, Khufu, and that he served Khafre as vizier and overseer of works. In this last capacity, he may have overseen the building of the second pyramid and carving of the sphinx.

Ankhhaf's features are those of a mature man. His skull shows a receding hairline. His eyelids droop slightly over eyes originally painted white with brown pupils. Puffy pouches are rendered underneath. Diagonal furrows set off a stern mouth. Apparently, he once had a short beard made from a separate piece of plaster. It was lost in antiquity, as were his ears. His gaze is that of a commanding and willful man, someone who was accustomed to having his orders obeyed. It was the way he wanted to be remembered for eternity.

Ankhhaf's mastaba was the largest in the great Eastern Cemetery at Giza. His bust was installed in a mudbrick chapel attached to the east side of the tomb and oriented so that it faced the chapel's entryway.

The chapel walls were covered in exquisitely modeled low relief. It has been suggested that Ankhhaf's arms were sculpted on the low pedestal on which he sat, thereby making him appear even more lifelike. Passersby left more than ninety models of food and drink for Ankhhaf to enjoy in the afterlife.

Ankhhaf is unique, and by the terms of the Museum's contract with the Egyptian government, he should have gone to the Cairo Museum. However, he was awarded to Boston by the Antiquities Service in gratitude for the Harvard-Boston Expedition's painstaking work to excavate and restore objects from the tomb of Queen Hetepheres (see pp. 31–32, 70–71).

Painted limestone
Giza, tomb G 7510
H. 50.5 cm (H. 19⅞ in.)
Harvard University-Museum of Fine Arts Expedition 27.442

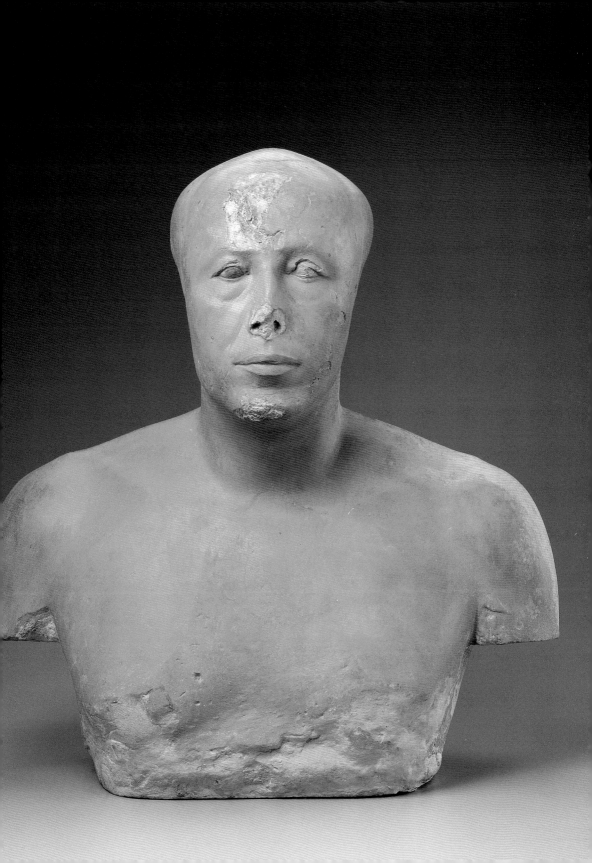

Colossal statue of King Menkaure

Dynasty 4, reign of Menkaure, 2490–2472 B.C.

This colossal statue is one of the largest
sculptures of the Pyramid Age. With a height
of nearly 2.35 meters (8 feet), as restored, it
features King Menkaure, who built the small-
est of the three pyramids at Giza. His cloth-
ing and headgear clearly identify him as the
ruler. He wears a wraparound kilt with a cen-
tral projection, a garment worn only by kings
until the end of the Old Kingdom. On his head
is a royal kerchief, called a *nemes*. A cobra,
known as a *ureaus*, is at his brow. This ser-
pent was considered a deity and charged
with protecting the king by wrapping itself

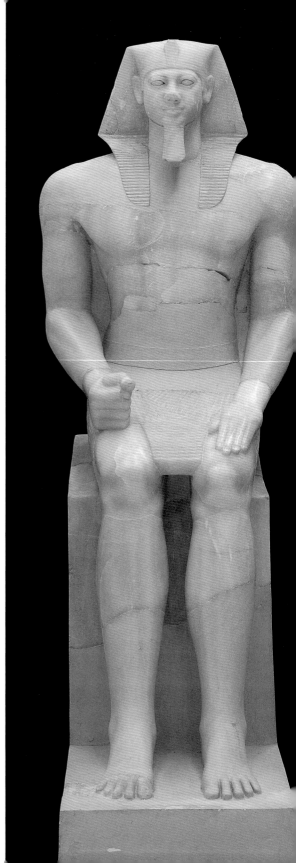

around the royal brow and spitting its poisonous venom at the king's enemies. Menkaure's long straight beard, another symbol of royalty, was attached by means of a strap that was once painted on the statue's head. His right hand is clasped around a folded cloth, the ends of which extend onto his thigh.

The king's expression is one of regal composure and supreme control. With its slightly bulging eyes, bulbous nose, painted moustache (now barely visible), set mouth with pouting lower lip and firm chin, the face is distinctive, but whether or not it represents a true portrait of Menkaure can never be known. This is the face of a mature adult, although neither face nor body displays any signs of aging. It has often been remarked that the head is unusually small for the king's body. Whatever the artist's reason for doing this, it certainly emphasizes the breadth of the figure's torso and enhances its image as omnipotent king.

This statue sat in the deep niche at the back of Menkaure's Pyramid Temple located at the base of the eastern face of his pyramid until, for reasons unknown, it was deliberately destroyed. In January 1907, George Reisner found fragments from the shoulder and torso in a pit in that room and the large fragment comprising the hands, legs, and throne base in an adjacent corridor. Two months later, while excavating what proved to be a robber's trench nearby, Reisner found the head in nearly perfect condition.

The different installations of Menkaure at the MFA reflect the changing aesthetics of the Museum audience. When the fragments first arrived in the Museum, only the head and leg were exhibited. Two years later, additional torso pieces were added, and an abstract restoration of the missing torso elements was attempted. In 1925, at Reisner's request, the well-known watercolorist and artist for the expedition, Joseph Lindon Smith, sculpted the torso and buttocks in a more naturalistic manner. The restoration that visitors see today was accomplished in 1935 by Smith, assisted by Museum School student Charles Muskavitch.

Travertine (Egyptian alabaster)
Giza, Menkaure Pyramid Temple
H. 235 cm, w. 86.5 cm (H. 92 ½ in., w. 34 ¹/₁₆ in.)
Harvard University-Museum of Fine Arts Expedition
09.204

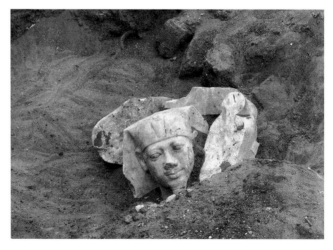

fig. 21 Head from colossal alabaster statue of King Menkaure in situ, April 14, 1907. Harvard University-Museum of Fine Arts Expedition Photograph.

Unfinished statues of King Menkaure
Dynasty 4, reign of Menkaure,
2490–2472 B.C.

By the Old Kingdom, Egyptian artists had perfected the process of statue making, in terms of both the exploitation of stone and the achievement of the ideal body form. This group of statuettes, found in the Valley Temple of Menkaure, illustrates exactly how they did it. Representing three of a total of fifteen statuettes discovered there, they mark distinct stages in the manufacturing process.

Using hammers of harder stone, artists began by cutting into a block of stone from all four sides to approximate the shape of the finished product, in this instance, the seated figure of the king. Details of the head and limbs were refined gradually with the aid of copper chisels. A few red lines were painted to mark the location of strategic body parts, thereby insuring that the proper canon of proportion was maintained. By the Middle Kingdom, these few lines expanded into a full grid. This technique allowed the same relative proportions to be achieved regardless of the size of the piece. After the details had been carved, rubbing stones and a powdered abrasive were used to polish the surface. Finally, the sculpture was personalized by means of an inscription that identified the owner and important office held in life. The early, middle, and final pre-polish stages are illustrated by the three sculptures pictured here.

Given the full range of manufacturing stages illustrated by these statuettes, it seems likely that they were deliberately made to serve as models for sculptors working on a larger scale and that there was no intention to ever complete them. Although many unfinished statues are known, these represent the only such series. At first it seems puzzling that artists would have made them from gneiss, a very hard stone quarried from an area near Abu Simbel, far to the south of Giza. However, a clue to the choice of material may lie in the fact that the bottom of one of the statues was polished to a high gloss. Because the ever-practical Egyptian artists never polished the bottoms of their statues more than they polished the visible areas, this suggests that the sculptures were made from stone that was recycled from another object — perhaps one of several gneiss statues of Menkaure's predecessor, Khafre, which exists today only in fragments.

Although these statuettes were never completed, this does not mean they did not function as complete statues. Nearly four hundred years after his death, priests who maintained the cult of Menkaure installed them on a ledge in the Valley Temple and dedicated offerings to them.

Anorthosite gneiss
Giza, Menkaure Valley Temple
left to right:
H. 35 cm, w. 15.5 cm, d. 19.5 cm
(H. 13 ¾ in., w. 6 ⅛ in., d. 7 ¹¹/₁₆ in.)
H. 43 cm, w. 16 cm, d. 24.7 cm
(H. 16 ¹⁵/₁₆ in., w. 6 ⁵/₁₆ in., d. 9 ¾ in.)
H. 36 cm, w. 16 cm, d. 23.2 cm
(H. 14 ³/₁₆ in., w. 6 ⁵/₁₆ in., d. 9 ⅛ in.)
Harvard University-Museum of Fine Arts
Expedition
11.731, 11.729, 11.732

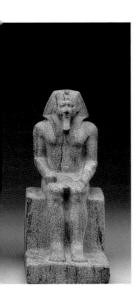

King Menkaure, Hathor, and the Hare Nome
Dynasty 4, reign of Menkaure, 2490–2472 B.C.

The sublime beauty of this triple statue masks the sophistication of its composition. The central and largest figure is Hathor, an important goddess throughout Egyptian history associated with fertility, creation, birth, and rebirth. She was the king's divine mother and protector. Here, she wears a headdress of cow's horns and a sun disk, but otherwise her appearance is that of a human female, and she is depicted with the same hairstyle and garment as her earthly counterparts (see pp. 86–87).

Hathor embraces King Menkaure, who is standing to her left. He wears a crown symbolic of Upper Egypt (the Nile Valley) and a wraparound kilt whose sharp pleats conform to the outline of his body. In his right hand he holds a mace, a weapon frequently wielded by kings in relief, but until now not reproduced in stone sculpture. Here, artists solved the problem of carving its thin and fragile shaft in the round by resting it on Hathor's throne. In Menkaure's left hand is a short implement with a concave end; it is generally interpreted as a case for documents. Size corresponds to hierarchical position in Egyptian art, and while visually Hathor and Menkaure appear to be the same height, the seated goddess is significantly larger in scale. Like Menkaure's queen in the pair statue (pp. 86–87), Hathor's embrace is one of association, not affection, and all three figures gaze impassively into a distant horizon.

The third and smallest figure is a goddess of lesser importance, associated not with the entire country, but with a single district in Upper Egypt known as the Hare nome. It is symbolized by the rabbit standard she wears on her head. An artist has cleverly merged the *ankh* sign she carries in her left hand with Hathor's throne. The Hare nome goddess, like Hathor and Menkaure, exhibits a body proportioned according to the Old Kingdom ideal of beauty

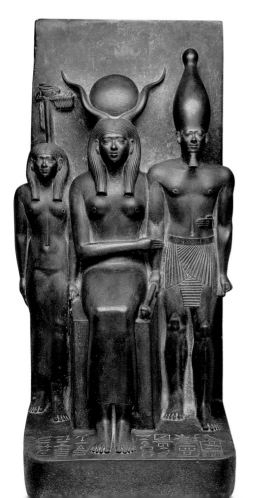

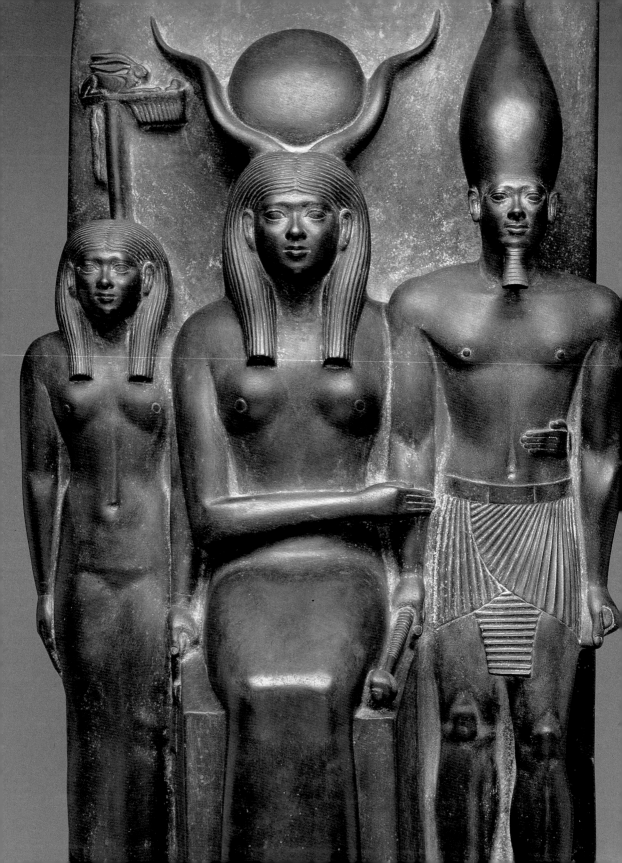

and is modeled with the restrained elegance that makes this period a highpoint of Egyptian art.

The inscription on the sculpture's base clarifies the meaning of this complicated piece: "The Horus (Kakhet), King of Upper and Lower Egypt, Menkaure, beloved of Hathor, Mistress of the Sycamore. Recitation: I have given you all good things, all offerings, and all provisions in Upper Egypt, forever." It signifies that all the material goods produced in the Hare nome will be presented to the king to sustain him in perpetuity. One theory suggests that eight such triads, each featuring the king and Hathor with one of the other nome deities, were set up in Menkaure's Valley Temple.

Graywacke
Giza, Menkaure Valley Temple
H. 84.5 cm, w. 43.5 cm, d. 49 cm
(H. 33 ¼ in., w. 17 ⅛ in., d. 19 ⁵⁄₁₆ in.)
Harvard University-Museum of Fine Arts Expedition
09.200

King Menkaure and queen

Dynasty 4, reign of Menkaure, 2490–2472 B.C.

At twilight on January 10, 1910, a young boy beckoned George Reisner to the Menkaure Valley Temple. There, emerging from a robbers' pit into which they had been discarded were the tops of two heads, perfectly preserved and nearly life-size. This was the modern world's first glimpse of one of humankind's artistic masterworks, the statue of Menkaure and queen.

The two figures stand side-by-side, gazing into eternity. He represents the epitome of kingship and the ideal human male form. She is the ideal female. He wears the *nemes* on his head, a long artificial beard, and a wraparound kilt with central tab, all of which identify him as king. In his hands he clasps what may be abbreviated forms of the symbols of his office. His high cheekbones, bulbous nose, slight furrows running diagonally from his nose to the corners of his mouth, and lower lip thrust out in a slight pout, may be seen on her as well, although her face has a feminine fleshiness, which his lacks. Traces of red paint remain on his face and black paint on her wig.

His broad shoulders, taut torso, and muscular arms and legs, all modeled with subtlety and restraint, convey a latent strength. In contrast, her narrow shoulders and slim body, whose contours are apparent under her tight-fitting sheath dress, represent the Egyptian ideal of femininity. As is standard for sculptures of Egyptian men, his left foot is advanced, although all his weight remains on the right foot. Typically, Egyptian females are shown with both feet together, but here, the left foot is shown slightly forward. Although they stand together sharing a common base and back slab, and she embraces him, they remain aloof and share no emotion, either with the viewer or with each other.

Who is represented here? The base of the statue, which is usually inscribed with the names and titles of the subjects represented, was left unfinished and never received the final polish of most of the rest of the statue. Because it was found in Menkaure's Valley Temple and because it resembles other statues from the same findspot bearing his name, there is no doubt that the male figure is King Menkaure. Reisner suggested that the woman was Queen Kamerernebty II, the only one of Menkaure's queens known by name. She, however, had only a mastaba tomb, while two unidentified queens of Menkaure had small pyramids. Others have suggested that she represents the goddess Hathor (see pp. 83–84), although she exhibits no divine attributes. Because later kings are often shown with their mothers, still other scholars have suggested that the woman by Menkaure's side may be his mother. However, in private sculpture when a man and woman are shown together and their relationship is indicated, they are most often husband and wife. Because private sculpture is modeled after royal examples, this suggests that she is indeed one of Menkaure's queens, but ultimately, the name of the woman represented in this splendid sculpture may never be known.

Graywacke
Giza, Menkaure Valley Temple
H. 142.2 cm, w. 57.1 cm, d. 55.2 cm
(H. 56 in., w. 22½ in., d. 21¾ in.)
Harvard University-Museum of Fine Arts Expedition
11.17385.

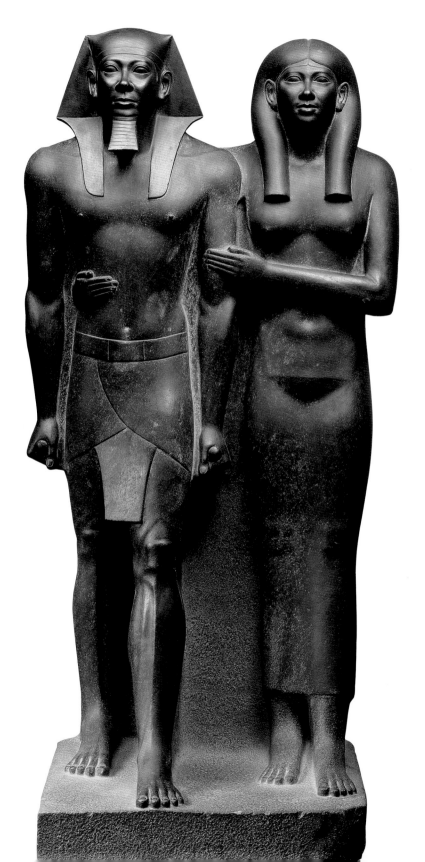

Prince Khuenre as a scribe

Dynasty 4, reign of Menkaure, 2490–2472 B.C.

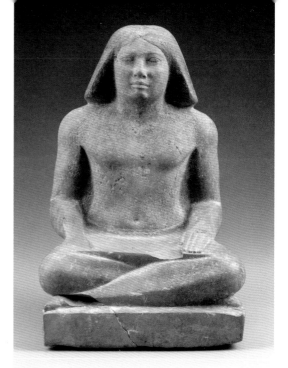

A man seated with his legs crossed comfortably beneath him is the subject of this fine statue. While the pose is that of a peasant, his dignified demeanor and aloof expression suggest a higher station. The piece is uninscribed, but its findspot inside the rock-cut tomb of Khuenre, son of King Menkaure, suggests that it represents that prince. In the Fourth Dynasty beginning with Khufu, this pose seems to have been reserved for sons of kings, particularly those who held important offices. Some, like Khuenre, place their left hands flat on their laps and hold folded handkerchiefs in their right hands, as Khuenre may once have. Others unroll papyri with their left hands across "desks" formed by kilts pulled taut between their knees while positioning their right hands to hold a writing implement. The latter were clearly scribes. This identification has led scholars to refer to all sculptures in this position as scribal statues, although whether or not their owners, including Khuenre, actually served as scribes is not known. It is estimated that in the Old Kingdom, less than one percent of the population was literate.

The statue is further remarkable for the details found in its face and head. Khuenre wears a shoulder-length wig whose outswept sides frame his alert, intelligent face. Traces of its original black paint are still preserved. His eyes, enhanced by naturalistically rendered brows and a line outlining the upper lid, gaze directly outward at the viewer. A fold of flesh marks the nostrils. In a touch of individuality, the left side of his mouth droops slightly lower than the right.

Limestone
Giza, Menkaure cemetery, MQ 1, found in
outer chamber of tomb of Khuenre
H. 30.5 cm, w. 21.5 cm, d. 16 cm
(H. 12 in., w. 8 ⁷⁄₁₆ in., d. 6 ⁵⁄₁₆ in.)
Harvard University-Museum of Fine Arts Expedition
13.3140

Ptahkhenuwy and wife

Dynasty 5, 2465–2323 B.C.

Private sculpture of the Old Kingdom copied royal sculpture: the poses, youthful body forms, and the wife's embrace of the husband in this private sculpture is the same as those of King Menkaure and his queen in their dyad (see p. 86). The man here is identified by an inscription painted on the base in black paint as Ptahkhenwy, supervisor of palace retainers. He stands with his left leg forward in the traditional male pose, and his partner, her name no longer legible in the inscription and identified now only as "his wife whom he loved," stands beside him with both feet together.

Most Egyptian sculpture was painted, but all too often the paint has not survived. Fortunately, such is not the case with this statue. The husband's skin is red ochre, the traditional color for men, whose work outside would have left them sunburned. The wife's yellow-ochre skin reflects the traditional role of women inside the house. Both their facial features

are the same. Neither is a true portrait, but rather an idealized likeness of how each wished to be remembered for eternity. Negative space between the couple and the base is painted dark gray.

The garments of the pair are white, to reflect the color of the undyed linen from which they were made. She wears a V-neck sheath dress that was customary for a woman of the Old Kingdom. It clings so tightly here that it reveals every aspect of her body beneath. Walking would have been impossible. Surviving examples show that in reality, such garments were much looser (see pp. 100–101). He wears a knee-length, wraparound kilt, the most common garment for men.

Jewelry added bright splashes of color. Both wear broadcollars, brightly painted to imitate semi-precious stone or faience. She wears two anklets and a bracelet in addition, making up a parure that is strikingly similar to actual jewelry found in Old Kingdom tombs (pp. 90–91). His black wig is composed of curls cut in rows. Natural black hair peeks out from beneath her black wig, which is parted in the center and reaches to shoulder level.

The statue was found in the *serdab* of the couple's tomb and was one of the first objects to be excavated by the Harvard University-Museum of Fine Arts Expedition. The excitement of the Museum Trustees when it first arrived in Boston played a key role in their decision to commit to funding further excavations.

Painted limestone
Giza, tomb G 2004
H. 70.1 cm (H. 27⅝ in.)
Harvard University-Museum of Fine Arts Expedition
06.1876

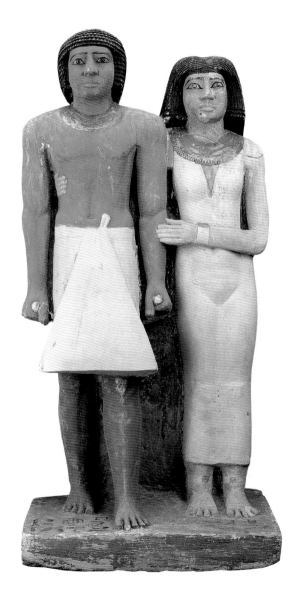

Bracelets, broadcollar, and counterpoise
Dynasty 5, 2465–2323 B.C.

For both men and women alike, jewelry added interest and color to garments of undyed linen. The parure shown here, which consists of a collar, counterpoise, and pair of bracelets, was restrung from elements of blue, green, and black faience left behind by robbers in an otherwise empty, plain wooden coffin. The colors were the most commonly used in making the ceramic during the Old Kingdom.

The broadcollar was the most common type of Old Kingdom jewelry. At Giza alone, George Reisner found nineteen such collars in tombs of both men and women. In addition, brightly painted broadcollars are represented on statuary and reliefs of deities, royalty, and wealthy private individuals from the Old Kingdom through Roman times. Although jewelry was often made for funerary purposes only, in this case the presence of the counterpoise that served to redistribute the weight of the collar and to ensure that it hung properly suggests that this example was worn in life as well.

The earliest bracelets known from Egypt are bangles that were found in tombs of the Predynastic Period. Bracelets have been found in royal tombs dating to as early as Dynasty I. Representations of bracelets like those shown here usually depict women wearing them in pairs. The vertical spacers with nine holes permitted many rows of tubular beads to be strung together.

Faience
Giza, tomb G 2422 D
Bracelets: H. 10.8 cm, w. 5.2 cm, d. 1.2 cm
(H. 4 ¼ in., w. 2¹/₁₆ in., d. ½ in.)
Broadcollar: H. 19 cm, w. 27 cm, d. 0.5 cm
(H. 7 ½ in., w. 10⅝ in., d. ³/₁₆ in.)
Counterpoise: H. 15 cm, w. 3.5 cm, d. 0.4 cm
(H. 5⅞ in., w. 1⅜ in., d. ³/₁₆ in.)
Harvard University-Museum of Fine Arts Expedition
37.1313, 37.1312, 37.1311a–b

Statuette of a young boy
Dynasty 5, 2465–2323 B.C.

In Egyptian art, strict rules dictated not only how adult figures should be represented, but children as well. In sculpture, boys and girls alike were shown naked before they reached puberty, touching their right index finger to their lips. Particularly in the Old Kingdom, they have their hair braided in a single lock on the right side. The boy shown here is Ptahneferty, according to the inscription on the front of his right foot. Such a statue of a child alone is rare—more frequently, children were represented with their parents. It is possible, however, that Ptahneferty was already an adult when this sculpture was commissioned. Not only is he named, but his title, "craftsman," is indicated as well.

Although Ptahneferty's body displays the pudginess typical of depictions of children of the time, his stance, with his left foot forward and left arm held rigidly at his side, is that of an adult man. The paint, so marvelously preserved, also shows him with the red skin color of adult males. The sculpture's base and back pillar are painted black, making those areas recede and calling attention to the figure itself. The face is emotionless, with large eyes, straight mouth, and pug nose. Like sculptures of adults in Egypt, what is depicted here represents an ideal rather than reality. In an Egyptian winter, it would have been far too cold for a child to go without clothes, and child-size garments preserved in tombs show that they did not. Like children everywhere, they played with toys, were protected by amulets, and assisted their parents.

Painted limestone
Giza, tomb G 2009
H. 18 cm (H. 7 1/16 in.)
Harvard University-Museum of Fine Arts Expedition 06.1881

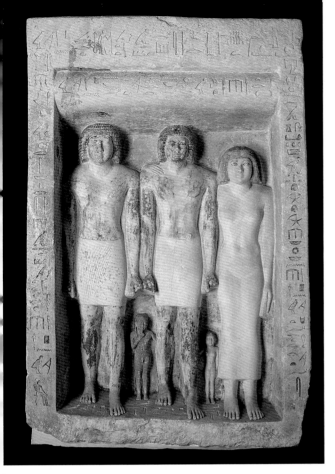

Psuedo-group statue of Penmeru
Dynasty 5, 2465–2323 B.C.

Throughout Egyptian civilization, artists developed new types of statuary to address the constantly changing needs of tomb and temple. Some types found wholesale acceptance and entered the general repertoire; others flourished briefly but were subsequently abandoned. The latter is the case with the statue type shown here; it is known only from Dynasties 5 and 6.

Three adults and two children emerge from inside a rectangular frame. The two on the viewer's left are clearly male and differ from each other only in their garments. They do not interact in any way. The rest of the figures form a unit, apparently a family group. A woman on the viewer's right, slightly shorter than the two men, rests her hand on the shoulder of the man in the center, while two diminutive children, a boy on the left and girl on the right, touch his leg. One would expect the figure on the far left to be unrelated to the others.

The inscription, however, tells a different story. Both male figures are identified as Penmeru. A Belgian Egyptologist in the 1920s coined the term "pseudo-group" to describe such sculptures in which the same person was depicted two or more times. Different interpretations have been advanced since then to explain the meaning of pseudo-group statues. Do they reflect the dual nature of Upper and Lower Egypt? Are they representations of a man and his *ka*? Do they show the same man at different stages of his life? It is clear that by Dynasty 5, ever-increasing numbers of statues were included in tombs. (One tomb owner had up to fifty representations of himself.) Pseudo-group sculptures may reflect that trend. Penmeru's tomb contained three pseudo-group statues, bringing the total of his depictions to seven. The present example is the only one in which additional family members are shown. The figures are placed inside a frame that mimics the architecture of a door. It is speckled in imitation of granite, a costlier stone than the limestone from which it is actually made.

Limestone
Giza, tomb G 2197
H. 155 cm, w. 105 cm (H. 61 in., w. 41 5⁄16 in.)
Harvard University-Museum of Fine Arts Expedition
12.1484

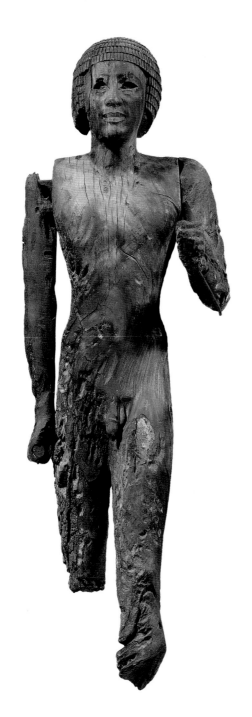

Statue of Snedjemibmehy
Dynasty 5, reign of Unis, 2353–2323 B.C.

Ancient tomb robbers carelessly tossed this splendid wood statue under the floor of a mastaba chapel as they plundered Snedjemibmehy's tomb. Perhaps the location sheltered it from the ravages of wood fungus, insects, and the elements until it was rediscovered in the winter of 1912. Understandably, little wood sculpture remains from ancient Egypt. Those that have survived, including this one, are among its finest and most sensitively modeled sculptures.

Snedjemibmehy stands with his left foot forward, his left arm bent at the elbow and his right arm hanging down at his side. Because the tree from which the torso was carved was not wide enough to accommodate the arms as well, they were made separately and affixed by means of mortise-and-tenon joins, a common practice. When plastered and painted, the joins would have been completely hidden. A walking stick and a scepter must have been inserted in his left and right fists respectively, as relief representations show.

Snedjemibmehy's wig, with its meticulously carved rows of curls, draws attention to the modeling of his face. The eyes, once inlaid, were carved at a slight angle and with pronounced tear ducts. A fold of flesh at each nostril continues obliquely downward. His straight mouth contributes to his intelligent expression. Delicate modeling sets off his pectorals and bisects his torso down to the navel, which is marked by a deep hollow. His nipples were also once inlaid. These details are characteristic of a more expressive style that coexisted during the Old Kingdom with more idealized representations (pp. 88–89, for example).

Most unusually, this sculpture is nude. Traditionally, only young children were shown without clothes. However, the static pose and large scale leave little doubt that the tomb owner himself is represented, and the fact that he is circumcised, a practice that took place at puberty, indicates that he was an

adult when the sculpture was carved. While clothing may have been added in paint or plaster or his torso may have once been wrapped in cloth, no trace of any of these materials has been found.

Snedjemibmehy was a member of a family of architects that served the royal family from the reign of Isesi of Dynasty 5 to Pepy II of the end of Dynasty 6. He was Unis's chief architect. The entire family was buried in the same tomb complex at Giza.

Wood
Giza, tomb G 2378
H. 106 cm (H. 41¾ in.)
Harvard University-Museum of Fine Arts Expedition
13.3466

Woman tending a fire
Dynasty 5, 2465–2323 B.C.

The vast majority of Egyptian three-dimensional stone sculptures feature subjects in static and formal positions. By contrast, the figure here is engaged in action, and the artist has captured a single moment rather than a timeless eternity. A woman wearing only a skirt sits with one knee on the ground and the other up. True to life, her entire torso shifts slightly to the left as she pokes a fire with a rod in one hand and raises the other to shield herself from the glare. A kerchief protects her hair from sparks.

The woman is making bread in a manner frequently represented on contemporary tomb walls. The pile in front of her consists of coarse ceramic vessels that would be placed atop bowls filled with dough and buried in hot ash. The combination of heat from top and bottom baked the bread in just over an hour and a half. Bread and beer made from emmer wheat were staples of the ancient Egyptian diet.

This piece belongs to a category of sculptures termed "serving statues" in a recent scholarly study. Although such objects appear to depict humble servants, those that are inscribed bear the name of a member of the tomb owner's family or other dependent. Like this one, they were found in *serdab*s, sealed chambers that formed part of the tomb chapel, where family members left food offerings for the deceased. Through their useful service to the tomb owner, they too would be entitled to take part in the offerings and be sustained for eternity.

Apparently, when the artist carved this statue or shortly thereafter, it broke in half at the base. The ancient repair, a wooden peg connecting the two pieces, has held to this day.

Limestone
Giza, tomb G 2415
H. 23.8 cm, w. 12.5 cm, d. 32 cm
(H. 9⅜ in., w. 4¹⁵⁄₁₆ in., d. 12⅝ in).
Harvard University-Museum of
Fine Arts Expedition 21.2600

False door of Redines
Dynasty 5 or 6, 2465–2150 B.C.

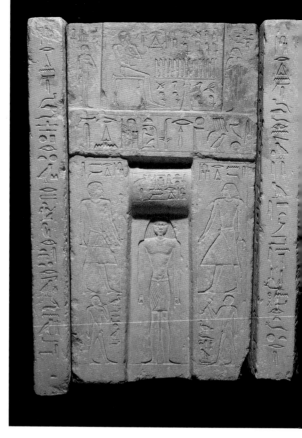

One of the most important elements of an Old Kingdom tomb was the false door, so called because it reproduced elements of a typical doorway but had no opening. It marked the transition between the world of the living in front of it, and the world of the dead behind it. It was thought that the *ka*, or soul, of the deceased tomb owner would pass through the door to consume food and drink left by family members or friends in front. In most cases, the owner is shown partaking in such offerings on a panel over the door.

The false door of Redines was discovered in one of two niches in his mastaba tomb at Giza. Broken fragments of pottery found on a ledge in front may have been the remains of offerings. The door, together with its two outer jambs, was the only decorated element in the tomb. These elements not only provide biographical information about the owner and his family, but also show one of the very rare attempts by an Egyptian artist to depict a fully frontal figure.

From the beginning of Egyptian relief representation, artists employed a combination of profile and frontal views to reproduce the human form. A profile face with frontal eye, frontal shoulders, and profile torso and limbs showed the most characteristic elements of the figure with clarity and ease. On Redines's false door, all the figures on the jambs and the panel above are shown in this manner. For the representation of Redines himself, centered in the doorway, however, a frontal figure is depicted, perhaps for reasons of symmetry or to create a more direct confrontation with the viewer. He appears to be emerging from the land of the dead and entering the land of the living. In the absence of an existing vocabulary to accomplish this view, the artist was forced to invent one. He adapted the hieroglyph of a frontal head and combined it with a frontal torso, and modeled the combination as if it were sculpture in the round. His greatest difficulty was with the feet, which are splayed in an unnatural pose.

The remainder of the false door was executed in a traditional manner. The inscriptions tell us that Redines was a scribe and funerary priest. He is shown seated at a table of bread loaves in the upper panel, a common pose. To the right is his young daughter and to the left, his wife. On the jambs of the door itself, the large figures are again those of Redines, wearing another wig and carrying different implements in each depiction. His two young sons are shown below.

Limestone
Giza, tomb G 5032
H. 79 cm, w. 43 cm (H. 31 ⅛ in., w. 16 ¹⁵/₁₆ in.)
Harvard University-Museum of Fine Arts Expedition
21.961a–c

Statue of a seated man

Dynasty 5 or 6, 2465–2150 B.C.

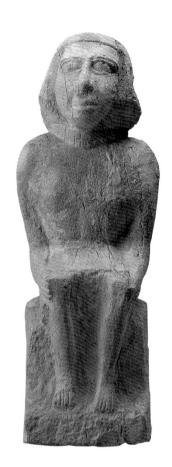

Some statues are appealing because of their superb workmanship, beautiful stone, or interesting composition. This one captivates because it has none of these attributes. From the Old Kingdom through the Late Period, Egyptian artists employed a canon based on natural body proportions to dictate the relative size and shape of each element of the human figure. When those guidelines are applied here, it is immediately apparent that the head is much too large, the neck is nonexistent, the torso tapers abruptly, and the limbs are spindly. In addition, the hands, which traditionally rested atop the thighs, here hug the sides. Was the maker a bad artist? A junior apprentice? Or simply untrained? Was the tomb owner unable to afford better?

At the end of the Old Kingdom, when the economy was drained by nonproductive building projects (including the pyramids) and inadequate crops decreased taxes flowing into central coffers, little sculpture could be commissioned by the king or the court at Giza. Without this forum for the training of artists, what was made exhibited a decided decline in quality.

The tomb from which this sculpture came unfortunately provides no information about its date. A second statue from the same tomb is similar in style and workmanship, but is likewise uninscribed.

Although the tomb owner may not have had the resources for an elaborate tomb, it was nevertheless important to include statues of himself in it. He thereby guaranteed that his *ka* would have a resting place after its rebirth in the afterlife. Despite its crude workmanship, the statue displays a decided spirituality. With his large eyes and head tilted heavenwards, this unnamed man awaits his apotheosis.

Limestone
Giza, tomb G 7772
H. 47 cm, w. 17.5 cm, d. 19 cm
(H. 18½ in., w. 6⅞ in., d. 7½ in.)
Harvard University-Museum of Fine Arts Expedition
39.832

Body covering

Dynasty 5 or 6, 2465–2150 B.C.

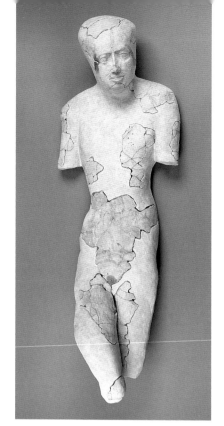

This modern-looking sculpture brings to mind a figure in quiet repose. Made of plaster, it was molded directly over a body that had been wrapped in multiple layers of linen, and then buried in a simple wooden coffin. The head is slightly raised and splayed at the back because it lay on a wooden headrest, fragments of which were also found. Because coffins were often quite narrow, the body had to be angled slightly on its side. That requirement would account for the manner in which one leg is crossed over the other.

Burial practices and styles of mummification changed constantly throughout Egyptian history. At first, the body was buried in a simple pit in the desert, where the dry climate preserved it. With the development of larger and more complex tombs and coffins, the flesh, ironically, was subject to decay, and artificial ways to preserve it were sought. By Dynasty 4, internal organs were removed and the body was desiccated before being wrapped in linen. Sometimes features were modeled and painted directly on the cloth. Covering the head (or the head and torso) with plaster was a short-lived custom of Dynasties 5 and 6, particularly at Giza but occasionally at nearby Saqqara and Abusir as well. It has been suggested that these body coverings replaced the reserve heads (see pp. 75, 77) that were sometimes placed in the burial chambers of what were for the most part Fourth Dynasty tombs. By the First Intermediate Period (about 2100–2040 B.C.), masks that covered the head and chest were made beforehand of cartonnage, painted, and placed over the body. Still later, entire coffins of anthropoid shape were made of cartonnage and the body inserted through a slit at the back (p. 176).

This Giza body covering is the finest of its kind. Details of the face, including the straight brows, thin straight nose, widely spaced eyes, and straight mouth set off by a sharp line were carved separately into the wet plaster. Stylistically, these features are similar to those found on stone sculpture of Dynasty 5 or 6. The navel is marked by a depression. The molded ridges around the abdomen may indicate that originally the figure was clothed in a kilt.

Plaster
Giza, tomb G 2037b
H. 21 cm (H. 8¼ in.)
Harvard University-Museum of Fine Arts Expedition 39.828

Funerary furniture of Impy

Dynasty 6, reign of Pepy II, 2246–2152 B.C.

"Almost like a doll's house," is how George Reisner described the confusion of miniature dishes, jars, and tables of copper that had spilled out of a decayed wooden box in Impy's tomb. Pictured here is a selection of the nearly forty metal vessels found in the burial chamber beside his coffin. Too small to have been used in daily life, they were made especially for the tomb, where it was thought that they would magically function like their full-size prototypes. Some of the jars and dishes were meant to hold offerings of food and drink for the deceased to enjoy in the afterlife. In fact, skeletal remains of beef, goose, duck, and other offerings were found beside them.

The table was made in the form of the *hetep* hieroglyph, the Egyptian word for "offering," that took the shape of an oblong loaf of bread placed upright on a mat. Other vessels were intended to hold the sacred oils and unguents that guaranteed rebirth. A basin and ewer for ritual washing and an incense burner rounded out the assortment.

The use of copper in Egypt dates back to early Predynastic times. Minor amounts were found in the Eastern Desert, but the majority came from mines in Sinai. Impy's vessels are ninety-nine percent pure copper, thanks to their smelting process. Metalsmiths melted prepared ingots and then cast or cold-hammered them into the desired shapes. Rivets were used to join different pieces.

Impy was the son of the royal architect Nekhebu. When Reisner discovered his tomb, it was unplundered, perhaps thanks to the 7.6 meters (25 feet) of stone slabs that blocked the burial shaft. A large cedar coffin contained the mummy, which had been adorned with a gold and faience broadcollar, copper bracelet, and gilded belt.

Copper

Giza, tomb G 2381 A

Offering table: H. H. 12 cm, w. 18.7 cm, d. 19.6 cm
(4 ¾ in., w. 7 ⅜ in., d. 7 ¹¹⁄₁₆ in.)

Bowl: H. 6 cm, diam. 12 cm
(H. 2 ⅜ in., diam. 4 ¾ in.)

Basin: H. 2.8 cm, diam. 6.4 cm
(H. 1 ⅛ in., diam. 2 ½ in.)

Neckless jar: H. 5 cm, diam. 4.2 cm
(H. 1 ¹⁵⁄₁₆ in., diam. 1 ⅝ in.)

Model dish: H. 1.5 cm, diam. 6.2 cm
(H. ⁹⁄₁₆ in., diam. 2 ⁷⁄₁₆ in.)

Harvard University-Museum of Fine Arts Expedition

13.2938a, 13.2944, 13.2954, 13.2957, 13.3237

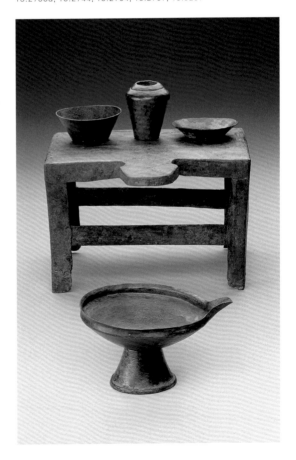

Pleated dress

Dynasty 6, 2323–2150 B.C.

Representations of women from the Old Kingdom almost always depict them in tight-fitting, plain, sheath dresses with skirts held in place by shoulder straps. The long sleeves, formless shape, and overall pleating of this perfectly preserved linen dress demonstrate that actual garments could be decidedly different. Perspiration stains and creases leave little doubt that the unnamed woman from Naga el-Deir in whose tomb it was found wore it during her lifetime. Her coffin also contained what may have been the rest of her wardrobe — eleven similar frocks. Together they represented one of the largest and best-preserved collections of clothing from ancient Egypt.

This dress consists of three pieces. The sleeves and half the bodice were made of a single piece of linen, which was sewn on top of the skirt, leaving a V-shaped opening for the neck. The pleating was most likely done by hand prior to assembly. After washing — with natron serving as soap — the pleating would have been redone for wearing.

Linen was by far the most popular material for clothing both men and women in ancient Egypt, although wool was undoubtedly worn as well, according to the climatic needs. (Cotton was unknown until Ptolemaic times.) The planting, harvesting, and weaving of linen were common themes in tombs. Until the end of the Middle Kingdom, linen was woven on horizontal ground-looms by men, women, or children. The fabric was graded into four categories on the basis of its coarseness and was seldom dyed. The warm brown of this example is its original color, somewhat darkened with age.

Linen
Naga el-Deir, tomb N 94
L. 74 cm, w. 43 cm
(L. 29 ⅛ in., w. 16 ¹⁵⁄₁₆ in.)
Harvard University-Museum of Fine Arts Expedition
34.56

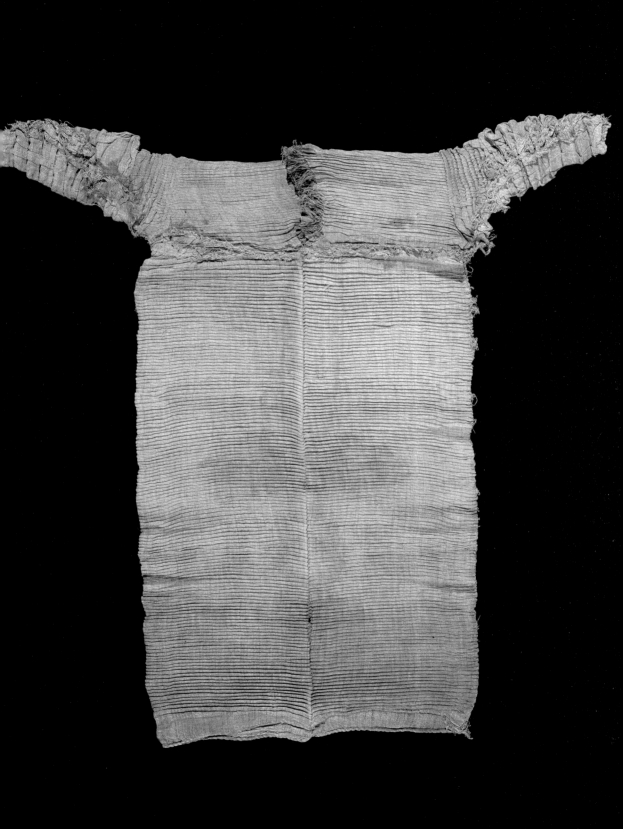

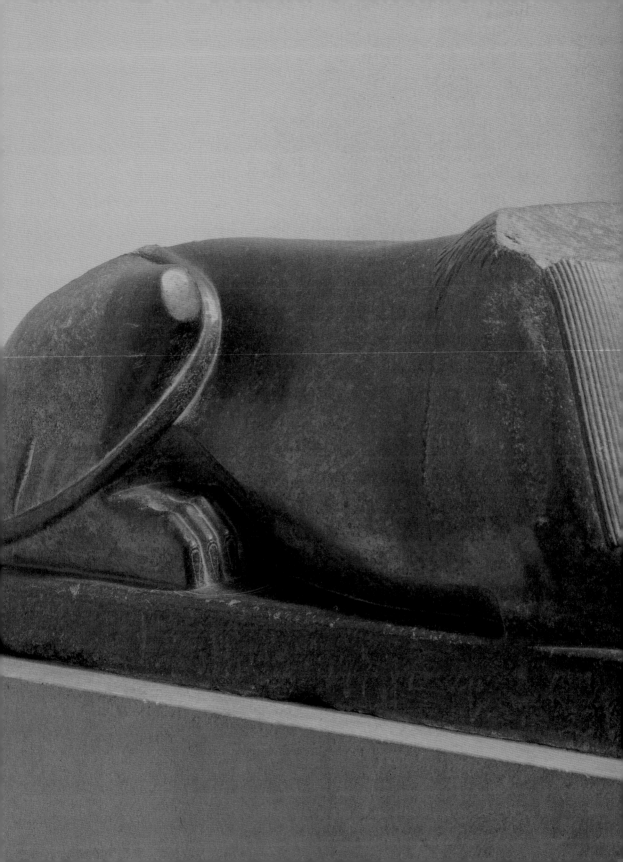

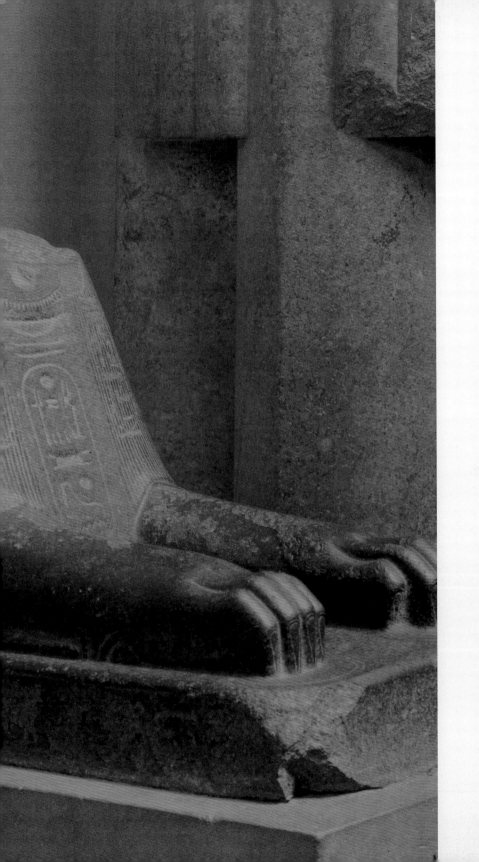

3

FIRST INTERMEDIATE period and middle kingdom about 2100 – about 1640 B.C.

First Intermediate Period and Middle Kingdom (about 2100 – about 1640 B.C.)

With the collapse of the Old Kingdom and the onset of the First Interme-
diate Period (about 2100–2040 B.C.), political control came to be divided
between two rival centers. The members of a family ruling from Herak-
leopolis near the Fayum (Dynasties 9 and 10) called themselves the right-
ful heirs to the Old Kingdom, while a rival dynasty (Dynasty 11) made the
same claim from Thebes in the south. The nation was effectively divided
between Upper and Lower Egypt for the first time since Dynasty 0. Local
district rulers in the intervening provinces rallied their own troops,
fought over disputed territories, and supported whichever of the larger
powers best suited their needs. Some of these provincial leaders
amassed enormous wealth and influence, and used their resources to
construct large and elaborately decorated tombs for themselves. The
inscriptions on the walls of these tombs are among our best sources of
historical information about the period. Based on some of the texts, along with
fictionalized accounts of famine and violence composed during the Middle
Kingdom that followed, scholars have formed a view of the First Intermediate
Period as a time of great turmoil and suffering. However, with few surviving
inscriptions and little other supporting evidence, it remains uncertain to what
extent this picture is accurate.

By the late First Intermediate Period, the Theban kings extended their con-
trol well into Middle Egypt. Then about 2040 B.C., the fifth king of their dynasty,
Nebhepetre Mentuhotep II, finally reunited the two lands and thereby ushered
in the Middle Kingdom (2040–about 1640 B.C.). Despite intermittent battles
to solidify his control, Mentuhotep ruled for half a century, during which he
pursued an energetic domestic agenda. He reorganized the country's adminis-
tration, sent mining and quarry expeditions to remote desert locations, and com-
missioned numerous construction projects. The most notable of his structures is
the immense and innovative mortuary temple at Deir el-Bahri. The architecture
and relief of the period, which unfortunately has not survived as well as that of

fig. 22 Inscribed tomb stelae of the
First Intermediate Period display
distinctive local styles. Stelae from
Middle Egypt feature large eyes, long,
thin limbs, and beaklike noses.
Funerary seta of Sheditef, First
Intermediate Period, about
2100–2040 B.C., limestone, from
Mesheikh tomb 102, 73 x 48 x 10 cm
(28 ¾ x 19 x 4 in.), Harvard Univer-
sity-Museum of Fine Arts Expedition
12.1477

either the Old or New Kingdoms, show a delicacy and restraint that the ancient Egyptians never surpassed.

Among the most profound and long-lasting developments of the First Intermediate Period and Middle Kingdom were innovations in funerary religion. For the first time, officials other than the king sought to identify themselves in death with the god Osiris. Although Osiris is mentioned prominently in the Pyramid Texts found in royal tombs of the Old Kingdom, he became particularly popular with Egyptians of all classes during the two periods that followed. He would remain one of Egypt's most important deities. Osiris was believed to be the prototypical benevolent king who was deceived and murdered by his brother Seth, the god of chaotic forces. Revived through magic by his devoted wife Isis, he then became the lord of the afterlife by whom all mortals would be judged after death. Isis's power as a magician also enabled her to conceive a son, Horus, whom she protected fiercely through his childhood against dangers beset on him by Seth. Upon reaching adulthood, Horus avenged his father's death, defeated Seth, and became the divine ruler of Egypt. Egyptian kings from the Early Dynastic Period throughout the country's long history considered themselves the embodiment of Horus on earth.

Egyptians who could afford it made pilgrimages to Osiris's sacred site of Abydos where an annual festival reenacted his death and resurrection. They left behind statues and stelae by the hundreds to commemorate their visit and to encourage other pilgrims to include them in their prayers and offerings. In this way, they hoped to share in an afterlife once considered an exclusive privilege of the king. Officials also composed new funerary texts in accordance with their beliefs — the route to the afterlife was fraught with dangers, and the dead required spells to guide them safely to Osiris and also to assist them as he judged them. These spells are now called Coffin Texts because they are known primarily from inscriptions on the interiors of wooden coffins. They would eventually evolve into their better-known New Kingdom counterpart, the *Book of the Dead*.

Despite Egypt's political unification in the middle of Dynasty 11, local officials retained considerable strength and independence for several generations, well into Dynasty 12. We know them today from their monumental tombs, the stelae they dedicated at sanctuaries, and the graffiti they left behind at mines and quarries. While the remaining kings of the Eleventh Dynasty (all of whom took the name Mentuhotep after their illustrious ancestor) continued to pursue ambitious mining, quarrying, and building projects, they ultimately failed to maintain control over their highest officials. After the death of Mentuhotep IV, in

circumstances that remain unclear, power abruptly shifted to a new family. Dynasty 12 was headed by a Theban named Amenemhat, who seems to have seized the throne after serving as vizier, the highest-ranking official under the king.

Amenemhat I set out to curtail the personal authority of the provincial nobles, taking a lesson from his predecessor's misfortune. He reestablished the boundaries between districts, appointed new governors where necessary, and allowed cooperative local rulers to retain limited autonomy and control over their subjects. This compromise permitted the government to function effectively for generations. Later in the reign, perhaps in an additional effort to consolidate his authority, Amenemhat I moved the capital northwards from Thebes to a previously undeveloped site near the Fayum, called Itj-tawy. Nearby, he and his successor Senwosret I built pyramid complexes and mortuary temples modeled on those of Dynasty 6 in an effort to identify themselves with Old Kingdom rulers.

Despite his administrative success, Amenemhat was not spared from political intrigue and he became the victim of an assassination attempt, which some scholars believe may actually have taken his life. His successor continued the program of demonstrating the dynasty's authority by erecting new temples to deities throughout the realm, from Bubastis to Elephantine. While very few of these buildings have survived, Senwosret's small kiosk at Karnak, the great sanctuary of the Theban god Amen, is an architectural gem (fig. 23).

fig. 23 **Senwosret I's chapel at Karnak is the best surviving example of early Middle Kingdom temple architecture.** Limestone chapel of Senwosret I at Karnak, Dynasty 12, reign of Senwosret I, 1971–1926 B.C. Photo: Lawrence M. Berman

Toward the end of the dynasty, under the Middle Kingdom's two most powerful kings, Senwosret III and Amenemhat III, Egypt reached a level of prosperity and security it had not enjoyed since the height of the Old Kingdom. Senwosret III (see fig. 24), one of the greatest pharaohs in history, achieved dazzling success in both his foreign and domestic activities. In Nubia, he completed a series of conquests begun by Senwosret I by bringing all of Lower Nubia firmly under Egyptian control and building a series of massive fortresses to protect the borders and trade routes. At home, he undertook an administrative restructuring that resulted in bringing the hereditary authority of the provincial governors to an end. Symbolic of the pharaoh's renewed control was the return to the custom of officials being buried near the royal pyramid, at Dahshur. By building there, Senwosret followed the example of his grandfather, Amenemhat II, and thus, he may have intended to make a symbolic return to the burial place of the founders of Dynasty 4. In addition, Senwosret commissioned a second mortuary complex that included a temple and vast subterranean tomb at Abydos, the burial place of Egypt's earliest rulers. The vast cemeteries of large and elaborately decorated officials' tombs in Middle Egypt ceased to be used.

Senwosret III's successor, Amenemhat III, took advantage of his secure position and unprecedented wealth to expand trade, mining, and quarrying, and to undertake enormous building projects in the Sinai, the Delta, and especially in the Fayum region during his nearly half century of rule. Elements from his temples, appropriated by later kings for their own building projects, provide a hint of the grandeur of Amenemhat's original structures. Following the example of his father and grandfather, he built a pyramid complex at Dahshur, but he was buried in a second pyramid he constructed later at

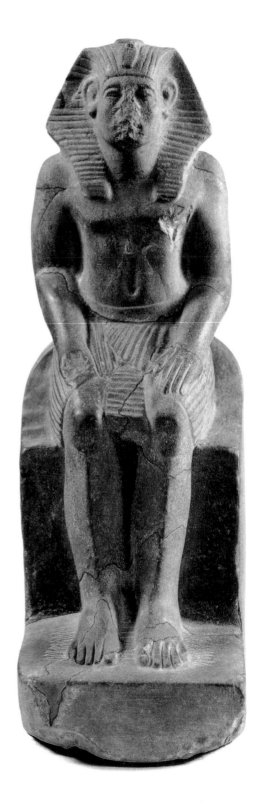

Hawara in the Fayum. There, he built another massive funerary temple complex that admiring Classical authors would label the Labyrinth.

Dynasty 12 came to end with a female pharaoh, Nefrusobek, suggesting that the male line had reached its end. Although the early kings of the following dynasty continued to carry out building projects and mining expeditions, trouble seems to have been brewing. Historians record a large number of rulers with short and sometimes overlapping reigns. In the south, the powerful kingdom of Kerma eroded Egyptian holdings in Nubia, while to the north, increasing numbers of foreigners from the Syro-Palestinian region settled in the Delta. As the Middle Kingdom drew to a close, these newcomers, whom the Egyptians later remembered as the Hyksos, would declare themselves pharaohs, casting Egypt into its first period of foreign rule.

Denise M. Doxey

fig. 24 Seated statuette of Senwosret III, Dynasty 12, reign of Senwosret III, 1878–1841 B.C., limestone, from Sinai, h. 26.6 cm (10 ½ in.), Gift of the Egypt Exploration Fund 05.195a–c.

Stela of the Nubian soldier Nenu

Dynasty 9 to early Dynasty 11, about 2100–2040 B.C.

During the tumultuous years between the Old and Middle Kingdoms the local rulers of Middle Egypt were drawn into a heated rivalry between the Thebans from southern Egypt and the Herakleopolitans from the north. Nubian mercenaries, particularly the highly skilled archers, fought on behalf of all the factions involved. Many of them served in the Egyptian army and then settled in Egypt, where they lived, died, and were buried according to local customs.

This limestone stela was set into the tomb wall of one such Nubian soldier who had evidently married an Egyptian. The stela served as the focal point for offerings brought to the tomb to honor and sustain the deceased and his family in the afterlife. The inscription requests offerings from Anubis, the jackal god of the necropolis, for the tomb owner, a man named Nenu. Nenu is identified as a Nubian not only by the text, but also by certain elements of his dress, including a wide leather sash and a distinctive, curly wig. His wife stands beside him wearing a characteristically Egyptian sheath dress, wig, and broadcollar, although the conventions of Egyptian two-dimensional representation make her

appear to be behind him. Other family members in Nubian attire face them in the lower register, accompanied by a pair of curly-tailed hounds wearing collars. In the upper register, a servant figure offers a libation from a large jar resting on a stand behind him. Servants of this type, energetically proffering a cup to the tomb owner, are characteristic of the First Intermediate Period. Hunting hounds such as the two portrayed with Nenu also appear frequently on stelae and tomb reliefs of both the First Intermediate Period and Middle Kingdom.

During the First Intermediate Period, local relief styles replaced the refined relief of the preceding Old Kingdom, and the figures on this stela display the awkwardness characteristic of the age. Particularly noteworthy are the enormous eyes, beaklike noses, extremely long limbs, and the unrealistic manner in which the wife's arm bends around Nenu's waist.

Painted limestone
Probably from Gebelein
H. 37 cm, w. 45 cm (H. 14 ⅝ in., w. 17 in.)
Purchased by A. M. Lythgoe 03.1848

Coffin of Menqabu

Probably early Dynasty 11, 2140–2040 B.C.

Built to house the mummified body of an official named Menqabu, this beautifully preserved rectangular coffin features the remarkably simple but visually appealing decorative scheme that emerged during the First Intermediate Period. A single line of text around the rim of the box and another down the center of the lid contain traditional offering prayers requesting a good burial and eternal sustenance from the king and the funerary deities Anubis and Osiris. The brightly painted hieroglyphs display the crude but lively and experimental style of the First Intermediate Period, and each sign has become a vivid expression of the artist's imagination. A feature peculiar to this period in Egyptian art is the "killing" of the glyphs portraying dangerous animals, such as the horned viper, which has been decapitated wherever it occurs in the text. Evidently, the Egyptians feared the presence of such potentially hostile symbols in close proximity to the body.

On the left side of the coffin, at the end where the head of the deceased would have rested, a white panel contains a pair of sacred *wadjet* eyes. Representing the eyes of the falcon god Horus, they served as protective symbols to ward off perils on the dangerous journey to the underworld. Because the body

would have been placed on its side, with the face of the mummy immediately behind the panel, the eyes also allowed Menqabu to "look" out into the tomb. He would have faced east, the direction of the rising sun, because Egyptians believed that just as the sun god arose from the eastern horizon, the deceased would be reborn in the afterlife. The remainder of the coffin is painted a dark reddish brown to simulate imported cedar wood, which only the elite could afford.

Wood
Farshut
H. 57 cm, l. 195 cm, w. 42 cm
(H. 22 7/16 in., l. 76 3/4 in., w. 16 9/16 in.)
Emily Esther Sears Fund 03.1631a–b

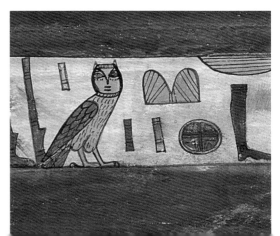

Relief of Nebhepetre Mentuhotep II
Dynasty 11, reign of Nebhepetre
Mentuhotep II, 2040–2010 B.C.

Only one major building has sur-
vived from the reign of Nebhepetre
Mentuhotep II, the king who reuni-
fied Egypt at the end of the First
Intermediate Period to found the
Middle Kingdom. The spectacu-
larly innovative funerary temple
at Deir el-Bahri in western
Thebes was begun soon after
Mentuhotep took the throne,
before he or his artists had seen the
Old Kingdom monuments of northern Egypt. The
mortuary temple therefore underwent dramatic
changes in both plan and relief after the conquest of
the north. While the relief in the earlier sections
reflects the Theban style of the late First Intermedi-
ate Period, the later style emulates the flat relief
favored by Mentuhotep's Old Kingdom predecessors.
The temple is now largely destroyed, and most of the
visible remains are from the later reconfigurations.
Nevertheless, tantalizing fragments of relief sculp-
ture in the Theban style, such as this exquisitely

carved head of the king, attest to the high quality of
art from the early years of Mentuhotep's reign. The
sculpture is characterized by the artist's meticulous
attention to detail and the manner in which he varied
the height of the relief to create a sense of depth and
perspective rarely found in Egyptian art. The well-
preserved paint — brick red for the skin, blue for the
wig and eyebrow, and red, blue, and yellow for the
inlaid diadem and uraeus serpent — add to its liveli-
ness and immediacy. The Old Kingdom relief style,
which Mentuhotep emulated during the period fol-
lowing the reunification, had featured very thin,
almost waferlike carving, with clean lines and limited
interior detail. In copying it, Mentuhotep's artists
produced work that, though technically very fine,
lacked the vigor and intensity of their earlier work.

Painted limestone
Deir el-Bahri, mortuary temple of King
Nebhepetre Mentuhotep II
H. 35 cm, w. 25.5 cm, d. 12 cm
(H. 13¾ in., w. 10¹/₁₆ in., d. 4¾ in.)
Gift of the Egypt Exploration Fund 06.2472

Statue of Wepwawetemhat
Probably late Dynasty 11, 2040–1991 B.C.

This masterful wooden statue, made for the tomb of a minor official who lived at the end of the First Intermediate Period or early in the Middle Kingdom, represents the culmination of the style that emerged in the late Old Kingdom. A brief text on the base identifies the figure as "the venerated one, Wepwawetemhat," who is shown as a slender, idealized young man striding forward with his left foot — the traditional pose for a sculpture of an Egyptian dignitary. The head, torso, and legs were carved from a single piece of wood, while the arms and the base of the figure were made separately. The entire statue was then coated with gesso and brightly painted and the eyes were inlaid with black and white stones. The features of the face, including the slightly arched eyebrows and well-preserved eyes, impart a youthful intensity and energy.

This statue is among the best-preserved wooden sculptures of its time. Its style retains certain features of the First Intermediate Period, including the wide, staring eyes, long limbs and fingers, and angular lines of the face and collarbone. The date of the unplundered rock-cut tomb in which this figure was discovered, however, remains uncertain. It was long thought to predate the reunification of Egypt in Dynasty 11, but a number of scholars now suggest that it and contemporary tombs may date from as late as Dynasty 12.

Wood
Asyut, tomb 14
H. 112 cm, w. 23.1 cm, d. 71.1 cm (H. 44 ⅛ in., w. 9 ⅛ in., d. 28 in.)
Emily Esther Sears Fund 04.1780

**Sankhkare Mentuhotep III as Osiris,
reinscribed for King Merenptah**
Dynasty 11, reign of Sankhkare Mentuhotep III
2010–1998 B.C.

The pose of this life-sized statue of Mentuhotep III,
with the arms folded across the chest, identifies the king
with Osiris. His body is enveloped in a tightly fitting
garment, reminiscent of a mummy's wrappings, from
which only his hands protrude. A knee-length robe is
barely visible beneath it. Holes through the hands indi-
cate that he once held the crook and flail scepters that
served, like the tall white crown of Lower Egypt, as
attributes both of the reigning king and of the god of the
afterlife. Traces of the long, curved beard of the gods
may also be detected on his chest above his crossed arms.

The statue originally stood in the temple of the war-
rior god Montu at Armant in southern Egypt. It was one
of six such figures that had been ceremonially buried
beneath the floor when the temple was rebuilt in the
Greco-Roman period. Although no longer needed in the
new building, nearly two millennia later they were evi-
dently still considered too sacred to destroy. The
inscription running down the center is misleading
because it identifies the king as the Nineteenth Dynasty
pharaoh Merenptah. The text, however, was inscribed
centuries after the statue was erected, perhaps at a time
when Merenptah undertook renovations of the temple.
Most of the other figures of Mentuhotep found with it
are uninscribed.

Sandstone
Armant
H. 213 cm (H. 83⅞ in.)
Gift in recognition of a contribution to the Robert Mond Expedi-
tion of the Egypt Exploration Society, Harriet Otis Cruft Fund
38.1395

Seated statuette of an official
Dynasty 11 or early Dynasty 12,
2140–1926 B.C.

This enigmatic travertine statuette of an unidentified official differs strikingly in both form and material from most three-dimensional representations of humans in Egyptian art. The figure, seated on a cube-shaped seat without a back, is highly abstract, with barely articulated limbs and a short, thick neck. His head appears to be shaven, and the line of the kilt is hardly apparent. The eyes were originally inlaid with stone set in a copper frame, a technique that would have made the face significantly more lifelike. The lack of eyes, along with damage to the nose, exaggerates the figure's disturbing, almost ghostlike appearance.

The unusual appearance of the statuette may be explained by its function. It is one of a small group of travertine funerary figures so similar in style that they are probably products of the same workshop. Because one of them was found in the cabin of a wooden model funerary ship in a rock-cut tomb in Middle Egypt, it is thought that all of them are likely to have portrayed the tomb owner sailing on his journey to the afterlife. Scholars have suggested that the men who carved these figures were sculptors who normally manufactured stone vessels and wooden models, and that they were only beginning to experiment with carving the human figure in stone.

Travertine (Egyptian alabaster)
Probably from Asyut
H. 28 cm (H. 11 in.)
Gift of William Kelly Simpson in memory of
William Stevenson Smith 1971.20

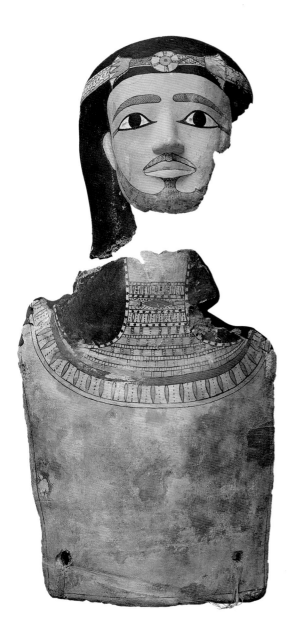

Mummy mask

Dynasty 11 to early Dynasty 12, 2140–1926 B.C.

While Egyptians of the Old Kingdom had attempted to add lifelike features to the outer wrappings of mummies, masks with idealized images of the deceased, designed to cover the head and shoulders of the mummy, were introduced during the First Intermediate Period. By the early Middle Kingdom they became a standard part of the Egyptian burial assemblage, and they would continue to be used for two thousand years, into the Roman era (see p. 192). This mask, like many funerary masks of the period, was made of cartonnage. It was painted to imitate a mask that was covered with gold and inlaid with semiprecious stone, materials that would have been used for the masks of higher officials who could better afford them. The long, plain front panel was designed to be hidden under the outermost layer of mummy wrappings, with only the head revealed.

Due to its imperishability, gold was believed to be the color of the gods' flesh. By using it for the skin of the deceased, the artist therefore indicated that he or she had entered the realm of the divine. Likewise, the eyebrows and beard were painted blue because the hair and beards of deities were believed to be of lapis lazuli. Although men in Egyptian art were typically portrayed as clean shaven or wearing a short goatee, moustaches and fuller beards such as those depicted here seem to have been fashionable on funerary masks for a brief period in the early Middle Kingdom. The artist of this mask paid careful attention to details, such as the stippling of the beard and eyebrows and the meticulous rendering of the eyes' canthi, and thus gave the face a lifelike and expressive quality despite the symbolic coloring.

Cartonnage

Asyut

H. 60 cm (H. 23 ⅝ in.)

Edward and Mary S. Holmes Fund 1987.54

detail of **Outer coffin of Djehutynakht**

Late Dynasty 11 or early Dynasty 12, 2040–1926 B.C.

The outer coffin of the local governor Djehutynakht of Deir el-Bersha is perhaps the finest Middle Kingdom coffin in existence. Like the second coffin that once nested inside it, the rectangular outer coffin was made of massive planks of imported cedar, pegged together and decorated on both its inner and outer faces. The paintings and inscribed funerary texts were intended to facilitate Djehutynakht's passage to the afterlife and to sustain his *ka* in eternity.

While coffins of later periods would feature elaborate exterior decoration, those of the early Middle Kingdom were relatively plain on the outside, but beautifully embellished inside, where the offering scenes often parallel those seen in painted tombs. The paintings on the interior of Djehutynakht's coffin are masterpieces, exquisitely detailed in thick, vividly colored paint. The artist's painstaking brush strokes and eloquent use of shading produced a level of realism rarely surpassed in Egyptian art. The primary scene is on the left side of the coffin at the location where Djehutynakht's head once faced. The focal point is an intricately decorated false door through which the *ka* could pass between the afterlife and the world of the living. Djehutynakht sits in front of the false door and receives an offering of incense. Before and beneath him is a vast wealth of neatly piled offerings, including an oversized ceremonial wine jar, sacred oils, the legs and heads of spotted cattle, tables laden with fruits, vegetables, meat, bread, and magnificently detailed geese. The two rows of large painted hieroglyphs above the scene contain a funerary prayer requesting offerings from the king and the funerary god Osiris on festival days. At the far right is the beginning of a menu giving a full list of desired offerings. Inscribed below in neat columns of tiny, cursive hieroglyphs are the Coffin Texts, a collection of funerary rituals and spells intended to protect and guide the dead on their way to the afterlife. These texts continue around the coffin's interior.

Painted cedar

Deir el-Bersha, tomb 10A

H. 115 cm, l. 263 cm

(H. 45 ¼ in., l. 103 ⁹/₁₆ in.)

Harvard University-Museum of Fine Arts

Expedition 20.1822

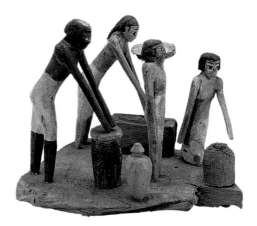

Model of a granary

Late Dynasty 11 or early Dynasty 12, 2040–1926 B.C.

Wood
Deir el-Bersha, tomb 10A
L. 29 cm, w. 29 cm, d. 29 cm
(L. 11 7/16 in., w. 11 7/16 in., d. 11 7/16 in.)
Harvard University-Museum of Fine Arts Expedition 21.409

Model of a brewery and bakery

Late Dynasty 11 or early Dynasty 12, 2040–1926 B.C.

Wood
Deir el-Bersha, tomb 10A
H. 24.3 cm, w. 22 cm, d. 28 cm
(H. 9 9/16 in., w. 8 1/16 in., d. 11 in.)
Harvard University-Museum of Fine Arts Expedition 21.886

While late Old Kingdom tombs had included lime-stone statuettes of people engaged in chores such as food preparation (p. 95), a new development occurred during the First Intermediate Period and Middle Kingdom. Now, models made of wood, a less costly material, were manufactured in large numbers and placed in the burial chamber to furnish provisions for the deceased in the afterlife. In symbolically providing for the tomb owner's needs, the models functioned in much the same way as painted scenes of these activities did on the walls of tomb chapels.

The tomb of Djehutynakht contained what may be the largest collection of wooden models ever discovered in Egypt. At least thirty-nine of them, including these four, represent scenes of food production and crafts. Upon opening the tomb, however, archaeologists discovered that robbers had ransacked it in antiquity, possibly on more than one occasion, throwing the models haphazardly around the small burial chamber. Only through years of research and restoration are they being returned to their original configuration. The models vary greatly in quality, and

many of them were mounted on pieces of wood recycled by the artists from old boxes or chests. The colorfully painted figures nevertheless convey a liveliness and energy that give us a sense of the bustling activities of Egyptian daily life. They also demonstrate innovative poses and subjects that would never have been attempted in the more formal sculptures that represented the tomb owner and his family.

Food production is the dominant theme among the model scenes, and a variety of activities are represented. The most common scene shows a group of three men at work in a granary building. Grain was the basic unit of wealth and exchange in ancient Egypt, and careful accounting of the crop was essential. Thus, in each granary we see one man carrying a filled sack, while another bends down to measure grain into a bucket, and a seated scribe records the quantity on a board held across his knees.

Much of this grain was destined for the production of bread and beer, staples of the Egyptian diet. Brewing and baking took place in the same shop, and both men and women shared in the work. In the model

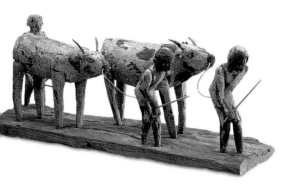

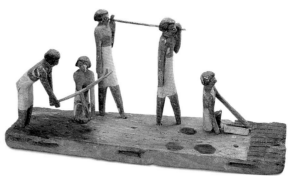

Model of men herding cattle

Late Dynasty 11 or early Dynasty 12, 2040–1926 B.C.

Wood
Deir el-Bersha, tomb 10A
H. 26 cm, l. 63 cm, w. 18 cm
(H. 10 in., l. 24⅞ in., w. 7 in.)
Harvard University-Museum of Fine Arts Expedition 21.831

Model of brickmakers

Late Dynasty 11 or early Dynasty 12, 2040–1926 B.C.

Wood
Deir el-Bersha, tomb 10A
H. 25.5 cm, l. 54.5 cm, w. 17.4 cm
(H. 10 in., l. 6⅞ in., w. 21 in.)
Harvard University-Museum of Fine Arts Expedition 21.411

shown here, one woman grinds the flour while a second carries a tray of bread loaves to the oven, and a third tends to the flame. Meanwhile, a man prepares beer by pressing mash through a sieve and into a jar.

A number of models feature scenes of cattle rearing. The recently restored model shown here depicts plump steers being driven — reluctantly it seems — to a cattle count or perhaps to slaughter. The artist has taken pains to include lifelike details so that the robust animals contrast dramatically with their slouched, weary, and balding keepers.

Djehutynakht's collection of models also included a variety of manufacturing scenes. One of the more unusual shows several phases in the making of bricks. At one end, two men gather clay. One breaks up the hard ground with a hoe while the other collects or kneads the clay with his hands. The Nile valley's rich mud is represented by the black paint used for the base of the model, as well as on the hands of the crouching figure. A second pair of men carried the clay in a now-missing basket suspended from a pole. Finally, a squatting man shapes the bricks

with a mould and places them in the sun to dry.

Toward the end of Dynasty 12 a change occurred in Egyptian burial customs for reasons that remain unclear. Although model boats continued to be placed in tombs, the scenes of crafts and food production disappeared permanently from the repertoire of funerary offerings. At approximately the same time, early versions of *shawabty*s, mummiform figurines intended to serve on behalf of the deceased in the afterlife, began to become more common in burials.

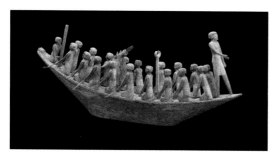

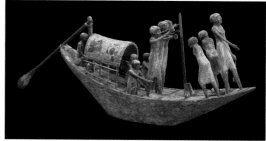

Model of a sailing boat

Late Dynasty 11 or early Dynasty 12, 2040–1926 B.C.

Wood
Deir el-Bersha, tomb 10A
H. 44.5 cm, l. 127 cm, w. 19.5 cm (H. 17½ in., l. 50 in., w. 7¹¹⁄₁₆ in.)
Harvard University–Museum of Fine Arts Expedition 21.407

Model of a traveling boat

Late Dynasty 11 or early Dynasty 12, 2040–1926 B.C.

Wood
Deir el-Bersha, tomb 10A
L. 100 cm, w. 21 cm (L. 39⅜ in., w. 8¼ in.)
Harvard University–Museum of Fine Arts Expedition 21.877

Along with a collection of wooden models representing scenes of daily life, Djehutynakht equipped his tomb with a fleet of more than fifty-five model boats, the largest collection known from a single Egyptian tomb. Several types of craft are represented, including funerary vessels, boats for traveling, ships for troop or freight transport, hunting and fishing boats, and kitchen boats of the sort that would have accompanied a Middle Kingdom official and his entourage on voyages up and down the Nile. Although they vary in size and quality, all of Djehutynakht's boat models are constructed in the same fashion, with the hull carved from a single piece of wood, while the cabins, masts, other fittings, and crews were made separately and attached with pegs.

Wide-hulled funerary vessels, like the example on the right made of papyrus bundles lashed together, transported the deceased either to a cemetery across the Nile or to the sanctuary of the god of the afterlife, Osiris, at Abydos. Models of such vessels were painted white with reddish lines representing the bindings. The prow and the upright, inward-curving stern of this example terminate in rosettes imitating papyrus umbels, and the pair of eyes on the prow were believed to provide magical guidance in steer-

ing the ship clear of obstacles. On the deck, a canopy encloses the bier that would have held the mummy of the deceased. The two figures bent over at one end of the bier represent priests offering incense and reciting funerary prayers before the body. The figure seated at the stern was responsible for navigating by means of the pair of steering oars attached to stanchions. In the forward section, a crew of sailors had to maneuver the sail, now missing on the model, and a lookout was to watch for sandbars and other hazards.

The models seen above represent the type of boats that carried living people on journeys up and down the river. Such vessels, unlike funerary boats, were made of wood. The model of Djehutynakht's own boat features an arched cabin in which he could sit sheltered from the sun or weather. This model portrays the boat equipped as it would be for hunting and military trips. Shields made of spotted cowhide are painted on the side of the cabin, and long quivers holding spears are stowed below. The vessel appears to be under sail and the crew is reaching upward to work the rigging, which is now lost, as are the mast and sail. Behind the lookout, a man stands at the prow with his arm upraised. He once held a pole like the ones used on actual

boats to push away from the shore and to maneuver vessels in shallow water.

A rapid troop transport vessel powered by eight pairs of rowers would have accompanied Djehutynakt on his expedition. Between the rowers on the model at the far left are small-scale versions of a long cowhide quiver of spears and a pair of shields. This boat was also equipped with a mast, which, on the real vessel, would have been taken down while the sails were not in use and placed in crutches at the center of the ship. The forked posts in the center of the model represent these crutches.

Model of a funerary boat

Late Dynasty 11 or early Dynasty 12, 2040–1926 B.C.

Wood
Deir el-Bersha, tomb 10A
L. 95 cm, w. 16 cm (L. 37 ⅜ in., w. 6 ⁵⁄₁₆ in.)
Harvard University-Museum of Fine Arts Expedition 21.880

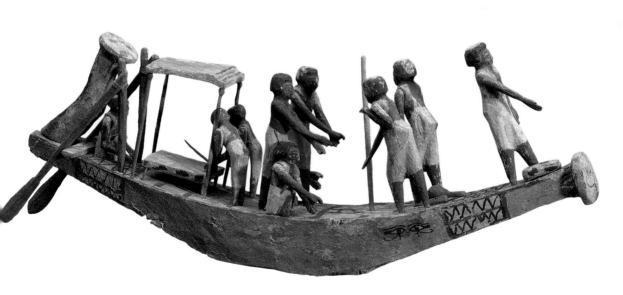

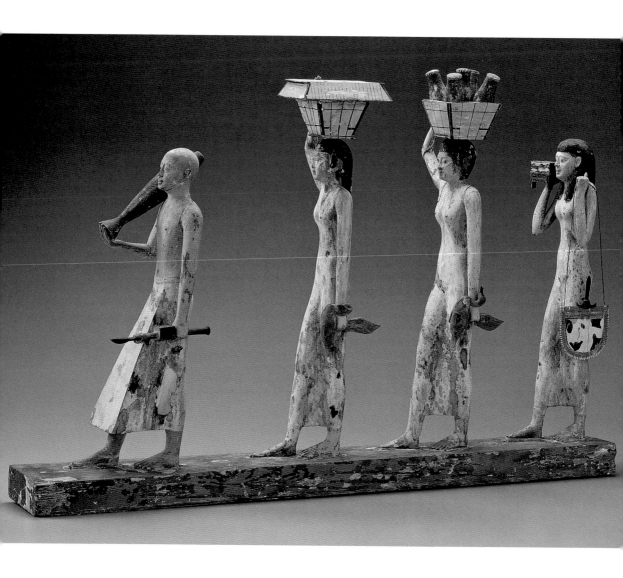

Procession of offering bearers

Late Dynasty 11 or early Dynasty 12, 2040–1926 B.C.

Among the more than one hundred wooden models found scattered throughout the tomb of Djehuty-nakht, the quality of this procession of offering bearers stands out from the others. The skill and delicacy with which it was carved and painted rank it among the finest wooden models ever found in Egypt. It shows a man and three women bringing offerings to sustain the *ka* of Djehutynakht in the afterlife. Each figure advances with the left leg forward, following the convention of larger scale Egyptian sculpture and relief. A priest leads the way, carrying a ceremonial wine jar and incense burner for use in the burial rites. Two women follow with offerings of food and drink — the first carries a basket of bread and a duck, while the second brings another duck and a basket filled with beer jars. The third woman furnishes items for Djehutynakht's personal care, a small wooden cosmetic chest and a mirror, the latter slung over her shoulder in a case made of animal hide. This brief procession symbolically provides all that was essential to sustain Djehutynakht in eternity: food, drink, items of personal adornment, and the incense used to attract and appease divinities and the blessed dead.

The procession was found overturned between Djehutynakht's coffin and the eastern wall of his burial chamber, in a pile of broken models that robbers had thrown aside. Although the four figures remained attached when the model was discovered, the two central offering bearers had lost their raised arms, and nearly all the offerings had come loose. Some pieces were found a considerable distance away. Since its discovery, the scene has been reconstructed twice. The first attempt, carried out in 1941 before all the elements had been identified, was incorrect. The current configuration was established in 1987.

Wood with gesso and pigment
Deir el-Bersha, tomb 10A
L. 66.36 cm (L. 26 ⅛ in.)
Harvard University-Museum of Fine
Arts Expedition 21.326

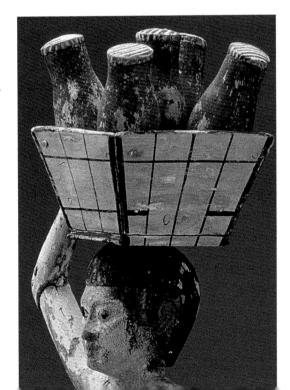

Statue of Lady Sennuwy

Dynasty 12, reign of Senwosret I, 1971–1926 B.C.

Egyptian officials of the Middle Kingdom continued the practice of equipping their tombs with statues to house the *ka* of the tomb owner and to provide a focal point for the offering cult. Highly ranked officials also dedicated statues of themselves at sanctuaries of gods and deified ancestors. Following the experimental and idiosyncratic interlude of the First Intermediate Period, sculptors once again produced large-scale stone statues, returning to the basic forms and poses established in the Old Kingdom.

This elegant seated statue of Lady Sennuwy of Asyut is one of the most superbly carved and beautifully proportioned sculptures from the Middle Kingdom. The unknown artist shaped and polished the hard, gray granodiorite with extraordinary skill, suggesting that he was trained in a royal workshop. He has portrayed Sennuwy as a slender, graceful young woman, dressed in the tightly fitting sheath dress that was fashionable at the time. The carefully modeled planes of the face, framed by a long, thick, striated wig, convey a serene confidence and timeless beauty. Such idealized, youthful, and placid images characterize the first half of Dynasty 12 and hark back to the art of the Old Kingdom. Sennuwy sits poised and attentive on a solid, blocklike chair, with her left hand resting flat on her lap and her right hand holding a lotus blossom, a symbol of rebirth. Inscribed on the sides and base of the chair are hieroglyphic texts declaring that she is venerated in the presence of Osiris and other deities associated with the afterlife.

Sennuwy was the wife of a powerful provincial governor, Djefaihapi of Asyut, whose rock-cut tomb is the largest nonroyal tomb of the Middle Kingdom. Clearly, the couple had access to the finest artists and materials available. It is likely that this statue, along with a similar sculpture of Djefaihapi, was originally set up in the tomb chapel, although they may also have stood in a sanctuary. Both statues were discovered, however, far to the south at Kerma in Nubia, where they had been buried in the royal tumulus of a Nubian king who lived generations after Sennuwy's death. They must have been removed from their original location and exported to Nubia some three hundred years after they were made. Exactly how, why, and when these pieces of sculpture, along with numerous other Egyptian statues, found their way to Kerma, however, is still unknown.

Granodiorite
Sudan, Kerma, tumulus K III,
originally from Egypt, perhaps Asyut
H. 172 cm, d. 116.5 cm
(H. 67 11/16 in., d. 45 7/8 in.)
Harvard University–Museum of
Fine Arts Expedition 14.720

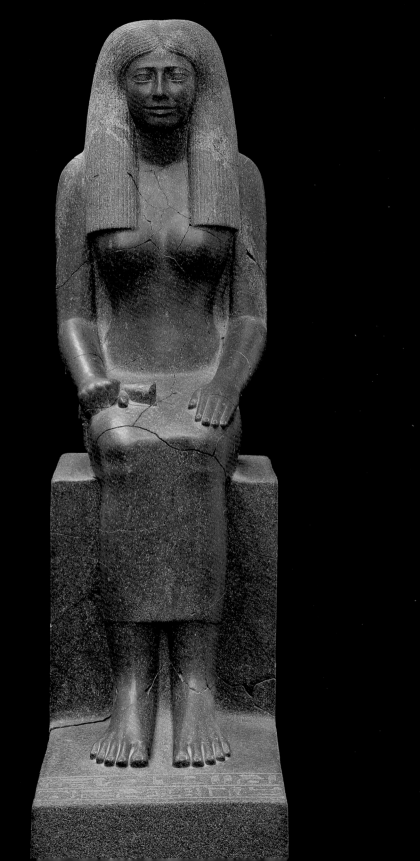

Head of a female sphinx

Early Dynasty 12, 1991–1892 B.C.

This nearly life-sized head of a royal woman comes from a sphinx. The ancient Egyptians viewed sphinxes both as symbols of royal authority and as manifestations of the sun god. Accordingly, both male and female members of the royal family had themselves portrayed as sphinxes. Female sphinxes, however, are exceedingly rare before Dynasty 12, and males remained more common throughout the Middle Kingdom.

Carved of glistening quartzite, this woman is identified as a queen or princess by the royal uraeus cobra on the brow of her wig. While the long, striated wig, large ears, and straight mouth are typical Middle Kingdom features, the modeling of the face is remarkable. When compared to the idealized youthfulness of Lady Sennuwy (pp. 126–27), this face is decidedly more lifelike. The careful rendering of the full cheeks, the high cheekbones, the hollows beside the nose, and the lines around the mouth and chin convey a real sense of individuality and maturity often lacking in representations of Egyptian women, leading some scholars to suggest that the statue approaches true portraiture, rare in Egyptian art in any period.

While the original context is unknown, the statue almost certainly stood in a temple. It is reported to have come from a site near ancient Heliopolis, the cult center of the sun god and therefore a particularly appropriate setting for a sphinx.

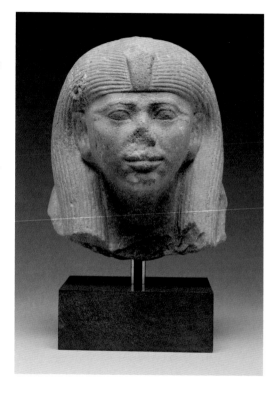

Quartzite
Said to be from Matariya
H. 27 cm, w. 24 cm, d. 22 cm
(H. 10 ⅝ in., w. 9 ⁷⁄₁₆ in., d. 8 ¹¹⁄₁₆ in.)

Partial gift of Magda Saleh and Jack A. Josephson in honor of Dr. Rita Freed, Norma-Jean Calderwood Curator of Ancient Egyptian, Nubian and Near Eastern Art and Museum purchase with funds donated by Mr. and Mrs. James M. Vaughn, Jr., The Vaughn Foundation Fund, Mr. and Mrs. John H. Valentine, Mrs. James Evans Ladd, Frank Jackson and Nancy McMahon, Meg Holmes Robbins, Mr. and Mrs. Mark R. Goldweitz, Alan and Elizabeth R. Mottur, Mr. and Mrs. Gorham L. Cross, Celia and Walter Gilbert, Clark and Jane Hinkley, Barbara and Joanne Herman, Mr. and Mrs. Miguel de Bragança, Honey Scheidt, and Margaret J. Faulkner. 2002.609

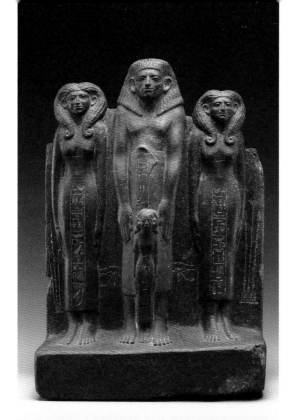

Group statue of Ukhhotep II and family
Dynasty 12, reign of Senwosret II or III, 1897–1841 B.C.

During the second half of Dynasty 12, Egyptian artists produced increasing numbers of small-scale, hard-stone statues that portrayed officials in family groups. Although it is unclear exactly why this change in customs took place, it was part of a larger trend toward shared funerary and votive objects that would continue into Dynasty 13. This finely carved statuette depicts a provincial governor, Ukhhotep II of Meir, standing between his two wives with a daughter before him. Vertical lines of text running down the center of the garments identify each of the four family members. The figures stand on a thick base and share a wide back pillar with rounded edges. The back pillar is incised on either side of Ukhhotep with protective *wadjet* eyes, and at the far ends with sedge and papyrus, the heraldic plants of Upper (southern) and Lower (northern) Egypt. When the statue stood in its original position along the

west wall of the tomb, the plants would have been positioned appropriately on the south and north respectively.

Ukhhotep and his wives are attired in wigs and clothing fashionable during the mid to late Middle Kingdom. He wears a shoulder-length wig and long, wraparound kilt. His hands rest on his thighs in a position of reverence, a pose that had already been popularized by statues of Middle Kingdom kings. His identically clothed wives wear the sheath dresses common from Old Kingdom times through the Middle Kingdom, and the heavy wigs favored by both royal and nonroyal women in the second half of Dynasty 12. The wigs featured a central part, with the hair pulled forward into lappets ending in tightly wound coils. The young girl wears a dress similar to those of the grown women, but her hair is styled in the distinctive sidelock worn by Egyptian children. The facial features of all four figures are typical of the second half of Dynasty 12, with very large, high-set ears and heavily lidded eyes. Although they display the characteristic furrowed cheeks of the period, they lack the concerned frowns found on many contemporary pieces, and instead smile contentedly.

Ukhhotep II is known from his beautifully painted rock-cut tomb to have been the local governor, or *nomarch*, of the fourteenth Upper Egyptian administrative district during the reign of Senwosret II. He probably continued to serve under the following king, Senwosret III. This statue, which once must have stood in the offering chapel of the tomb, would have functioned as a focal point for the offering cult. Paintings of the two women, who must have been favorite wives, also appear in the shrine at the back of the tomb.

Granodiorite
Meir
H. 37 cm, w. 38.1 cm, d. 7.6 cm (H. 14 9/16 in., w. 15 in., d. 3 in.)
Gift of the Egyptian Exploration Fund by exchange 1973.87

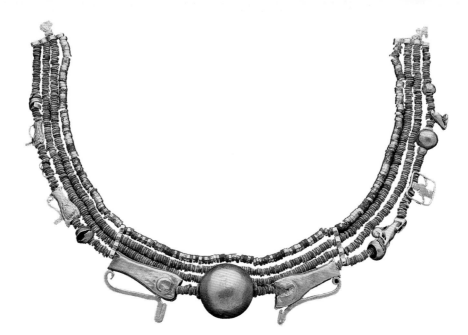

Collar with amulets

Dynasties 11–13, 2140–about 1640 B.C.

The craftsmen of the Middle Kingdom produced some of ancient Egypt's finest jewelry. Both men and women wore broadcollars, as they had in the Old Kingdom, and now amulets became an important element of their design. The central motif of this small, elegant collar, is a large, hollow gold ball bead flanked by a pair of amulets in the form of *wadjet* eyes, one of the most popular and powerful amulets for warding off potential threats. Centrally placed on each side of the main motif is an openwork amulet representing Heh (the one on the left is very small), the personification of "infinity," portrayed as a kneeling man holding the hieroglyphic symbol for "year" in each of his hands. These amulets, it was hoped, would help to ensure an infinite life in the hereafter. On the left side, the Heh amulet stands between two additional *wadjet* eyes. On the right side are a sphinx and a falcon, both emblems of the cosmic power associated with the sun god and the king. The rest of the collar consists of four rows of delicately crafted, blue-glazed disk beads linked by gold spacer beads.

Glazed steatite, gold, electrum

Sheikh Farag, tomb 43

L. 18.5 cm (L. 7 ⅜ in.)

Harvard University-Museum of Fine Arts Expedition 13.3609

Head of Amenemhat III

Dynasty 12, reign of Amenemhat III, 1844–1797 B.C.

Despite its fragmentary condition, what remains of this sculpted head of King Amenemhat III displays the distinctive and powerful style of royal portraiture from the last few reigns of Dynasty 12. By the time Amenemhat took the throne, his predecessors had consolidated and strengthened royal authority by overcoming the civil unrest of the early Middle Kingdom, reorganizing the administration of the provinces and conquering territory far to the south in Nubia. With unprecedented access to raw materials and without political distractions, Amenemhat's reign was one of great prosperity and artistic achievement.

The official image chosen by the king for his royal sculpture borrows much from that of his father,

Senwosret III, whose statues are characterized by a wise but careworn visage. Distinctive features of this style include the high cheekbones, down-turned mouth, hollows beside the nose, and bags under the eyes. In the head of Amenemhat III, the chin also tilts slightly upward and forward, conveying a defiant confidence. Amenemhat originally wore a *nemes* headdress, indicated by preserved traces of the striped lappet on his left shoulder. No trace of a broadcollar or other personal adornment remains. The face is beautifully modeled in hard graywacke, a stone once favored by Old Kingdom rulers that regained popularity in the late Middle Kingdom. The impeccably smoothed surface still retains a polish that emphasizes the line of the strong, angular features. It is uncertain where the statue originally stood, but it is likely to have been made for a temple, a common site for Middle Kingdom royal statuary. In addition to memorializing the king, temple statues allowed him to partake of the offerings of the divine cult and, by transferring these blessings to his sub-

jects, to serve as a perpetual intermediary between the divine and human realms. Like a number of important Middle Kingdom Egyptian statues in the Museum's collection, this one was discovered at the site of Kerma in Nubia, where it had been buried in a royal tumulus generations after Amenemhat III had died. How this large group of sculpture ended up at Kerma remains a mystery.

Graywacke
Sudan, Kerma, tumulus K II (Eastern Deffufa)
H. 11 cm, w. 8 cm, d. 13 cm (H. 4 in., w. 3 ⅛ in., d. 5 ⅛ in.)
Harvard University-Museum of Fine Arts Expedition 20.1213

Papyrus bundle column

Dynasty 12, 1991–1783 B.C.

The architects of Egyptian temples drew their inspiration from natural forms. They often created interior spaces in which columns modeled after Nile plants seemed to grow from the floor, painted with floral and animal motifs to evoke a marsh. This column, of which only the upper half (approximately) is preserved, was intended to represent a bundle of six papyrus stems tightly bound together just below the cluster of buds that forms the capital.

The column was discovered, along with the later column capital in the form of a fetish of the goddess Hathor (p. 173), in the Great Temple of the feline goddess Bastet at Bubastis in the Nile delta. The temple was built during the Third Intermediate Period, but papyrus bundle columns are known to date to a much earlier time, and this example was probably made in Dynasty 12. Like many elements from Middle Kingdom temples in the Nile delta, the column was originally made for another structure and was removed by a later king for use in a project of his own, probably after the earlier building had long been abandoned. The location of the original temple can no longer be identified with certainty, but recent scholarship suggests that it was probably located on the same site or nearby. The monolithic column was carved from a massive block of pink granite quarried at Aswan, some 1,126 kilometers (700 miles) south of the Nile delta. After being shaped in the quarry, the block was transported by barge to the Delta, where the final finishing would probably have taken place.

Granite
Bubastis, temple of Bastet, hypostyle hall
H. 455.8 cm, w. abacus 119 cm (H. 180⅝ in., w. abacus 47 in.)
Gift of the Egypt Exploration Fund 89.556a–b

Stela of Ameny

Late Dynasty 12 or early Dynasty 13,
1878–about 1700 B.C.

Abydos, the great sanctuary of the funerary god Osiris, was one of ancient Egypt's most sacred places. During the Middle Kingdom, officials ranging from relatively humble civil servants to the most powerful administrators in the central government commissioned monuments along the approach to the temple in the hope of achieving immortality by sharing in the benefits of the god's cult. It was most likely at that site that a police captain named Ameny dedicated this limestone stela on behalf of himself, his wife, and his parents. Its symmetrical composition suggests that it may have formed the central panel of a small shrine lined with decorated limestone slabs.

The stela is competently carved in sunk relief. The composition centers on a mat piled with offerings of meat, vegetables, and bread. Ameny sits on the left and faces right, the prominent position in Egyptian relief scenes; his wife Neferhathor sits beside him. Ameny wears a short kilt and broadcollar, along with the shoulder-length wig and short goatee fashionable among Middle Kingdom men. In his hand is a folded handkerchief, evidently a symbol of rank, that was shown in the hands of dignitaries since the time of the Old Kingdom. Neferhathor wears a long, straight sheath dress, a broadcollar, and a tripartite wig, and sits with one arm around her husband's shoulder and the other holding his arm in a gesture of affection. Facing them on the right of the stela and similarly attired are Ameny's parents, Yotsen and Nebuemmer. In the register below, four servants bearing additional offerings converge on the center of the stela. Hieroglyphic labels identify each of them: the two on the left are from Ameny's household, while the two on the right attend to Yotsen and his wife. Three lines of text at the top of the stela request offerings for both Ameny and Yotsen, invoking Osiris, lord of Abydos, and the canine funerary god Wepwawet. The content and style of the stela suggest a date late in Dynasty 12 or early in Dynasty 13. While stelae representing individual officials, sometimes with long inscriptions, were common earlier in the Middle Kingdom, the end of Dynasty 12 witnessed an increase in the popularity of stelae portraying larger groups of relatives and colleagues. The style of the figures, with their heavily lidded eyes and hollow cheeks, also places them in the late Middle Kingdom. The ornamental frieze at the top, which copies a decorative element found in tombs, is a feature that became common early in Dynasty 13.

Limestone
Probably from Abydos
H. 64 cm, w. 49.4 cm, d. 9 cm (H. 25 3/16 in., w. 19 5/16 in., d. 3 9/16 in.)
Seth Sweetser Fund 1970.630

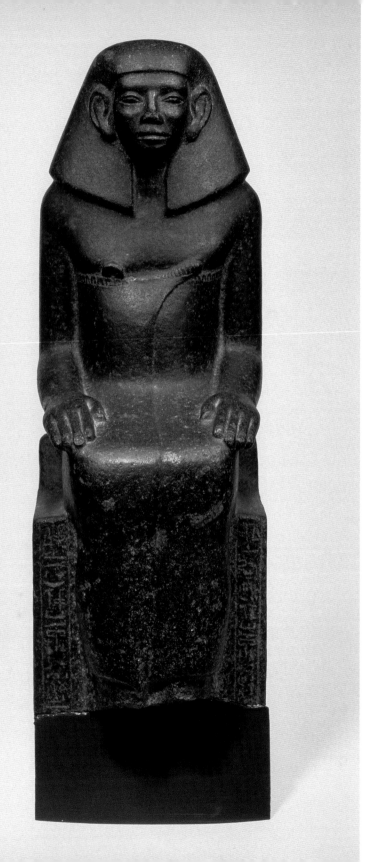

Statue of an anonymous official
Dynasty 13, 1783–about 1640 B.C.

Skillfully carved in hard, black granodiorite and polished to a high sheen, this statue of an unknown official exemplifies the high quality of nonroyal sculpture of the late Middle Kingdom. The features — a somber expression, high cheekbones, the ridge over the heavily lidded eyes, and enormous ears — do not reflect the man's actual appearance, but were inspired by those of the powerful kings Senwosret III and Amenemhat III of late Dynasty 12. The official portraiture of those kings not only was reflected in sculptures of their subjects during their own age, but also continued to influence artists for generations.

This individual sits upright with both palms open and resting flat on his lap. His long, thick wrap-around kilt, tied across his chest with the pointed ends tucked in at the top, identifies him as man of high rank. This garment, along with the heavy, shoulder-length head covering with points at the front, was fashionable male attire during the period from late Dynasty 12 through Dynasty 13. Statues of this type were made for use both in private tombs and as votive offerings in sanctuaries. Their relatively large numbers suggest a wider distribution of wealth and access to high status material among officials of the late Middle Kingdom.

Inscribed on the base of the seat is a prayer requesting offerings on behalf of the deceased from the gods Re and Anubis. Unfortunately, the text breaks off before giving the official's name, leaving his identity a mystery. Because the statue has much in common stylistically with examples from the sanctuary of the deified Old Kingdom official Heqaib at Elephantine, it is possible that it comes from that site. However, it was found along with numerous other Egyptian objects in the royal burial of a Nubian ruler at Kerma, hundreds of miles to the south of Egypt. Whether it reached Nubia as plunder or as a trade item during the unstable period at the end of the Middle Kingdom remains unknown.

Granodiorite
Sudan, Kerma, tumulus K III
H. 65 cm, w. 22 cm, d. 28.5 cm
(H. 25 ⁹/₁₆ in., w. 8 ¹¹/₁₆ in., d. 11 ¼ in.)
Harvard University-Museum of Fine Arts Expedition 14.723

Kohl jar

Dynasties 12–13, 1991–about 1640 B.C.

Obsidian, gold

H. 2.9 cm, diam. 2.9 cm

(H. 1 ⅛ in., diam. 1 ⅛ in.)

Gift of Mrs. Horace L. Mayer 1973.663

Ointment jar in the form of a goose

Dynasties 12–17, 1991–1550 B.C.

Anhydrite

L. 15 cm, w. 6.2 cm, d. 7.4 cm

(H. 5 ⅞ in., w. 2 ⁷⁄₁₆ in., d. 2 ¹⁵⁄₁₆ in.)

Gift of Horace L. Mayer 65.1749

Kohl jar with monkeys in relief

Dynasties 12–17, 1991–1550 B.C.

Anhydrite, Probably from Thebes

H. 5.5 cm, diam. 5.8 cm

(H. 2 ³⁄₁₆ in., diam. 2 ⁵⁄₁₆ in.)

John Wheelock Elliot Fund 49.1073

Cosmetics and other toiletries were highly valued by the ancient Egyptians. Both men and women wore eye makeup, which served to protect the eyes from the bright sun and from blowing sand and dust. Pigment was made either from green malachite (a type of copper ore) or from grayish black galena (lead ore) and was kept in a powdered form generically known as *kohl*. Perfumed unguents, made from oils or fats scented with flowers, herbs, spices, and resins, were prized for their rare ingredients and were used both in the daily cosmetic regimen of wealthy Egyptians and as funerary offerings to anoint the bodies of the dead.

Kohl was stored in specially made containers, frequently carved from hard stones and featuring a squat body, flat lip and rim, and a neck opening just wide enough for the insertion of a finger or kohl stick. The delicate little kohl jar on the left is clearly a luxury item, made of highly polished black obsidian, a form of volcanic glass. The rim is covered in gold leaf, and it is likely that the cover (now missing) would originally have been rimmed with gold as well.

The other two vessels are both carved from pale blue anhydrite, a stone favored by the makers of cosmetic vessels in the Middle Kingdom and Second Intermediate Period, although rarely found in contexts dating to other eras. The source of this beautiful stone remains unidentified. The kohl jar on the right, which would originally have had a lid, is decorated with monkeys in raised relief. The monkeys sit with their tails stretched out beneath them and their limbs spread wide to envelope the jar. Monkeys are frequently associated with cosmetic items as well as with erotic scenes in Egyptian art. They appear to have symbolized sexual attraction.

The larger jar, an ointment vessel, is carved in the form of a trussed goose, and is one of about a dozen such objects known. Ducks and geese were popular motifs for cosmetic vessels, spoons, and other toiletry items throughout the history of Egyptian art. Although the quality of the stone is not as fine as that of the kohl jar, the technical skill of the artist is superb. The details of the bird's head, folded wings and webbed feet are carefully rendered, and the eyes are inlaid. The yellowish tone of the head and neck are the result of natural veining in the stone.

Pair of magic wands

Probably Dynasty 13, 1783–about 1640 B.C.

Magic played a crucial role in ancient Egyptian life. It was invoked to protect both the living and the dead from potential hazards, as well as to cure illnesses and other misfortunes that had already occurred. Preserved writings, from literary tales to medical papyri, indicate that both kings and commoners sought the services of well-educated sages capable of combining the roles of advisor, physician, priest, prophet, and magician. In addition to their ability to predict and diagnose problems and their knowledge of essential spells and potions, magicians required appropriate devices for rendering the spells effective. This pair of magic wands is a rare surviving example of such a magician's tool.

The wands take the form of two-headed cobras. Serpents were believed to be capable of averting adversity, just as the uraeus cobra on the brow of the royal headdress defended the king by spitting venom at his enemies. Here, the serpents are probably meant to represent the snake goddess Weret-Hekau, known as the "One Great of Magic." Their bodies are extended into stylized, sinuous lines, while their heads rear up with outstretched hoods as if about to strike. The wands would have been held in the hand during magical rites, perhaps to protect mothers and newborns during childbirth. Similar wands appear in the hands of a figurine, now in the Manchester Museum in England, of a young, nude woman wearing a lion mask and playing the role of the protective lioness demon Beset. It is possible that such a priestess or a physician once used this pair of wands.

Egyptian magicians with serpent wands also appear in the Bible. In the story of the Exodus (Exodus 7:8–13), Pharaoh summons his wise men and sorcerers, who cast their rods on the ground, transforming them into snakes. Aaron does the same, turning his own staff into a serpent that devours those of Pharaoh's magicians.

Bronze

L. 57 cm (L. 22 7/16 in.)

Museum purchase with funds donated by Walter and Celia Gilbert 2002.31-2

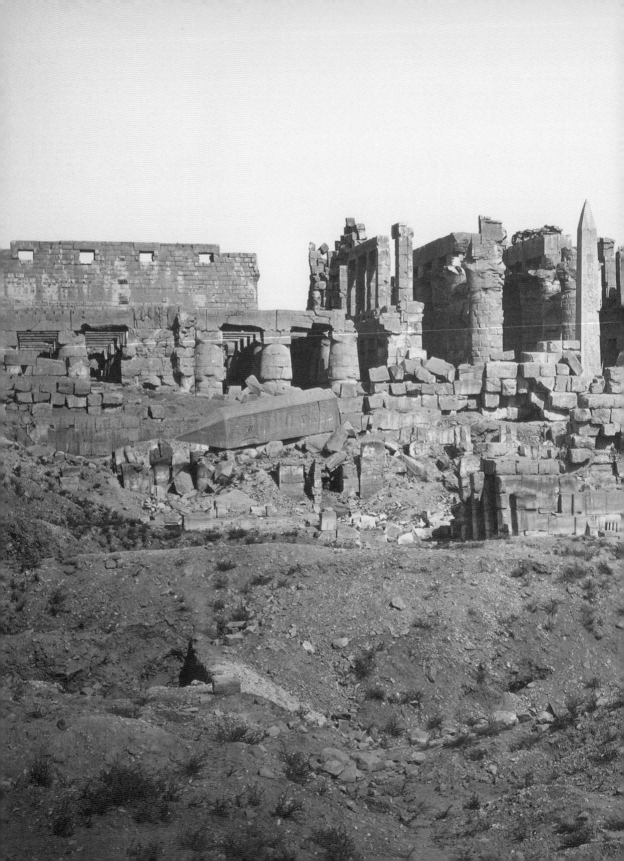

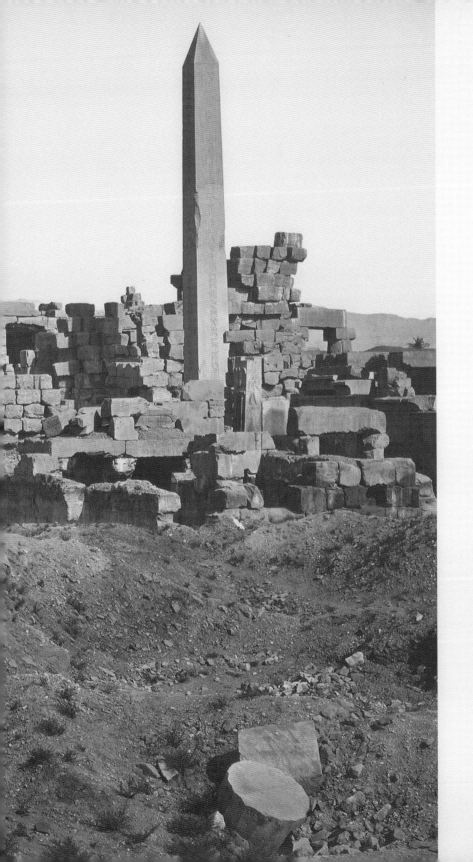

Second Intermediate Period and New Kingdom [about 1640–1070 B.C.]

About 1630 B.C., pressure from the Hyksos, a Canaanite group that had begun to expand its power base in the eastern Delta, forced the native line of kings to relocate from Itj-tawy to Thebes. The Second Intermediate Period (about 1640–1550 B.C.) began with the Theban kings of Dynasty 17, the direct successors of Dynasty 13, controlling Upper Egypt, and the Hyksos, Dynasty 15, controlling Lower and Middle Egypt. The Hyksos ruled from the mighty fortress of Avaris (Tell el-Daba) in the eastern Delta, and maintained extensive connections with the Near East and the Aegean. Meanwhile, just south of Egypt, the Nubian civilization flourished at Kerma, in northern Sudan. Sandwiched in between were the Thebans.

The New Kingdom (1550–1070 B.C.) began with a burst of energy. After years of fighting, the Theban King Ahmose drove the Hyksos out from Egypt and finally defeated them at Sharuhen (Tell el-Ajjul, in present-day Israel) some years later. His successors followed his victories, with Thutmose I and III penetrating as far as the Euphrates in the north and Kurgus (between the fourth and fifth cataracts of the Nile in present-day Sudan) in the south.

Early New Kingdom art drew its inspiration from the early Middle Kingdom. The area around Thebes abounded in imposing monuments dating back to Dynasties 11 and 12, reminders of past greatness. These served as models to imitate, and eventually, to surpass.

When Thutmose II died leaving a young son by a minor wife as heir, his widow Queen Hatshepsut took the bold step of assuming the reins of government, first as regent, then as full-fledged king beside the boy. Because kingship in ancient Egypt was a male gender role, Hatshepsut was regularly depicted as a bare-chested pharaoh on temple walls.

fig. 25 The artist who made this relief of Amenhotep I was inspired by images of Mentuhotep II carved five hundred years earlier. Relief of Amenhotep I, Dynasty 18, reign of Amenhotep I, 1525–1504 B.C., limestone, probably from Karnak, 16 x 24 cm (6 5/16 x 9 7/16 in.), John H. and Earnestine A. Payne Fund 64.1470

Hatshepsut was a great builder and patron of the arts. In addition to her funerary temple at Deir el-Bahri, one of the architectural marvels of the ancient world, she made considerable additions to the temple of Amen-Re at Karnak, directly across the river. These included a new bark shrine for the god, later dismantled (now reassembled in the Open Air Museum at Karnak), and two pair of obelisks. Fragments of one of these obelisks are now in Boston (fig. 26). Its mate, 29.7 meters tall (97½ feet) and weighing 293 metric tons (323 tons), still stands between the fourth and fifth pylons in the temple of Amen-Re.

fig. 26 **The god Amen-Re wears a double plumed crown on this corner fragment of Hatshepsut's fallen obelisk at Karnak. Obelisk fragment, Dynasty 18, reign of Hatshepsut, 1473–1458 B.C., granite, from Thebes, 86 x 122 x 74 cm (33 ⅞ x 48 1/16 x 29 ⅛ in.), Gift of Heirs of Francis Cabot Lowell 75.13**

Thutmose III spent the first twenty-two years of his reign in the shadow of his stepmother. Immediately after her death, he embarked on a series of annual military campaigns in western Asia — seventeen in all — that established his reputation as the greatest warrior pharaoh in Egyptian history. Force of arms, and an abundant supply of gold from the Eastern Desert and northern Sudan (by then firmly under Egyptian control), gave the Egyptians the upper hand in trade relations with the other great powers. Raw and manufactured goods — precious metals, horses, lapis lazuli, furniture, and cosmetic equipment — flowed in both directions. This affluence is manifest in the decorative arts of the period.

In the reign of Amenhotep III Egypt reached the acme of wealth and power. The kings of Assyria and Mittani wrote regularly to Egypt begging for gold: "Gold is like dirt in your country, one has only to scoop it up." In return, they sent their sisters and daughters as wives for Amenhotep III. But when the king of Babylon asked for an Egyptian princess in marriage, they were told that never had a daughter of Egypt been given to anyone.

With the advent of Amenhotep IV, Amenhotep III's son and successor, Egypt experienced a shock. In his sixth regnal year he changed his name from Amenhotep ("Amen is satisfied") to Akhenaten ("Serviceable to the Sun Disk"), moved to a new capital at el-Amarna, which he called Akhetaten ("Horizon of the Sun Disk"), and dedicated it to the worship of the sun disk, Aten. Elsewhere, the temples of the other gods were closed, their images destroyed, their names hacked out of the walls — even the word "gods" was expunged, for there was then no god but Aten.

Akhenaten ruled for seventeen years. Shortly after his death, his successor

Tutankhamen restored the cults of the old gods. Yet Tutankhamen received little thanks for his piety, for later rulers still associated him with the heretic Akhenaten. History forgot him until the discovery of his tomb in 1922 catapulted him to world fame.

The dominant figure in Dynasty 19 was Ramesses II, who ruled for sixty-seven years. Ramesses II left his name at nearly every site up and down the Nile. In addition to his own great monuments, he liberally inscribed his name on those of his predecessors, in effect absorbing their greatness and at the same time enhancing his own reputation. Ramesses II so overshadowed his successors that nine of them in a row were called Ramesses, but only Ramesses III, the second king of Dynasty 20, lived up to his predecessor's name by his military triumphs and impressive building campaign. The rest were content to decorate their fine tombs in the Valley of the Kings.

Lawrence M. Berman

Rishi coffin

Dynasty 17, about 1640–1550 B.C.

In Dynasty 17 a new type of coffin appeared in
Thebes: anthropoid, but no longer conceived solely as
an inner coffin, and resting on its back because of
a change in funerary customs whereby the deceased
was no longer laid on one side. The anthropoid coffin
was to become the burial container of choice among
royals and commoners alike. The earliest examples
are decorated in paint with a feather pattern, and so
they are known by the Arabic word for "feathered,"
rishi. Carved from local sycamore because the The-
bans no longer had access to imported cedar, all rishi
coffins, royal or private, show the deceased wearing
the royal *nemes* headdress. This example was clearly
a stock item made for a commoner, for a blank space
was left for the owner's name to be inserted at the
end of the vertical inscription on the lid (a conven-
tional offering formula for the dead).

 Great vulture's wings envelop the legs and lower
abdomen. Even the top of the headdress is decorated
with a feather pattern so that the deceased appears
as a human-headed bird according to the concept
of the *ba*, or mobile spirit. The *ba* could travel to any
place and transform itself into anything it desired.
The face on the coffin is painted black, not to represent
the unknown owner's race but to reinforce his identi-
fication with Osiris. The flesh of the god of death and
resurrection was often shown as black or green to sig-
nify the black silt that fertilized the land with each
year's Nile flood, and the new life in the form of green
vegetation that it brought forth. Painted on the chest
is a pectoral, or chest ornament, in the form of a vul-
ture and cobra, symbols of Nekhbet and Wadjyt, the
tutelary goddesses of Upper and Lower Egypt.

Painted sycamore
Probably from Thebes
H. 33.5 cm, l. 158 cm, w. 36 cm
(H. 13 3/16 in., l. 62 3/16 in.,
w. 14 3/16 in.)
Morris and Louise Rosenthal
Fund, Horace L. and Florence
B. Mayer Fund, Marilyn M.
Simpson Fund, William S.
Smith Fund, Egyptian Spe-
cial Purchase Fund, Frank
B. Bemis Fund 1987.490a–b

Pectoral

Dynasties 13–17, 1783–1550 B.C.

Composed of baseplates made of hammered silver sheet, with soldered and gilded silver cloisons (partitions) inlaid with carnelian and glass, this sumptuous pectoral was fit for a king. It takes the form of a vulture with outstretched wings representing the tutelary goddess of Upper Egypt, Nekhbet, grasping coils of rope, a symbol of eternity. To the left of the vulture's body is a rearing cobra. She is Wadjyt, the goddess of Lower Egypt. Together, they form a pair referred to as the "two ladies," guardian deities of the king.

The pectoral was made as a piece of funerary equipment rather than as jewelry to be worn in life. The three separate pieces representing the wings and body of the bird were not joined to one another; rather, the edges of the base plates were pierced with holes for fastening the ornament to something else, most likely the chest of the mummy or an anthropoid coffin. The wings also curve laterally, further supporting this assumption.

Gold, silver, carnelian, and glass
Possibly from Thebes
H. 11.2 cm, w. 36.5 cm (H. 4 7/16 in., w. 14 3/8 in.)
Egyptian Special Purchase Fund, William Francis Warden Fund, Florence E. and Horace L. Mayer Fund. Ex Collection Lafayette College, 1890–1981 1981.159

Sarcophagus of Queen Hatshepsut recut for her father, Thutmose I

Dynasty 18, reign of Hatshepsut, 1473–1458 B.C.

The word "sarcophagus," from the Greek *sarkophagos*, "flesh-eater," refers to a stone coffin that devoured its occupant. (Such a coffin was presumably made of limestone, because of the material's corrosive action on flesh.) Although the very notion of a container that would devour the body inside it would have horrified the ancient Egyptians, we use the term "sarcophagus" today to refer to coffins of stone as opposed to wood. The Egyptians used a happier name, "lord of life," because it was meant to protect and preserve the body forever.

The kings of Dynasty 18 were buried in magnificent hard stone sarcophagi of quartzite or red granite. Because of their ruddy hues, these stones were associated with the sun, ultimate symbol of rebirth, and were thus particularly well suited for the rulers' journey to the next world. To intensify the color, a coat of red paint was often applied to the surface of the stone, filling in the hieroglyphs and outlines of the figures.

This Eighteenth-Dynasty royal sarcophagus is the only one outside of Egypt. It was the second of three quartzite sarcophagi made for the queen turned pharaoh, Hatshepsut. After she assumed control of the throne, she commissioned a tomb in the Valley of the Kings and ordered this sarcophagus to be made for it. Later, however, Hatshepsut decided to transfer

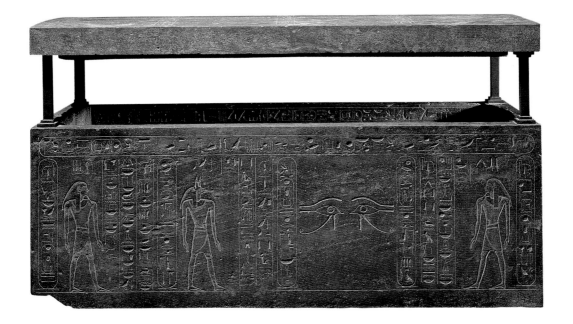

her father's mummy from his tomb to hers, and ordered her coffin to be retrofitted for him. The original inscriptions were altered to reflect the new recipient, Thutmose I. His name was substituted for hers, feminine pronouns changed to masculine, and new inscriptions added. This pious act of filial devotion is commemorated in an inscription on the outer right side of the sarcophagus: "She [Hatshepsut] made it as her monument for her beloved father, the good god, lord of the Two Lands, king of Upper and Lower Egypt Aakheperkara, the son of Re, Thutmose, vindicated." At the last minute, it was discovered that the sarcophagus was too small for Thutmose I's mummy, still in its original wooden coffin. Therefore, the insides of the box had to be cut back to receive it.

Thebes, Valley of the Kings, tomb KV 20
Painted quartzite
H. 82 cm, l. 225 cm, w. 87 cm
(H. 32 ⁵⁄₁₆ in., l. 88 ⁹⁄₁₆ in., w. 34 ¼ in.)
Gift of Theodore M. Davis 04.278

Figure vase in the form of a woman and child
Mid-Dynasty 18, late reign of Thutmose III to early reign of Amenhotep III, 1435–1380 B.C.

This delightful little bottle takes the form of a kneeling woman, holding a child about to nurse in her lap. A consummate example of the potter's craft, the bottle was made in several parts, probably using molds, with incised details added later. The entire vessel was then covered with a reddish brown slip or wash and was heavily burnished, skillfully concealing the joins. The small size, fanciful shape, and distinctive reddish brown color identify this bottle as one of a select group of pottery containers known as figure vases. The category includes other figural vessels in the shape of a standing woman carrying a basket or playing a lute, or with necks in the form of a woman's head, as well as vessels in the form of wildlife such as fish, grasshoppers, hedgehogs, or reclining ibexes with fawns. Another related group cleverly imitates leather bags or stone vessels. Figure vases are fairly restricted in date to a period of some forty years at most, from the end of the reign of Thutmose III to the beginning of the reign of Amenhotep III.

Nursing-woman vases form a distinct subgroup of figure vases. Other known examples are so similar to Boston's in size and composition that they all must have been made by the same potters using the same molds. Their small size and narrow mouths suggest that they were meant to contain some precious, perishable substance such as a cosmetic or medicine, perhaps even mother's milk. Mother's milk was used in ancient Egypt as an ingredient in various medical prescriptions, not all of them pediatric. The vessel's capacity is roughly equal to the amount a single breast produces at one feeding.

The subject of this bottle, so evocative of Isis and Horus, may have held a reassuring message in any of a number of contexts, funerary or otherwise. As the son of Isis and Osiris, Horus was the rightful heir to Egypt's throne. To hide him from his jealous uncle Seth, Isis took the infant Horus to the Delta marshes, shielding him with her magic from snakes and scorpions. Isis therefore became in the Egyptian consciousness the archetypal protective mother.

Red polished clay
H. 14 cm, w. 5.3 cm, d. 8 cm (H. 5 ½ in., w. 2 ¹⁄₁₆ in., d. 3 ¹⁄₈ in.)
Frank M. Bemis Fund 1985.336

Marsh bowl

Dynasty 18, 1550–1295 B.C.

The marsh scene painted on the interior surface of this shallow bowl is perfectly adapted to its shape. The bowl is a pool: six curving stems with lotus buds radiate pinwheel-like from a central square, with four tilapia passing over and partly overlapping them to create a sense of depth. Three of the fish have other lotus stems issuing forth from their mouths; these also terminate in buds that float up to the vessel's rim to join the others.

In ancient Egyptian art no motif is too modest to be innocent of ritual symbolism. And so it is with this shallow bowl, for in Egyptian mythology, the marsh was the seething hotbed of creation. The blue lotus, whose flowers open from sunrise through midday and close at night, was closely associated with the sun's rebirth each morning. The tilapia was a symbol of fertility and rebirth since Predynastic times, based no doubt on the creature's remarkable habit of taking its newly hatched young into its mouth for shelter. The young fish appear to emerge from the parent's mouth as though newly born, a phenomenon the Egyptians interpreted as spontaneous generation. This recalled the god Atum, whose own act of spontaneous generation initiated the creation of the Egyptian universe. The waters in which the fish swim are those of the boundless, life-giving Nun, the primeval ocean, while the central square motif is the primeval mound that rose above these waters.

Such marsh bowls were not made as tableware. Many pottery fragments with marshland imagery have been found at temples and shrines dedicated to the goddess Hathor, who was associated with sex, love, motherhood, fertility, and rebirth. Less frequently, the bowls have been found as tomb gifts.

Given the intact condition of this bowl, it probably came from a tomb, where objects often survived best. The tombs from which such marsh bowls have been excavated belonged to nonroyal and mostly female persons. In a burial context, the fertility imagery on the bowls was meant to facilitate the tomb owner's rebirth.

Faience
H. 3.8 cm, diam. 15.7 cm (H. 1½ in., diam. 6³/₁₆ in.)
William E. Nickerson Fund 1977.619

Loincloth of Maiherpra

Dynasty 18, probably reign of Thutmose IV, 1400–1390 B.C.

Although primarily reserved for kings, the royal valley also sheltered the tombs of especially favored commoners. One of these tombs belonged to the "fanbearer on the king's right" and "child of the inner palace," Maiherpra. These titles indicate that he grew up in the palace and was a personal attendant of the king. Maiherpra's tomb was discovered in 1899 with two sets of coffins, Maiherpra's mummy, and a beautifully illustrated *Book of the Dead*, all now in Cairo. Three years later, another find was made in a hollow in the rock over the tomb: a small wooden box, painted yellow with hieroglyphic inscriptions in blue paint naming Maiherpra. The box contained two garments, each made of a single gazelle skin. One of these was presented to the Field Museum of Natural History in Chicago, from which it was later stolen. The other, along with the box, is now in Boston. A remarkable piece of work, the entire gazelle skin (except for the border and a horizontal patch of leather left plain near the top) was made into a fine mesh by cutting it with staggered rows of tiny incisions, about forty to the inch, and then pulling the skin out to expand it. The resulting garment would have been light, breezy, and flexible when worn.

This garment was the source of much hopeful speculation when it was presented to the Museum in 1903, as its function was misunderstood. Its shape reminded students of Biblical archaeology of the *ephod*, described in the Old Testament (Exodus 28: 6–12) as the ceremonial vestment of the Israelite high priest, and for many years thereafter it was vaunted as the only surviving example. As an *ephod*, it would have been worn like an apron, just as described in the Bible. But it is unquestionably a loincloth. Leather loincloths are often depicted in New Kingdom tomb paintings, and so we know how they were worn. The top would have been tied around the waist with the patch covering the buttocks, the rounded lower portion pulled up between the legs and tied in front. Most often such loincloths are associated with soldiers and Nubians. Therefore it should come as no surprise that Maiherpra himself was both a soldier and a Nubian: his name means "lion on the battlefield."

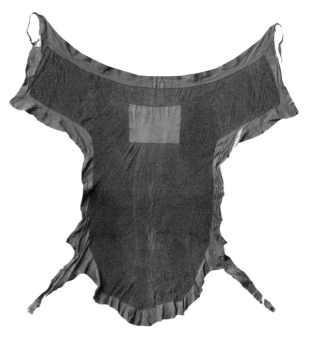

Gazelle skin

Thebes, Valley of the Kings, rock above tomb KV 36

H. 85 cm, w. 89 cm (H. 33 7/16 in., w. 35 1/16 in.)

Gift of Theodore M. Davis 03.1035

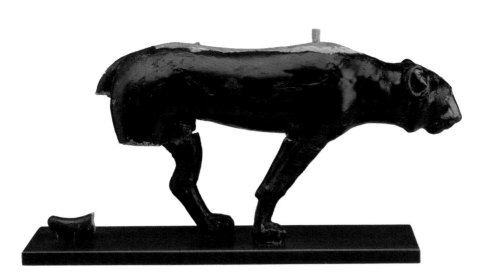

Leopard of Thutmose IV
Dynasty 18, reign of Thutmose IV, 1400–1390 B.C.

The Egyptians always excelled at animal sculpture. This leopard from the tomb of Thutmose IV is wonderfully naturalistic, striding stealthily forward, left paws advanced, neck craning ahead, head lowered. Its long tail trails gracefully behind, curving up at the tip. Its skin is not spotted, but black. Because black was the color of the fertile Nile silt and thus held the promise of resurrection, artisans liberally slathered black bitumen over all types of funerary equipment for the material's symbolic value as well as for its preservative properties.

Made of six pieces of wood joined together — the body, the four legs, and the tail — along with inlaid eyes that are now lost, the animal has two rectangular mortises on its back for the insertion of tenons. The leopard, therefore, did not stand alone, but was part of a group composition. From similar sculptures found intact in the tomb of Tutankhamen and from painted images, we know that each leopard carried on its back a striding figure of the king. Wrapped in linen shawls and stored in black wooden shrines, such sculptural groups appear to have been standard items of New Kingdom royal funerary equipment.

The leopard was not the king's adversary, but rather his hunting companion and escort. In ancient times, the wild leopard had a much wider distribution than it does now; it inhabited most of Egypt and was at home in both the desert and wetlands. Moving between two worlds as a liminal being, it was a fitting escort for the deceased. Both marsh and desert were perceived as battle zones, no-man's lands between the world of the living and the world of the dead. The passage through these unknown regions was full of obstacles, manifested in the wild and dangerous animals that needed to be overcome by the king and his leopard working side by side in the battle between good and evil.

In another interpretation, the leopard was an ancient sky goddess, her pelt studded with stars straddling the nocturnal horizon. This notion ties the animal in with the solar circuit, the king's vehicle across the heavens (like the solar boat) that protected him along the way and ensured his safe journey.

Wood covered with bitumen
Thebes, Valley of the Kings, tomb KV 43
H. 32.5 cm, l. 67 cm, w. 12.5 cm
(H. 12 ¹³⁄₁₆ in., l. 26 ³⁄₈ in., w. 4 ⁵⁄₁₆ in.)
Gift of Theodore M. Davis 03.1137a–b

Head of Amenhotep III

Dynasty 18, reign of Amenhotep III, 1390–1352 B.C.

Egypt in the reign of Amenhotep III was at the pinnacle of wealth and splendor, and the king was able to carry out a building program of unparalleled breadth and scope. Temples were erected up and down the Nile according to an organized and well thought-out plan, and these buildings were populated with thousands of statues of the king, large and small, in a variety of materials. This head, from a complete standing figure, is very fine and of the choicest material — quartzite — the stone the Egyptians called "wondrous."

Even though the sculpture is uninscribed, there is no mistaking its identity, for it captures Amenhotep III's exotic features to perfection. He has long, narrow, almond-shaped eyes, their length extended by makeup lines, paralleled by the equally long, sweeping curves of his cosmetically enhanced eyebrows. His mouth is wide and voluptuous, with thick lips

(the upper lip thicker than the lower). Not a line or blemish disturbs the Buddha-like serenity of his expression; there is not the slightest tension. When complete, the statue would have stood at least 182.9 centimeters tall (six feet), excluding the base. The tall crown would have had a knob at the top, as on the triad of Menkaure, Hathor, and the Hare nome (pp. 83–85). Enough remains to show that the king wore the long, plaited beard of a god, with a turned-up end. In all probaility this was an Osiride statue, showing the king standing, arms crossed, feet together, in the same mummiform pose as Mentuhotep III as Osiris (p. 115). To the ancient Egyptians, there was nothing inherently funereal about this pose; rather, it contained the promise of resurrection, for in a moment, the mummy would emerge from his wrappings, reborn, no longer motionless but free to move about as he desired. This type of statue was particularly appropriate for kings' funerary temples, their "mansions of millions of years," and indeed fragments of similar statues have been found at Amenhotep III's funerary temple at Kom el-Hetan, Thebes, where quartzite was lavishly employed.

Quartzite
Possibly from Thebes, Kom el-Hetan
H. 52.5 cm, w. 21.2 cm, d. 26.2 cm
(H. 20¹¹/₁₆ in., w. 8⅜ in., d. 10⁵/₁₆ in.)
Gift of Anna B. Slocum 09.288

Kneeling Amenhotep III as the god Neferhotep
Dynasty 18, reign of Amenhotep III, 1390–1352 B.C.

There is more to this charming statuette of Amenhotep III than meets the eye. The king is wide-eyed, innocent-looking, and decidedly chubby, his bare chest revealing his baby fat. But despite his youthful appearance, Amenhotep III was no child when this statue was created, for it is one of a number of closely related statuettes made in celebration of the king's thirty-year jubilee. Thirty years symbolized a generation, and during the celebration of the jubilee, the king was born again. Amenhotep III would have been at least in his forties at the time, but he appears as a child in token of his spiritual rebirth. The inscription on the back of the statuette calls Amenhotep III, "the son of Isis, who dwells in Edfu," so presumably the figure was placed in the temple of Edfu as an offering to Isis. True to his name, the king kneels to present an offering, now lost, to his mother.

The statuette's distinctive headdress — a round curly wig with uraeus, surmounted by the Double Crown of Upper and Lower Egypt — identifies the ruler with the child god Neferhotep. The crowns were meant to confer stability, while implicit in any child god is the prospect of a new beginning full of promise. The statuette is thus a visual pun, and even the color added to its symbolism. Originally, the figure was glazed a lustrous blue-green, now almost entirely worn away. In ancient Egypt as today, to be green meant to be young; in ancient Egyptian, the words for "green" and "to be young," *renput* and *renpy*, had the same root. Additional meaning is provided by the word for glazed material, *tjehenet*, "dazzling, luminous," which was also applied to sunlight, and by extension, to gold. In this image of himself as the child god Neferhotep, Amenhotep III — who liked to call himself the "dazzling sun-disk of all lands" — found the perfect form of self-expression.

Glazed steatite
H. 13 cm, w. 3.8 cm, d. 5.3 cm (H. 5 ⅛ in., w. 1 ½ in., d. 2 1/16 in.)
Gift of Mrs. H. L. Mayer 1970.636

Head of Queen Tiye
Dynasty 18, reign of Amenhotep III, 1390–1352 B.C.

By the second year of his reign, Amenhotep III was married to his "great royal wife," Queen Tiye. We know more about Tiye than we do about any other Eighteenth-Dynasty queen with the exception of Hatshepsut who ruled as pharaoh. The names of Tiye's parents, both commoners, were proclaimed far and wide on a series of large commemorative scarabs and circulated throughout the empire — an unheard-of practice. No previous queen figured so prominently in her husband's lifetime.

Just as many images of Amenhotep III show him as a god (see pp. 152–53), this head of Queen Tiye shows her as a goddess. The attributes of the goddess Hathor — cow horns and sun disks — on her headdress emphasize her role as the king's divine, as well as earthly, partner. She even has the king's facial features. In contrast, the large enveloping wig, encircled by a floral wreath and a band of rosettes, is not a conventional goddess's hairdo but that of a contemporary lady of fashion. The combination of divine and queenly attributes intentionally blurs the lines between deity and mortal ruler.

The head was acquired in the Sudan and is carved of Sudanese stone. It very likely comes from Amenhotep III's temple to his queen at Sedeinga in northern Sudan, where Tiye was worshipped as a form of Hathor. Her memory survives there today in the name of the neighboring village, which is locally known as Adey, from *Hut Tiye*, "the mansion of Tiye." The temple at Sedeinga was the pendant to Amenhotep III's own, larger temple at Soleb, about 14.5 kilometers (9 miles) to the south. Indeed, the emphasis on the queen's role as the king's divine female counterpart provided the model for Nefertiti in the reign of Amenhotep IV (Akhenaten) and anticipated the divine queens of the Ptolemaic Dynasty.

Peridotite
Sudan, Dongola Province,
probably from Sedeinga
H. 20.3 cm, w. 11.5 cm, d. 12 cm (H. 8 in., w. 4 ½ in., d. 4 ¾ in.)
Harvard University-Museum of Fine Arts Expedition 21.2802

Horus the Nekhenite
Dynasty 18, reign of Amenhotep III, 1390–1352 B.C.

One of the most striking examples of large animal sculpture known from ancient Egypt, this divine falcon is also exceptionally well traveled. It was made for Amenhotep III's temple at Soleb in the Sudan, in celebration of his jubilee. Seven centuries later, long after the temple and its cult had fallen into disuse, King Piye (743–712 B.C.) removed this sculpture, along with others, to adorn the newly renovated temple of Amen at Gebel Barkal farther south. There they were seen by early nineteenth-century travelers from Europe and the United States. John Lowell of Boston stopped at Gebel Barkal in 1835 and described in detail the lower part of a statue similar to this one. Although he noted the fine workmanship, he had no idea what it was. Lacking its head, there was no

means of telling the front from the back, so it resembled nothing so much as a human foot. "What animal or monster, or instrument it may have supported, one searches in vain to divine," Lowell wrote. Nine years later, in 1844, the "foot-shaped mass" was taken to Berlin by German Egyptologist Carl Richard Lepsius, who knew exactly what it was.

Little could Lowell know that lying in pieces just beneath his feet was the companion to the fragment now in Berlin. In 1916 the Harvard University-Museum of Fine Arts Expedition began work at Gebel Barkal, where in 1919 the excavators found two large and several smaller fragments stashed in a pit among the debris of the temple's second court, just opposite the spot in which the Berlin falcon had stood. Fortunately, the fragments included the falcon's head. It is easy to see why Lowell was confused, for this is not a statue of a falcon as it appears in nature, but a wrapped and mummified emblem of a falcon borne aloft on a standard. Carved in relief on the sides of the base are the carrying pole, supporting strut, and horizontal platform on which the image rests. The inscription calls the falcon Nekheny, "the Nekhenite," after the Upper Egyptian site of Nekhen, one of Egypt's oldest cities and the cradle of its monarchy. Early on, this falcon deity merged with another, the sun and sky god Horus, to form Horus the Nekhenite. His cult remained closely associated with the kingship ever after.

Granodiorite
Sudan, Gebel Barkal, originally from Soleb
H. 172 cm, w. 52.5 cm, d. 105 cm
(H. 67 ¹⁄₁₆ in., w. 20¹¹⁄₁₆ in., d. 41⁵⁄₁₆ in.)
Harvard University-Museum of Fine Arts Expedition 23.1470

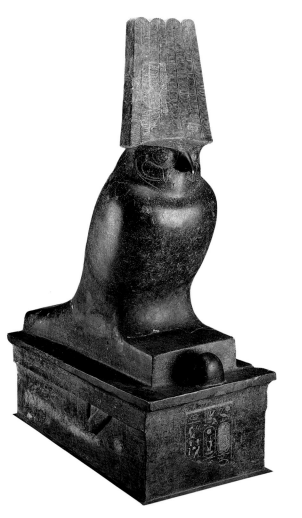

fig. 27 Charles Gleyre, Swiss, active in France, 1806–1874, *Gebel el Barkal*, broken pedestal in great temple, 1835, pencil on paper, 28.4 x 23.5 cm (11³⁄₁₆ x 9¹⁄₄ in.), Lowell Collection.

**Detail of north wall
of burial chamber of Sobekmose**
Dynasty 18, reign of Amenhotep III, 1390–1352 B.C.

To realize his ambitious plans, Amenhotep III could count on a group of able officials. One of these was the treasurer Sobekmose, whose tomb was discovered in 1908 at el-Rizeiqat, south of Luxor. As was the case with most tombs, there was a chapel above ground and a burial chamber in the rock below. However, the walls of the burial chamber were lined with sandstone blocks, an unusual material, particularly at el-Rizeiqat, which is well north of where sandstone was quarried. The burial chamber normally would have been cut in the bedrock and, because of the poor and crumbly quality of the local limestone, lined with brick. Sobekmose, however, was in a good position to obtain stone from afar. As treasurer, he was responsible for mining and quarrying operations in general, and in addition, inscriptions in his burial chamber tell us that Sobekmose was involved in the construction of Luxor Temple, which was built entirely of sandstone.

The scene illustrated here shows Sobekmose's funeral procession. This piece comes from the north wall of his burial chamber, so appropriately the procession would have moved west, in the direction of the cemetery. Leading the procession are two female mourners, beating their breasts in token of their grief. Labeled "the two kites," they impersonate Isis and Nephthys, sisters of the murdered Osiris. Following them are seven men grasping the towrope of a boat. They represent the gods who would drag the boat of the sun god Re across the sky by day and through the netherworld by night. But as Sobekmose's boat had to cross dry land, it was equipped with sledge runners. On deck is a shrine with a sloping roof, and inside, Anubis, the jackal-headed god of embalming, tends to the mummy of Sobekmose. Across the top of the scene is an excerpt from spell 130 of the *Book of the Dead*, "for enabling a spirit to embark on the boat of Re and his retinue":

Open, sky. Open, earth. Open, west. Open, east. Open, shrines of Upper and Lower Egypt. Open, doors, open, gates, to Re that he may go forth from the horizon. Open to him, doors of the day bark, open to him, gates of the night bark.... Do not stand in the way of the Osiris, the treasurer Sobekmose.

Sandstone
El-Rizeiqat
H. 172 cm, w. 316 cm (H. 67 11/16 in., w. 124 7/16 in.)
Acquired by exchange with the Metropolitan Museum of Art, New York 54.648

Painted limestone
El-Amarna, found at Hermopolis
Upper block: H. 23.9 cm, w. 54 cm, d. 3.5 cm
(H. 9 ⁷⁄₁₆ in., w. 21 ¼ in., d. 1 ⅜ in.)
Egyptian Curator's Fund 64.52
Lower block: H. 23.4 cm, w. 53.1 cm, d. 3.6 cm
(H. 9 ³⁄₁₆ in., w. 20⅞ in., d. 1 ⁷⁄₁₆ in.)
Helen and Alice Colburn Fund 63.260

River scene with royal barges
Dynasty 18, reign of Akhenaten,
1352–1336 B.C.

The Nile was Egypt's great artery, and river pageants formed an important part of ceremonial life. Depicted on these two adjoining blocks are two royal barges. The barge on the right may be identified as Nefertiti's by the two long steering oars that terminate in finials carved with her portrait. The queen wears the tall, flat-topped crown designed especially for her, surmounted by a sun disk and ostrich plumes.

On the walls of the kiosk at the stern of the boat is a scene unprecedented in Egyptian art. There, beneath the radiant Aten, Nefertiti appears in the age-old pose traditionally reserved for kings, that of smiting a foreign enemy. Her enemy is female—another departure from tradition. The king himself appears in a complementary scene partially preserved on the barge on the left, where the victim is male. Not again until the Meroitic Period in Nubia, thirteen hundred years later, does the queen appear in this pose.

Relief of Akhenaten as a sphinx
Dynasty 18, reign of Akhenaten, 1352–1336 B.C.

Although Akhenaten's religious reforms purged Egyptian art of many of its most familiar manifestations, the king remained fond of the sphinx and often had himself depicted as that fantastic creature—part man, part lion. In Old Kingdom times, the Great Sphinx at Giza probably stood for the king presenting offerings to the sun god, while in the Eighteenth Dynasty the mighty monument was reinterpreted as the sun god Horemakhet, or Horus in the Horizon. Its impeccable solar credentials therefore made the sphinx an appropriate image for Akhenaten at el-Amarna, the city he called Akhetaten, "Horizon of the Sun Disk."

This relief was one of a pair flanking a temple doorway. The sphinx on it rests on a plinth, suggesting that it represents a statue. A pair of such reliefs flanking the doorway of a small temple would have evoked the grand avenues of sphinxes that traditionally led up to the entrance pylons of larger Egyptian sanctuaries (see fig. 28). Here the sphinx is equipped with human arms and hands to enable him to make offerings to his god, the sun disk, Aten, who

appears at the upper left. He wears the uraeus of king-
ship while behind him (to the left) are two cartouches
containing his lengthy official name. The sun's life-
giving rays end in so many hands, some holding ankh-
signs. Below are three offering stands. To the right,
Akhenaten as sphinx raises one hand in adoration
while in the other he holds a *neb* sign, a basket signi-
fying lordship, holding Aten's cartouches. These same
cartouches appear a third time in the upper right
where they are joined with the cartouches of Akhen-
aten and Queen Nefertiti, who is thus present in
name if not in image. The rest of the inscription
describes the "great, living Aten" as "dwelling in the
Sunshade temple [called] Creator of the Horizon
[which is] in Akhetaten." The temple named here, yet
to be located, must be the one for which this block
was carved.

Akhenaten's religious revolution was accompa-
nied by a change in the way pharaoh was depicted,
showing a marked departure from the idealized
images favored by his predecessors. Even though the
king's face has been sadly hacked away, one can still
discern his characteristic slanted eyes, long nose, hol-
low cheeks, drooping lower lip, and pendulous chin.

Limestone
Probably from el-Amarna
H. 51 cm, w. 105.5 cm, d. 5.2 cm
(H. 20 ⅛ in., w. 41 ⁹⁄₁₆ in., d. 2 ⅛ in.)
Egyptian Curator's Fund 64.1944

fig. 28 Luxor Temple, entrance pylon and alleyway of
sphinxes, Dynasty 18, reign of Amenhotep III,
1390–1252 B.C. (sphinxes), and Dynasty 19, reign of
Ramesses II, 1279–1213 B.C. (pylon). Photo: John G. Ross

Dwarf holding a jar
New Kingdom, Dynasty 18, reign of Akhenaten,
1352–1336 B.C.

Whereas monumental sculpture in Egypt was more or less restricted to a certain number of well-established types destined for tomb and temple, objects of daily life afforded more opportunity for invention. This exquisite cosmetic container is in the form of a dwarf balancing the weight of a huge storage jar nearly half his size. A moment is frozen in time as his whole body adjusts to accommodate the load. Minuscule hieroglyphs on the shoulder of the jar spell out the names of Akhenaten and Nefertiti, indicating that the object was probably a royal gift to some favored courtier. Amenhotep III gave similar presents — in one case, he sent to the king of Babylon "one cripple, of stone, with a jar in his hand," evidently as a prize example of Egyptian workmanship.

 The cosmopolitan high society of Dynasty 18 was fond of luxury goods and able to afford them. Expensive cosmetics and lotions were enjoyed by both sexes and kept in specialized small containers. Whimsical containers in the form of a servant carrying a vessel were particularly in vogue during the reigns of Amenhotep III and Akhenaten. The bearers range from svelte young serving girls to wizened old menservants.

Boxwood
Possibly from el-Amarna
H. 5.9 cm, w. 1.8 cm, d. 2.6 cm (H. 2⁵⁄₁₆ in., w ¹¹⁄₁₆ in., d. 1 in.)
Helen and Alice Colburn Fund 48.296

Amphora with lid
Dynasty 18, 1550–1295 B.C.

In the late Eighteenth Dynasty a new type of painted pottery was introduced, characterized by the use of cobalt blue. Because many examples have been found at the residences of Amenhotep III and Akhenaten at Thebes and el-Amarna, it is sometimes known as palace ware. This jar is particularly large and ornate with painted, incised, and applied decoration. The volute handles, resembling those on later Greek vases, are unusual in Egyptian art and may be attributed to foreign influence. The jar has a distinct front and back and was probably intended primarily for display in a niche, although it also could have served as a wine jar on festive occasions. The lid is crowned with a recumbent calf while grapes hang below the rim. On the vessel's shoulder, a newborn ibex struggles to rise, its head raised up proudly to confront the viewer. Implicit in the young animals is the message of rejuvenation and rebirth.

Nile silt ware
H. 62 cm, diam. of rim 21 cm
(H. 24⁷⁄₁₆ in., diam. of rim 8¼ in.)
J. H. and E. A. Payne Fund 64.9

Head of King Tutankhamen
Dynasty 18, reign of Tutankhamen,
1336–1327 B.C.

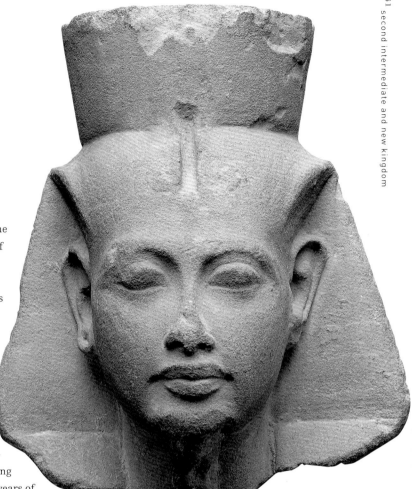

In 1922, Howard Carter discovered the tomb of Tutankhamen in the Valley of the Kings at Thebes. The smallest of the royal tombs, it was the only one that preserved its fabulous treasures virtually intact, the king's mummy resting undisturbed in its four coffins and four shrines nested one inside the other. Despite the unprecedented media coverage lavished on this sensational discovery, Tutankhamen remains a mysterious figure. He was probably born at el-Amarna, the new capital city built by Akhenaten. Succeeding to the throne as a boy of nine or ten years of age, Tutankhamen was taken in hand by the traditionalist clergy and made to repudiate Akhenaten's religious reforms. He abandoned el-Amarna, reopened the other temples, and showered attention on the old gods. He received little thanks for his piety, however, for later rulers continued to associate him with the heretic Akhenaten. His memory was suppressed, and his statues were appropriated by other rulers, notably Horemheb. When he was remembered at all, it was as a minor ruler. No wonder his tomb treasures caused such a sensation. So familiar are the "boy king's" gentle features now, that one immediately recognizes a sculpture as his even if it had been usurped by a later ruler or, as here, lacks an inscription. Traces of paint show that the *nemes* headdress was striped alternately blue and yellow as on the famous gold mask from his tomb.

Sandstone
H. 29.6 cm, w. 26.5 cm
(H. 11 ⁵⁄₈ in., w. 10 ⁷⁄₁₆ in.)
Gift of Miss Mary S. Ames 11.1533

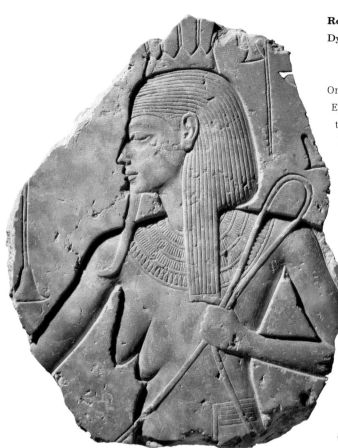

Relief from a throne base
Dynasty 18, reign of Ay, 1327–1323 B.C.

One of the classic symbolic motifs from ancient Egypt is the "unification of the two lands," in which the gods of the two halves of the country tie the heraldic plants of Upper and Lower Egypt — the sedge of the south and the papyrus of the north — around the hieroglyph for "unite," a tall narrow sign representing the lungs and windpipe of a mammal. Paunchy, androgynous, and with pendulous breasts, these figures are the embodiment of the bounty made possible by the Nile's annual flood. Because the scene symbolized the unity brought about under the king's rule, it was often used to decorate the base of his throne.

This handsome fragment of sunk relief once adorned the base of the throne of a colossal seated statue of King Ay, who ruled briefly as Tutankhamen's successor. The figure depicted here is Lower Egypt, identified by the clump of papyrus (the lower part of the hieroglyph for Lower Egypt) on top of the head, and the upside-down papyrus umbel by the right arm. Its counterpart, with the personification of Upper Egypt, was excavated by the Oriental Institute of the University of Chicago in Ay's mortuary temple at Medinet Habu, Thebes. Left unfinished at his death, Ay's mortuary temple and its statuary were taken over and completed by King Horemheb.

Limestone
Thebes, Medinet Habu, mortuary temple
of Kings Ay and Horemheb
H. 45.5 cm, w. 36.5 cm (H. 17 ¹⁵⁄₁₆ in., w. 14 ³⁄₈ in.)
Gift of Edward W. Forbes 50.3789

Head and shoulders

from a colossal statue of Ramesses II

Dynasty 19, reign of Ramesses II, 1279–1213 B.C.

Ramesses II, also known as Ramesses the Great, ruled for sixty-seven years. Early in his reign he distinguished himself in battle, but he is best known as having been a builder and patron of the arts. Innumerable buildings and statues, such as his mortuary temple in western Thebes (the Ramesseum), the Great Hypostyle Hall at Karnak (which he completed), and above all, the famed rock-cut temple at Abu Simbel with its four colossal seated figures of the king, attest to his taste for gargantuan display.

Ramesses' penchant for grandeur is well represented by this colossal bust of the king in red granite. Large as it is now, it is only a fragment. The complete statue was three times bigger, about nine feet tall. Enough remains to show that the king was represented standing, holding a pole or standard topped with an image of a deity along his left side. This type of statue first appeared in the reign of Amenemhat III but was most fashionable under Dynasties 19 and 20.

This great statue did not stand alone, but was part of an ensemble. Found with it were fragments of three others now in Cairo, London, and Berlin. Such large statues are inconceivable without an architectural framework, and indeed they were commissioned as part of the building program of a temple. They were not to be viewed in isolation, but rather were arranged around a great courtyard or along a processional way.

Granite was a precious commodity in the Delta, and colossal statues like this one were highly prized. When a temple was remodeled, the statues were readapted to the new space. Sometimes they traveled. It is possible that this statue and its companions originally stood in Ramesses II's Delta capital at Qantir and were taken to Bubastis only in Dynasty 22. Great state temples were like museums, populated with statues of different periods. Today, Bubastis is a field of ruins. Its surviving fragments enable us to form an idea of its former grandeur.

Granite
Bubastis, temple of Bastet, first hall
H. 137 cm, w. 72.5 cm (H. 53 ¹⁵⁄₁₆ in., w. 28 ⁹⁄₁₆ in.)
Gift of the Egypt Exploration Fund 89.558

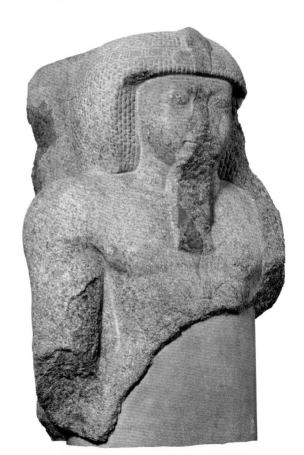

Block statue of Prince Mentuherkhepeshef
Dynasty 19, reign of Ramesses II, 1279–1213 B.C.

During his long reign Ramesses II had ample time and opportunity to father over a hundred children. They appear in procession on temple walls, always the same, in the order of their birth. Mentuherkhepeshef, the prince represented here, was Ramesses II's fifth son.

The prince sits on a high base with his legs drawn up to shoulder level and his arms crossed over his knees. His body is enveloped in a long mantle, from which only his head and hands emerge, so that the figure approximates a block or cube. The elegance and plasticity of the modeling subtly indicating the contours of the body belie the hardness of the stone. Most block statues were made for placement in temples rather than tombs; their compact form helped guard against breakage.

A closer inspection reveals that the statue has been reworked. The hieroglyphic inscriptions are clearly a later addition: the glossy smooth sides of the statue were abraded to receive the text. Also, what was originally a round headdress was recarved to represent the sidelock of youth, a mark of princely status. Either Mentuherkhepeshef usurped the statue from another individual, or else he himself revamped and updated it, perhaps to represent a change in his status.

Of Mentuherkhepeshef's life we know little except that he was an army man — his titles include "officer for horses of the lord of the two lands [the king]" and "first charioteer of his father." Mentuherkhepeshef never became king, for he and many of his brothers died before they could claim the throne. That lot fell to Merenptah, Ramesses' thirteenth son.

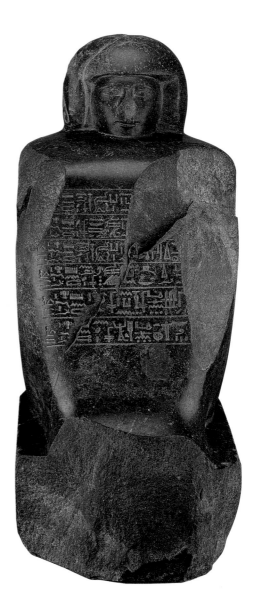

Granodiorite
Bubastis, temple of Bastet
H. 88 cm, l. 40.8 cm, w. 51.7 cm
[H. 34 ⅝ in., l. 16 ¹⁄₁₆ in., w. 20 3/8 in.]
Gift of the Egypt Exploration Fund 88.748

Wall tiles with Syrian and Nubian chiefs

Dynasty 20, reign of Ramesses III, 1184–1153 B.C.

Ramesses III was the last great military pharaoh of the New Kingdom. In his fifth year on the throne he defeated the Libyans and brought them back to Egypt as slaves. In his eighth year he faced an even greater threat: a confederation of displaced eastern Mediterranean tribes on the move, including Greeks and Philistines, known collectively as the Sea Peoples. Fresh from their victory over the Hittites, the Sea Peoples attempted to invade Egypt with the intention of settling there. Ramesses roundly defeated them both by sea and by land, recording his victories on the walls of his mortuary temple at Medinet Habu, "United with Eternity," which remains the best-preserved royal mortuary temple on the west bank of Thebes.

As the king was occasionally obliged for ritual and other reasons to stay at the mortuary temple, suitable quarters had to be arranged for him there, and so the temple complex included a ceremonial palace of mud brick luxuriously decorated with multicolored faience tiles and inlays. The two main entrance doorways showed the king as a sphinx trampling his enemies. Rows of bound foreigners on the lower jambs continued the theme of pharaoh's victory. The artists reproduced the foreigners' ethnic costumes and physiognomies according to convention.

Shown here in their finery, bound and helpless, are a Syrian and a Nubian chief, from opposite ends of the Egyptian empire. The Syrian in his fringes and tassels has a low forehead, prominent nose, and long, pointed beard. The Nubian has orange hair and a large loop-earring. Other tiles featured Libyans, Amorites, Philistines, Bedouins, and Sea Peoples. Ironically it was the descendants of the militant Libyan tribes settled in the Delta by Ramesses III who in the Third Intermediate Period, in Dynasty 22, ascended pharaoh's throne.

Polychrome faience
Medinet Habu, palace of Ramesses III
H. 25 cm, w. 6 cm (H. 9 13/16 in., w. 2 3/8 in.)
Sears Fund with additions 03.1573, 03.1570

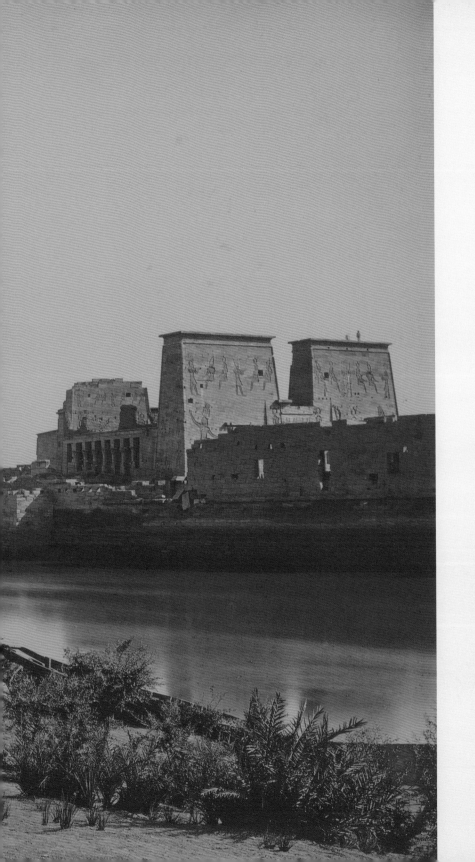

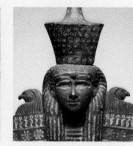

Third Intermediate, Late, and Greco-Roman Periods (1070 B.C.–A.D. 364)

The Third Intermediate Period (Dynasties 21–24, 1070–712 B.C.) saw Egypt once again divided along north-south lines. Although nominally rulers of the entire land, the pharaohs' authority was limited to Lower Egypt and the Faiyum. They ruled from Tanis in the northeastern Delta, and there they were buried, thus abandoning a four-hundred-year-old tradition of interment in the Valley of the Kings. The rest of the Nile Valley was controlled by Libyan army generals who took the titles of the high priests of Amen at Thebes. Some of them also assumed pharaonic titles and for all intents and purposes ruled as hereditary monarchs in their own right. Relations between the two families were mostly amicable, however, and they frequently intermarried.

It was also at this time that the high priests were compelled to remove the royal mummies from their individual places of rest and hide them in centralized locations where they could be better protected. The royal tombs had already been pillaged numerous times, notably in the reigns of Ramesses IX and XI. The situation had become so bad by the Third Intermediate Period that the mummies had to be shuttled from place to place, rewrapped and relabeled, placed in new or refurbished coffins, and reburied. In the process they were stripped of their gold, which was then recycled into the economy. In 1881 the appearance on the Luxor antiquities markets of objects inscribed with royal names and obviously coming from royal burials led authorities to the discovery of a group of royal mummies in a well-concealed tomb at Deir el-Bahri that had belonged to the family of High Priest Pinudjem I. A second cache was found in 1898 in the tomb of Amenhotep II. All the royal mummies (except for Tutankhamen, who still reposes where he was originally buried) are now in the Cairo Museum.

With the advent of Dynasty 22, Egypt regained some of its former prosperity. The first ruler, Shoshenq I, established his authority in the south by making his son high priest of Amen at Thebes. He even ventured beyond Egypt's borders and sacked Jerusalem, earning mention in the Bible as Pharaoh Shishak (1 Kings 14:25–28). Strong at first, the country became more and more fragmented, with

five pharaohs ruling simultaneously from Tanis (Dynasty 22), Leontopolis (Dynasty 23), Sais (Dynasty 24), Herakleopolis, and Hermopolis. A divided Egypt was ripe for invasion. The Late Period (Dynasties 25–30, about 760–332 B.C.) saw the land periodically occupied by the Kushites, Assyrians, Persians, and Greeks, with intermittent periods of native rule, and ended with the Roman conquest of 30 B.C.

The Nubian Kushites, whose homeland was in present-day Sudan, had a power base in Thebes by the final years of the Third Intermediate Period. In 715 B.C. King Shabaka annexed the Delta, and for the next forty years, the Kushites ruled Egypt as Dynasty 25. Their aggressive foreign policy soon brought them into conflict with the Assyrians. In 664 B.C. the Assyrians invaded Egypt and pursued the Kushites all the way to Thebes. The Kushites then fled south. After eliminating their rivals, the Assyrians went home with their booty, leaving their vassal, Psammetichus of Sais, in charge. He soon established his independence and founded the Saite Dynasty (Dynasty 26), one of the most brilliant in Egyptian history.

Psammetichus I came to the throne with the help of Ionian and Carian mercenaries, which he had settled in the Nile Delta, giving Greeks their first opportunity to experience Egyptian art and culture first hand. During Dynasty 26, Egypt became a great naval power for the first time in its history, with state-of-the-art Greek ramming galleys in the Red Sea and the Mediterranean. The Greeks, for their part, were amazed with what they saw in Egypt. There was nothing at home to prepare them for the monumental, man-made grandeur of pyramids, tombs, and temples dating back to remote antiquity. For the Greek historian Herodotus, who visited Egypt during the Persian period, about 454 B.C., Amenemhat III's funerary temple, which he called the Labyrinth, was greater than all the works of Greece put together.

Amid all the political turmoil and the passing of armies, it may seem miraculous that Egyptian art survived at all. But not only did it survive, it flourished. The consciousness of a long history, the presence of so many great monuments testifying to the glory of former times, and the desire to maintain cultural identity in the face of so many foreigners led artists and those who commissioned them to turn to the past for inspiration. This phenomenon, called archaism, is considered a hallmark of late Egyptian art. With such a long past, and so many styles to choose from, the result was often highly eclectic.

In 525 B.C. the Persians under Cambyses defeated the last Saite ruler, and Egypt became a province of the Persian Empire, the largest the world had yet known. After eighty years of Persian rule, known as Dynasty 27, Egypt regained

fig. 29 **The sumptuous building program of Nectanebo II included a new temple at Bubastis built entirely of granite. Relief of the god Khnum and a goddess, Dynasty 30, reign of Nectanebo II, 362–343 B.C., granite, from Bubastis, 105 x 131.5 x 57 cm (41 ⁵⁄₁₆ x 51 ¾ x 22 ⁷⁄₁₆ in.), Gift of the Egypt Exploration Fund 90.233**

its independence. Under Dynasties 29 and 30, Egypt experienced a burst of cultural and artistic achievement. Nectanebo II, the last native pharaoh, embarked on an extraordinary building campaign (fig. 29), sadly cut short by a second Persian invasion in 342.

Ten years later, Macedonian King Alexander the Great marched into Egypt without a struggle. He stayed long enough to found the city of Alexandria, and then marched off to conquer Persia, leaving Egypt in the hands of his general Ptolemy. Ptolemy's descendants ruled for nearly three hundred years, and dominated an area that at times also included Cyrenaica (Libya), Palestine, Cyprus, and the south Anatolian coast. Meanwhile, the power of Rome was ascendant; it eventually came to play an important role in eastern Mediterranean affairs. The last and most famous of the Ptolemies, Cleopatra VII, allied herself with the Roman Mark Antony. In 31 B.C. the combined forces of Antony and Cleopatra were defeated by Octavian (later called Augustus) in a great naval battle off the coast of Greece. The following year the lovers committed suicide, and Egypt became a province of the Roman Empire.

Egypt was important to Rome: the Nile Valley was its breadbasket, the Eastern Desert was its source of ornamental stone, and the Red Sea ports were its trade link to India. Augustus, Tiberius, Nero, and Hadrian sponsored major building projects in Egypt (fig. 30). But they were absentee pharaohs. With few exceptions, they seldom visited Egypt and they gradually lost interest in its culture. The last major building projects in Egypt were carried out in the mid-second century in the reign of Antoninus Pius (A.D. 138–161). In the third century imperial support for the temples virtually ceased.

At the same time, Christianity was catching on rapidly. It is estimated that by Constantine's death in 337 half of Egypt's population was Christian. In 384 Theodosius ordered that the temples be closed. (The beautiful temple of Isis on the island of Philae held out for a while as a bastion of the old faith. The last datable hieroglyphic inscription was carved there in 394.) With the formal division of the Roman Empire into eastern (Byzantine) and western halves in 395 (the traditional end of ancient Egyptian history), the fall of Rome to the barbarians in 476, and the Arab conquest of Egypt in 641, Egypt of the pharaohs was effectively cut off from western Europe.

Lawrence M. Berman

fig. 30 **The hieroglyphic inscription identifies this traditional Egyptian-looking pharaoh as Augustus, who in 30 B.C. added Egypt to the Roman Empire. Column drum, Roman Period, reign of Augustus, 30 B.C. to A.D. 14, sandstone with paint and traces of gold leaf, from Koptos, 55 x 54 cm (21 ⅝ x 21 ¼ in.). Harvard University-Museum of Fine Arts Expedition 24.1808**

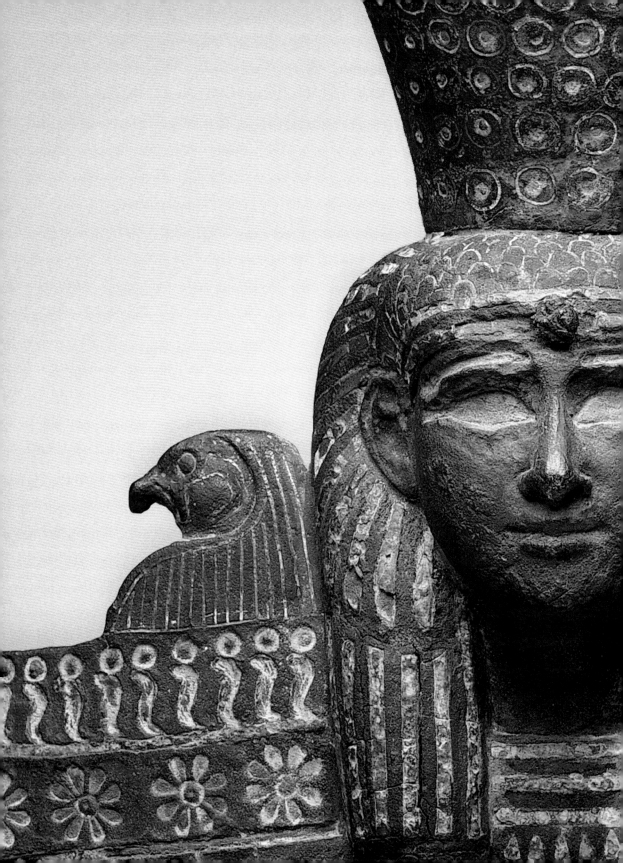

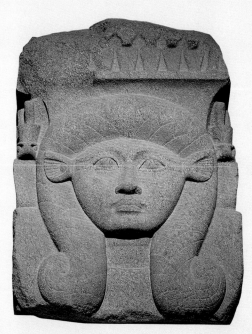

Hathor fetish capital

Dynasty 22, reign of Osorkon II, 874–850 B.C.

When the last king of Dynasty 21 died without an heir, the throne passed peacefully to his son-in-law's family. The new royals were of Libyan stock, but their family had lived in Egypt for five generations, and only their names, Shoshenq and Osorkon, betrayed their foreign ancestry. They hailed from Bubastis in the eastern Delta, which they embellished with great monuments. The ancient temple of Bastet was completely rebuilt. Herodotus, who visited several hundred years later, wrote that other temples might be larger, or have cost more to build, but none was "a greater pleasure to look at." Yet it was quite large enough, and costly. Today the site is so ruined that it is impossible to reconstruct an accurate plan of the temple in any period of its history. When the Egypt Exploration Fund excavated at Bubastis from 1887 to 1889, Boston received an exceptionally large and impressive share of the finds, including the enormous papyrus-bundle column (p. 132), the colossal statue of Ramesses II (p. 163), the block statue of Mentuherkhepeshef (p. 164), and this majestic column capital, the best-preserved example out of five found at the site. Front and back are beautifully carved with the face of the goddess Bat. She has the usual cow's ears and upturned hairstyle, crowned by a frieze of uraei (cobras) wearing sun disks. Engraved on the sides of the capital, beneath pairs of uraei wearing the crown of Upper Egypt, are the cartouches of Osorkon II, fifth king of Dynasty 22. Because the face of Bat was appropriated by Hathor as her fetish or sacred emblem about the end of the Eleventh Dynasty, it remained closely associated with her, although it was also considered an appropriate adornment for other great goddesses such as Bastet and Isis whose cults gained importance in the Late Period.

Granite
Bubastis, temple of Bastet, hall of Osorkon II
H. 178.8 cm, w. 137.5 cm, d. 108.2 cm
(H. 70⅜ in., w. 54⅛ in., d. 42⅝ in.)
Gift of the Egypt Exploration Fund 89.555

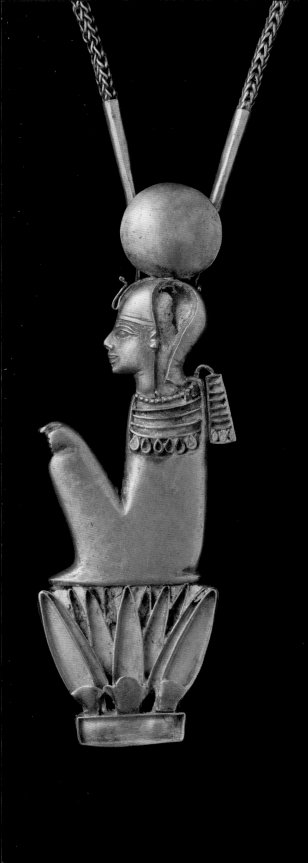

Pendant on a chain
Dynasties 21–24, 1070–712 B.C.

According to Egyptian mythology, the young sun god was borne up out of the primordial waters of chaos inside a blue lotus flower, which opened to reveal him on the first morning. The artist of this fine pendant characterized the god's tender age with the sidelock of youth. He is seated with knees drawn up as in a hieroglyph. The tiny uraeus on his brow proclaims him as royalty, illustrating the link between the king and the young sun god. Although the figure appears to be on top of a lotus blossom, we are meant to understand him as being inside the flower, in the same way as the contents of an open bowl in Egyptian art can be drawn standing up on its edge. Although the jewel was previously dated to the reign of Ramesses II, the closest parallels date to the Third Intermediate Period, when the motif of child god on the lotus enjoyed a great vogue.

Gold with glass inlays
Pendant: H. 7.1 cm, w. 2.5 cm (H. 2 13/16 in., w. 1 in.)
Chain: (doubled) L. 30 cm (L. 11 13/16 in.)
Gift of Mrs. Horace L. Mayer in Memory of Horace L. Mayer
68.836

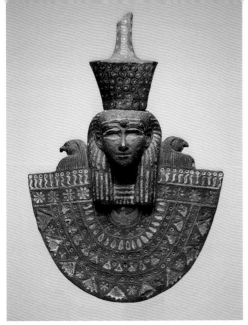
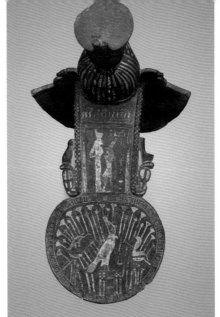

Aegis of Isis

Dynasty 22, 945–712 B.C.

Early Egyptologists with a Classical background often drew on vocabulary from Greek mythology to describe Egyptian antiquities for which a suitable term was lacking. They borrowed the word *aegis,* which refers to the shield or breastplate of Athena, for religious or cult objects shaped like a broadcollar surmounted by the head of a deity. Evidently such a composition reminded them of images from Greek vase painting of Athena with the head of Medusa on her breastplate, serpents swirling around the perimeter.

This particularly large and ornate aegis represents the goddess Isis. She wears the crown of Upper Egypt over a vulture headdress and a broadcollar with falcon-head terminals and a frieze of uraei along the top. The combination of different metal alloys for contrast was a specialty of the period and serves to point out the intricate patterns of the collar and crown.

In real life such a heavy collar would have required a counterpoise, called a *menat*, to keep it in place. Such a counterpoise, heavily decorated, is attached to the back of this aegis by a hinge. The square scene at the top of the *menat* shows Isis suckling Horus.

In Egyptian mythology, Isis took her newborn son Horus to the Delta marshes to hide him from his evil uncle Seth. There she protected him by her magic from snakes and scorpions. The round scene below shows Horus again, represented as a falcon in a papyrus grove flanked by the protective goddesses of the south (the vulture) and the north (the cobra). In both scenes Horus represents the king as recipient of divine sustenance and protection. Such elaborate mythological compositions were popular in Dynasty 22, when the technique of inlaid bronze was also at its height.

In Egyptian art aegises appear as prow ornaments on sacred boats and as finials on the top of poles carried in religious processions. They also occur as amulets and on finger rings, or they can be held in the hands of bronze statuettes of goddesses. It is not known how this particular aegis was used. There is no convenient way to hold it. It is perhaps best regarded as a votive offering placed in a temple.

Bronze with inlays of electrum, silver, and bronze

H. 27.5 cm, w. 19.2 cm, d. 29.3 cm

(H. 10 ¹³/₁₆ in., w. 7 ⁹/₁₆ in., d. 11 ⁹/₁₆ in.)

Adelia Cotton Williams Fund 31.195

Mummy case with mummy of Tabes

Dynasty 22, 945–712 B.C.

An innovation in funerary equipment in Dynasty 22 was the one-piece mummy case made of cartonnage. A core of mud and straw in the shape of a mummy was first covered with plaster. Layers of linen were then adhered to the plastered core with plant gum, leaving a hole at the foot end and a long narrow slit in the back. The surface was then coated with gesso, the core was removed through the slit in the back, and the wrapped mummy inserted in its place. The back was then sewn up, the foot end was plugged with a wooden board, and the sealed mummy case was delivered to painters to be decorated.

This cartonnage mummy case of Lady Tabes is one of the earliest of this type and one of the finest. Protective winged deities figure prominently in the decoration. No fewer than six pairs of wings wrap around Tabes's mummy. Two falcons—the first one ram-headed with up-curved wings, the second one bird-headed with wings spread out horizontally—stretch across her upper body. Below them, on the sides, are a pair of winged goddesses and a pair of falcons, their wings crisscrossing down the center of her lower body in a swirl of plumage. They are labeled Isis, Nephthys, Neith, and Selqet, the four traditional protective funerary goddesses.

Cartonnage with human remains
Probably from Thebes
L. 167 cm (L. 65¾ in.)
Hay Collection. Gift of C. Granville Way
72.4820c

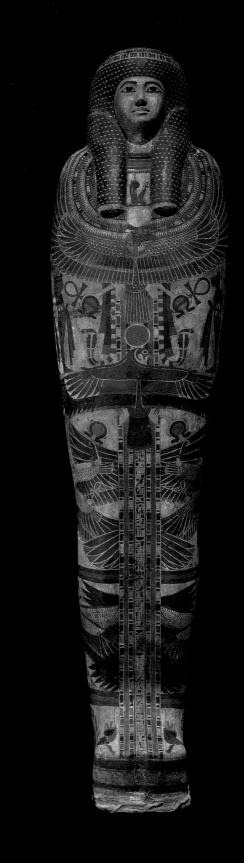

Amulet of Harsaphes

Dynasty 23, reign of Neferkare Peftjawybast, 740–725 B.C.

The town of Ihnasya el-Medina, capital of Lower Egypt in the First Intermediate Period, returned to prominence in the Third Intermediate Period when it was the seat of a local king named Neferkare Peftjawybast. An ancient inscription now in the Cairo Museum states that he collaborated with the invading Nubian kings of Dynasty 25.

This precious gold statuette, found in the pavement of the temple of Ihnasya, is one of the few surviving monuments of that ruler. It represents the local god Harsaphes, a ram deity. The Greeks identified him with Herakles (Hercules), hence the town's Classical name, Herakleopolis Magna. The god appears here in the form of a ram-headed man. As usual, the long wig masks what might otherwise be an awkward transition from human body to animal head. The ram's long corkscrew horns support a tall crown with two ostrich plumes at

the sides, known in Egyptian as the *atef*, which could be worn by the king as well as various gods, notably Osiris and Harsaphes. Cast using the lost-wax process, the god's body is svelte and elegant, simply clad in a short wraparound kilt. Chased into the underside of the base is a hieroglyphic inscription naming the ruler along with a prayer for "life and protection." In back of the head is a loop for suspension so that the statuette could be worn as an amulet.

Gold
Ihnasya el-Medina (Herakleopolis Magna)
H. 6 cm, w. 0.7 cm, d. 1.7 cm
(H. 2 3/8 in., w. 1/4 in., d. 11/16 in.)
Gift of the Egypt Exploration Fund
06.2408

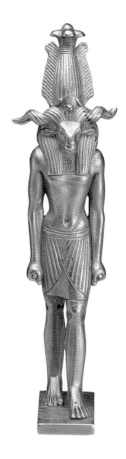

Statue of Khonsuiraa

Dynasty 25, about 760–about 660 B.C.

The Kushites were foreigners, but they practiced Egyptian religion and identified with Egypt's past. They considered themselves the true preservers of Egyptian tradition, more orthodox than the Egyptians themselves. The city of Memphis held a special fascination for them because of its great antiquity. King Shabaka, the second ruler of Dynasty 25, who brought Lower Egypt under Kushite control, proudly took up his residence in the ancient capital. One of the most important documents of his reign is the so-called Shabaka Stone, a black slab inscribed with a hieroglyphic text expounding the role of the Memphite god Ptah as the creator, which the pious king claimed to have had copied from an old papyrus. Even today scholars are uncertain whether the text is as old as it purports to be or an invention of Dynasty 25.

It is within this spiritual milieu that the revival of statuary in the round took place in Dynasty 25. Almost all statues are of hard stone, meant to last an eternity. This one of the priest of Amen Khonsuiraa is one of the finest examples known in the Kushite style. The figural proportions show a return to the concept of the ideal male form, devised by the Memphite sculptors of the Fourth Dynasty who carved the statues of King Menkaure (see pp. 82–87). The pose, costume, and taut musculature are traditional as well, and the carving in hard dark stone is of the utmost skill and refinement.

Black stone
Possibly from Karnak
H. 43.5 cm, w. 12.6 cm, d. 3.5 cm
(H. 17 ⅛ in., w. 4 ¹⁵⁄₁₆ in., d. 5 ⁵⁄₁₆ in.)
James Fund and Contribution 07.494

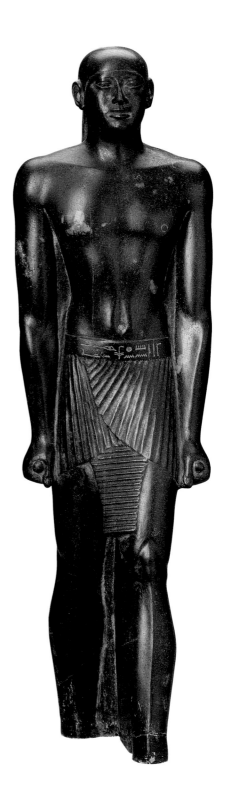

Head of Ankhkhonsu
Dynasty 26, 664–525 B.C.

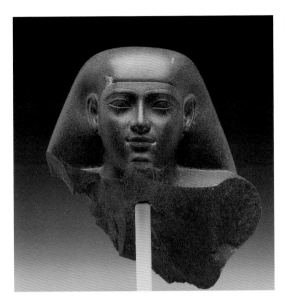

Head of a man
Dynasty 26, 664–525 B.C.

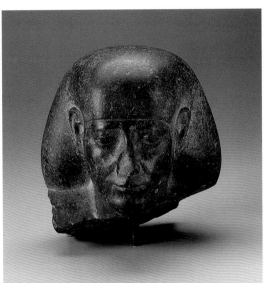

Two basic trends may be distinguished in Late Period portraiture: idealizing and nonidealizing. They existed side by side. The subjects of idealizing portraits appear youthful, while nonidealizing portraits show them as mature or even aged. The beautifully carved head of Ankhkhonsu exemplifies the idealizing approach in Late Period sculpture. The face is youthful and serene, without line or blemish. The nose, which is preserved intact, is fine and straight. After being identified in 1979 as

belonging with one of the headless block statues in the Egyptian Museum, Cairo, the inscriptions on the statue provided the subject's name, Ankhkhonsu.

The other head is an unusually accomplished and sensitive portrait in the nonidealizing style, with realistic features that are individualized rather than stereotyped. Although the subject's name is not preserved, the inscription on the back pillar mentions Khentykhety, god of Athribis in the Nile Delta, suggesting that was where he lived.

Graywacke
Thebes
H. 19.5 cm, w. 18.5 cm, d. 15 cm
(H. 7 11/16 in., w. 7 5/16 in., d. 5 7/8 in.)
Emily Esther Sears Fund 04.1841

Granodiorite
Probably from Athribis
H. 22.8 cm, w. 18 cm
(H. 9 in., w. 7 1/16 in.)
Seth K. Sweetser Fund 37.377

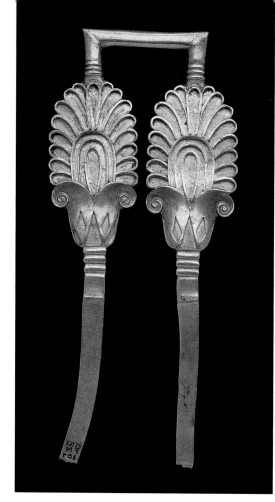

Tray handle
Dynasty 26, 664–525 B.C.

Strategically located on the main caravan route north to Syria and Palestine, the site of Tell Dafana (ancient Daphnae) at the northeast corner of the Delta was a frontier fortress and trading center. Psammetichus I stationed his expert troops of Ionian and Carian mercenaries there. Judging from the finds — Greek painted pottery, iron weapons, and scale armor — of the site's excavation in 1886 by Flinders Petrie for the Egypt Exploration Fund, the population was predominantly Greek. The town flourished in the reign of Amasis (570–526 B.C.), to which period most of the Greek painted pottery from Dafana may be dated.

 This elegant gold handle is unique. Nothing like it had been found before at Dafana or anywhere else. Petrie surmised it was soldier's loot. It was discovered folded in half lengthwise, obviously wrenched from the vessel it supported, along with about one and a half pounds of silver in lumps. The two straps were originally bent at a right angle just below the lotuses, presumably to support a tray. The thickness of the gold supports this assumption.

 The handle takes the form of two lotuses and palmettes, joined at the top, and originally inlaid or prepared for inlay with enamel or stone. The lotus-and- palmette motif is Egyptian in origin, going back at least to Dynasty 18. By the Late Period it had become a fixture in Greek and Near Eastern art as well, part of an international vocabulary of decorative forms. So although it is Egyptian, the style of this piece would have appealed to a wide international audience.

Gold
Tell Dafana
H. 13.9 cm, w. 6 cm (H. 5 ½ in., w. 2 ⅜ in.)
Gift of the Egypt Exploration Fund 87.763

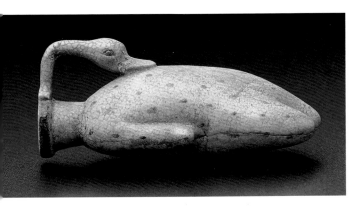

Perfume bottle in the form of a trussed duck or goose
Dynasty 26, 664–525 B.C.

The body of this slender vessel takes the shape of a plucked duck or goose bound with string and ready for cooking — a familiar theme in Egyptian art. During the Old Kingdom, some tombs were provided with life-size cases shaped like such birds with real food offerings inside, while other tombs contained miniature versions in solid stone. In the Middle Kingdom, perfume and ointment containers in the form of trussed ducks were carved in the beautiful blue stone anhydrite (see p. 136), and that tradition continued into the New Kingdom. This Late Period example, however, may owe as much to contemporary Aegean figural vases as it does to its Egyptian precedents. Like some Corinthian oil bottles, it rests horizontally on its belly (it will not stand unsupported), and has a handle in the form of an animal's neck that curves back from the rim of the vessel so that the head rests on the body.

The Egyptians loved such figurative vessels that were functional at the same time. The small size and narrow opening of this bottle would have been perfect for precious ointments or perfumes that were used only in small doses and needed to be protected from evaporation. The material from which the bottle is made, faience, is difficult to work. A nonclay ceramic manufactured from crushed sand and salt, and a colorant, it has none of the malleability of clay. The small size, fancy shape, subtle hues, and remarkably thin handle of this faience vessel make it a masterpiece in miniature.

Faience
H. 7.8 cm, w. 3.6 cm, d. 2.7 cm
(H. 3 ⅟₁₆ in., w. 1 ⁷⁄₁₆ in., d. 1 ⅟₁₆ in.)
Marilyn M. Simpson Fund 1996.108

Sarcophagus of General Kheperre
Dynasty 26, reign of Amasis, 570–526 B.C.

Although best known for its Old Kingdom monu-
ments, the site of Giza experienced a revival during
Dynasty 26. The small temple dedicated to Isis, "Lady
of the Pyramids," that had grown up in one of the
queens' pyramid chapels in the cemetery east of the
Great Pyramid, was expanded; the pyramid of
Menkaure was restored and the royal mummy pro-
vided with a new wooden coffin; and the Old Kingdom
necropolis once again became a burial place of choice
for people of means. One of these was Kheperre, an
army general, who chose to be buried in the cemetery
east of the Great Pyramid, not far from the temple
of Isis. In Khufu's day this cemetery had been reserved
for members of the royal family, and the whole area
was crowded with Old Kingdom tombs. Although
many Twenty-sixth Dynasty officials chose to convert
old burial shafts for their tombs, Kheperre opted to
dig a completely new tomb for himself and his family
consisting of a deep shaft sunk fifty feet into the
bedrock with ten small burial chambers opening from
it at various levels. Kheperre's chamber, being the
most important, was at the deepest level.

Although the entrance was originally plugged
with stone blocks cemented in place, robbers suc-
ceeded in entering the tomb. By the time modern
excavators found it, there was only Kheperre's mam-
moth sarcophagus containing the paltry remains
of his body, and 109 *shawabty*s, or funerary figurines,
of lustrous blue-green faience. Huge, hard-stone
sarcophagi of anthropoid shape, not used since the
New Kingdom, were once again in vogue during
Dynasty 26. Kheperre's is a fine example of the later
form. It is very wide in relation to its height, and
the head is disproportionately large. The deceased is
represented in the form of a mummy standing on
a pedestal with a round and flat face, large eyes, a
broad nose, and full lips. The wig and beard associate
the deceased with the god Osiris.

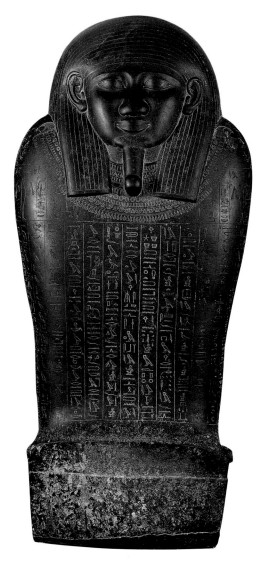

Graywacke
Giza, tomb G 7757 A
H. 76 cm, w. 108 cm, d. 226 cm
(H. 29 15/16 in., w. 42 1/2 in., w. 89 in.)
Harvard University-Museum of Fine Arts Expedition
30.384a–b

Statue of Osiris

Dynasty 26, 664–525 B.C.

Osiris, god of the dead, stands mummiform, arms folded right over left, with wedge-formed feet. Head and hands emerge from a shroud so smoothly contoured to the shape of the body that details such as arms, elbows, and kneecaps emerge from the plain undifferentiated surface as islands of relief, while the crook and flail appear less as accessories than as organic outgrowths of the underlying form. The base and back pillar are inscribed with mortuary texts on behalf of the "king's acquaintance" Ptahirdis, whose father's name was Wepwawetemsaf and whose mother's name was Merptahites.

The statue has the oldest modern history in the Egyptian collection. The upper part (from the knees up) was excavated in 1928 by the Harvard University-Museum of Fine Arts Expedition in the shaft of Giza tomb 7792, east of the Great Pyramid. The lower part (base and ankles) was discovered 130 years earlier. It was brought to France by General Jean Lannes (later marshal of France and duke of Montebello), one of Napoleon's most valiant officers, who participated in the short-lived but epoch-making Egyptian Campaign of 1798–1801, the beginning of the modern science of Egyptology.

General Lannes by all reports was no antiquarian. The feet of Osiris passed down in his family for six generations until 1999, when Egyptologist Olivier Perdu, visiting French country house collections of antiquities, recognized it as belonging to the MFA fragment. Although it does not directly join (approximately 8 centimeters [3 inches] in the middle are restored), its size, shape, material, and above all the identical names and titles of the personages mentioned in the inscriptions leave no doubt that it belongs. Through the generosity of a friend the lower part was purchased by the Museum, and the two fragments, sundered in antiquity, are now one. The result is both a masterpiece of Late Period sculpture and a historical link with the founding moment of modern Egyptology.

Graywacke
Giza, tomb G 7792 A

Upper part:
H. 55 cm (H. 21 ⅝ in.)
Harvard University-Museum
of Fine Arts Expedition 29.1131

Lower part:
H. 20 cm, w. 15.5 cm, d. 29 cm
(H 7 ⅞ in., w. 6 ⅛ in., d. 11 ⁷⁄₁₆ in.)
Museum purchase with
funds donated by Stanford
Calderwood in honor of
Norma-Jean Calderwood,
a member of the Visiting
Committee of Art of the
Ancient World 2000.973

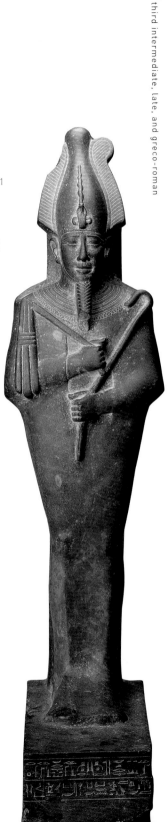

Torso of King Achoris

Dynasty 29, reign of Achoris, 393–380 B.C.

This magnificent sculpture fragment, one of few inscribed for King Achoris, is a wonderful combination of old and new. Enough remains of the torso and legs to show that the king was represented in the traditional striding pose for men, left foot forward, arms at his sides. What is new is the fleshiness of the body and the treatment of the anatomy, by which chest, rib cage, and abdomen are rendered as three separate areas, a convention known as tripartition. Although the head is lost, it probably closely resembled the Head of Nectanebo II in the Blue Crown (p. 185).

The statue came to the United States during the American Civil War (1861–65), along with four other Egyptian sculptures now in the Museum. They were acquired by a Yankee sea captain who touched at Alexandria on his way home from a voyage to the Mediterranean. No doubt they were collected more for their sheer weight (as ballast) than for their artistic merit. The ship was captured by the Confederates and brought to New Orleans, and the statues were deposited at the customs house there. After the war they were purchased by the Yankee postmaster, who took them to his home in Lowell, Massachusetts. There they stood on his front lawn for sixty years before being acquired by the Museum.

The back-pillar inscription that provides the king's titles and names is incomplete: "Horus: Great of heart, beloved of the Two Lands; Two Ladies: the Brave: Golden Horus: Who pacifies the gods; King of Upper and Lower Egypt: Khnummaatra Setepenbanebdjedet, the son of Re ..." What was likely to have been the lower portion of the statue, seen in 1842 in the courtyard of the Greek consul in Alexandria, is reported to have been inscribed on its back pillar with the remainder of the king's titulary, picking up exactly where the Boston fragment leaves off: "the son of Re Achoris [beloved of] Atum lord of Iunu." The present location of this fragment is unknown, so that it is impossible to verify the connection.

Granodiorite
H. 111 cm (H. 43 11/16 in.)
Maria Antoinette Evans Fund 29.732

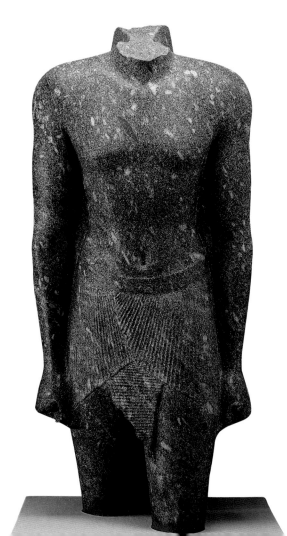

Head of Nectanebo II
Dynasty 30, reign of Nectanebo II, 360–343 B.C.

This superb portrait of Egypt's last native pharaoh is the product of three thousand years' expertise in carving hard stone. The volumes of his helmet-shaped crown — the Blue Crown, or *khepresh*, are sleek and streamlined, almost aerodynamic. The artist reveled in the mottled texture of the stone, and polished it to a glistening sheen in a painstaking process reserved for the most important statues.

Nectanebo II was known as the favorite of the gods, renowned for his piety, devotion to the sacred animal cults, lavish gifts of land, restoration of cult statues, and founding of new temples. Thirty sites from the Delta to Elephantine and as far west as Siwa attest to his extraordinary building activity: fourteen completely new structures plus extensions to existing sanctuaries and gifts of temple furniture. Such expenditures would have been remarkable at any time but were particularly so when the country was under constant threat of invasion from the Persians.

In 343 B.C. Nectanebo II was defeated by the Persians. Nothing is known of his death. Legend has it that he escaped to Macedonia. A skilled magician, he appeared to Queen Olympias in her bedchamber disguised as her husband Philip, and sired the future Alexander the Great. It is certain that he was honored under the Ptolemies, for whom he provided an ideal role model as pharaoh. A cult that worshipped Nectanebo II as a divine falcon, the epitome of kingship, persisted at least until the reign of Ptolemy IV.

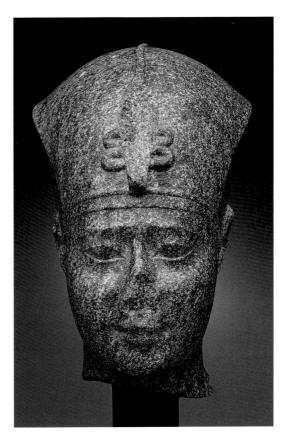

Granodiorite
H. 31 cm, w. 24.5 cm, d. 24 cm
(H. 11 13/16 in., w. 9 5/8 in., d. 9 7/16 in.)

Museum purchase with funds donated anonymously, Thomas H. Lee and Ann Tenenbaum, Egyptian Curator's Fund, Marilyn M. Simpson Fund, Mrs. William F. Shelley, Walter and Celia Gilbert, Florence E. and Horace L. Mayer Fund, Joan and Jerry Cross, Mr. and Mrs. Mark R. Goldweitz, Elizabeth H. Valentine, Mr. and Mrs. Miguel de Bragança, Clark and Jane Hinkley, Honey Scheidt, Barbara and Jeff Herman, Marietta Lutze Sackler, Velma and Robert Frank, James Evans Ladd, Allen and Elizabeth Mottur, Frank Jackson and Nancy McMahon, and Meg Holmes Robbins
2000.637

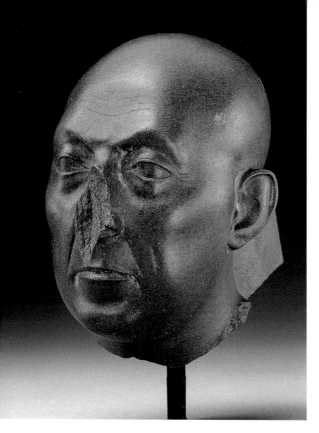

Head of a priest (the Boston Green Head)
Dynasty 30, 380–332 B.C.

This head of a priest, called the Boston Green Head, is the best portrait sculpture known from the Late Period. The face is wonderfully lifelike and individual. Light wavy lines indicate the furrows of his brow, and crow's feet radiate from the outer corners of his eyes. The top of his nose has a pronounced bony ridge. Deep creases run from the edges of his nose to the corners of his mouth. Thin lips and a downturned mouth impart an expression of strength and determination. The slight wart on his left cheek is unique in Egyptian art and also introduces an element of asymmetry dear to the artists of the Late Period.

The head has an illustrious provenance. In the spring of 1857, Napoleon Joseph Charles Paul Bonaparte, a cousin of Emperor Napoleon III known as Prince Plonplon, announced his intention to visit Egypt. Archduke Maximilian of Austria had recently returned from a Nile excursion with a handsome collection of Egyptian art, and the prince vowed to surpass him. Said Pasha, the passionately pro-French viceroy of Egypt, was determined to please his imperial guest. He charged Auguste Mariette, famed discoverer of the Serapeum, the burial place of the sacred Apis bulls, with the task of building a collection. To save time, Mariette was to explore the proposed itinerary, dig for antiquities, and then rebury them, thus facilitating their rediscovery by the prince. In the end, Plonplon canceled his reservations, but nonetheless received a selection of choice objects — including the Green Head as a souvenir of the trip that never was. Yet there were happy consequences, for as a result of his efforts and through the prince's influence, Mariette was appointed Egypt's first director of antiquities, a milestone in the care and protection of Egypt's monuments.

Graywacke
Saqqara, Serapeum
H. 10.5 cm, w. 8.5 cm, d. 11.3 cm
(H. 4 ⅛ in., w. 3 ⅜ in., d. 4 ⁷⁄₁₆ in.)
Purchased of Edward P. Warren,
Pierce Fund 04.1749

Relief of the gods Amen and Ptah-Sokar-Osiris
Probably Ptolemaic Dynasty, reign of Ptolemy II,
284–246 B.C.

The great temple of Isis, the Iseion, at Behbeit el-
Hagar in the central Nile Delta was begun by the last
of Egypt's native pharaohs, Nectanebo II, and was
completed by the early Ptolemies, who copied the
pharaonic style. In fact, the art of the early Ptolemies
continued the traditions of the Nectanebos so closely
that without an identifying inscription it is not
always possible to tell one from the other. The Iseion
has been reduced to a field of ruins, but enough
remains to show that it was once a magnificent and
luxurious structure, built entirely of granite. The
hard stone is carved with virtuoso skill to create var-
ious effects. The bare-chested figure of Amen, for
example, is rounded and fleshy, and shows how well
the tripartite division of chest, rib cage, and abdo-
men seen in the sculpture of King Achoris (p. 184)

translates into relief. The mummiform Ptah-Sokar-
Osiris is a real tour de force, with subtle undulations
of the surface suggesting the figure beneath the
shrouded form. The cherubic facial features of both
deities closely resemble Nectanebo's, yet experts
agree that they represent the second Ptolemy.

Granite
Behbeit el-Hagar
H. 82 cm, w. 90 cm, d. 13 cm
(H. 32 5/16 in., w. 35 7/16 in., d. 5 1/8 in.)
Martha A. Willcomb Fund 51.739

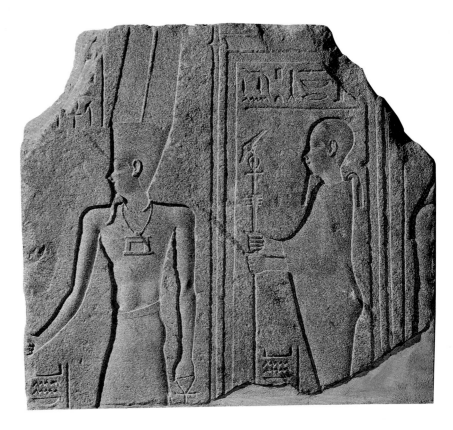

Double sided votive relief
Ptolemaic Dynasty, 305–30 B.C.

Although hundreds of relief plaques have survived from the Ptolemaic Dynasty, few are as fine and interesting as this one, decorated on both sides. The modeling of the cat is unusually bold and almost three-dimensional. Although it is widely regarded as the most Egyptian of animals, the sacred cat was a fairly late development in Egyptian religion, beginning about 1000 B.C., when the female of the species was identified with the goddess Bastet (formerly a lioness). She is ornamented with a necklace of cowrie shells, symbols of fertility, and a pendant in the form of the eye of Horus.

The ram-headed deity on the other side may be Khnum, the creator god that formed humankind from Nile clay, Harsaphes, or any of a number of Egyptian ram-gods all represented in the same fashion. He has a triangular depression beneath the chin meant to receive an inlay for a divine beard, and two pairs of long, upward-curving, corkscrew horns. The horns are those of a species that died out in Egypt during the Middle Kingdom (*Ovis longipes paleoaegypticus*), but they were retained as a symbol of divinity. These corkscrew horns appear to be unfinished. For this reason, plaques like this are often called trial pieces or sculptor's models, but they are more likely to have been votive offerings in honor of the king or a god.

Limestone
H. 20.5 cm, w. 22.2 cm, d. 1.1 cm
(H. 8 1/16 in., w. 8 3/4 in., d. 7/16 in.)
Helen and Alice Colburn Fund,
Martha A. Willcomb Fund, and Gift of
Mrs. Charles Gaston Smith's Group
51.2474

Statue of a queen

Early Ptolemaic Dynasty, third century B.C.

Statues of women were rare in Egyptian art during
the four centuries preceding Alexander the Great's
conquest of Egypt, but they reappeared in plenty
with the Ptolemaic Dynasty. That they did so had
everything to do with the Macedonians themselves.
Philip II of Macedon began the practice of setting
up statues of himself and his family at important
Greek shrines and other public places. Macedonian
tradition thus neatly harmonized with that of
Egypt, where centuries before Egyptian queens like
Queen Tiye had appeared as goddesses.

 Who is this voluptuous creature? Is she queen
or goddess? She strides forward in the traditional
attitude with left foot advanced and arms at her
sides. Her left fist is clenched around a folded bolt of
cloth, and in her right hand she holds an ankh-sign.
In true Egyptian style her ankle-length costume hides
nothing of her anatomy, and the traditional form-
fitting sheath has been fashionably updated to include
a shawl, the ends of which are tied in a knot between
her breasts. "Venus rings" (rolls of fat) adorn her neck.
Her head is missing but the lack of any trace of a long
wig on her shoulders indicates that she wore her hair
short, either in an Egyptian bob or a Grecian bun.

 Without identifying inscriptions, it is not always
possible to distinguish a queen from a goddess.
Ptolemaic queens were deified in their own right, and
their statues were set up in all the temples, where
they resided as *sunnaoi theoi*, or temple-sharing
gods. Living queens also served as priestesses in the
cults of deified dead queens. Queens even appear
making offerings to their deified selves. The knotted
garment worn by this figure was in Roman times
associated with the goddess Isis, but the Romans
took the robe from the Ptolemaic queens who identi-
fied themselves with Isis. Cleopatra VII, for example,
called herself "Nea Isis," the new Isis.

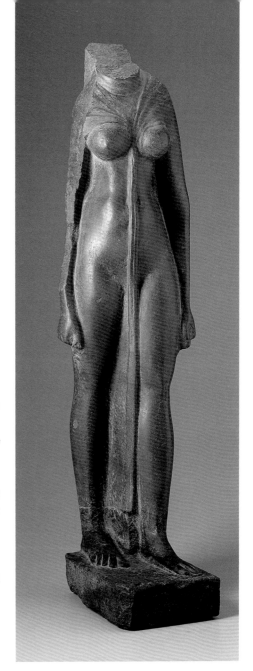

Stone
H. 75.5 cm, w. 19 cm, d. 24 cm
(H. 29¾ in., w. 7½ in., d. 9⁷⁄₁₆ in.)
Marilyn M. Simpson Fund, Horace and
Florence E. Mayer Fund, William Stevenson
Smith Fund, and Frank B. Bemis Fund
1990.314

Detail of gateway of Ptolemy VIII
Ptolemaic Dynasty, reign of Ptolemy VIII, 170–116 B.C.

One of the most colorful figures in Ptolemaic history was Ptolemy VIII, known familiarly as Physkon, "Fatso." He married both his sister, Cleopatra II, and her daughter, Cleopatra III, an arrangement that did not foster family harmony. He scandalized the Romans by his ostentatious display (extravagance entirely becoming in a god-king) and alienated the Alexandrians by his harsh treatment of the city's Jews and intellectuals. But he favored the Egyptian priesthood and the temples during his long rule, commissioning building activity at fifteen sites from the Delta to Nubia.

The ancient town of Koptos lay at the entrance to the main land route across the Eastern Desert to the Red Sea ports and thence to India, a trade much encouraged by Ptolemy VIII, and reason enough for his patronage. There, Ptolemy VIII erected a small temple gateway, which would have stood in a mudbrick enclosure wall of a temple. The gateway was still standing in the reign of Nero, when the emperor added his name to it. Sometime later it was dismantled and reused in a Roman bastion tower of the third or early fourth century A.D. In 1923 the Harvard University-Museum of Fine Arts Expedition excavated twenty-four blocks belonging to this gateway, consisting of the upper part of the right jamb and the façade of the left jamb, approximately one-fourth of the complete structure. Enough remained for scholars to estimate the original height and design, and in 1996 the gateway was reconstructed in the Museum. Presumably the rest is still at Koptos awaiting rediscovery.

The two scenes illustrated here come from the right façade. In the upper register, Ptolemy, looking every inch a pharaoh with his Double Crown and bull's tail, stands before Min and Isis, the chief gods of Koptos. In his right hand he holds a sphinx with an unguent vessel between its paws, representing the gift of myrrh specified in the hieroglyphic inscription. In the register below, the king stands before Harpokrates and Isis again. The king wears an elaborate headdress — the Blue Crown surmounted by ram's horns, a sun disk, ostrich plumes, and solar uraei. Harpokrates has the plump body of a child, with doughnut-shaped navel, and the sidelock of youth. Isis appears as usual with vulture headdress, cow's horns, and sun disk. Her figure is fleshy and voluptuous in the Ptolemaic manner. In return for a platter full of food, the gods grant the king "every good thing every day" and "all offerings and provisions," according to the inscription.

Painted sandstone
Koptos
Size as reconstructed: H. 544 cm, w. 458 cm, d. 378 cm (H. 214 3/16 in., w. 180 5/16 in., d. 148 13/16 in.)
Typical block: H. 48 cm (H. 18 7/8 in.)
Harvard University-Museum of Fine Arts
Exhibition 24.1632–33

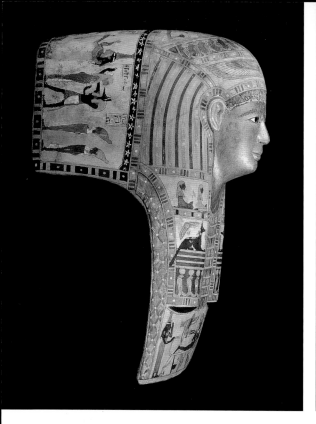

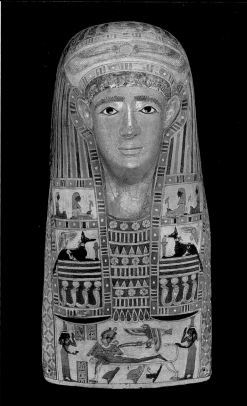

Mummy mask

Roman Period, first half of the first century A.D.

Traditional Egyptian funerary practices continued well into Roman times, when cartonnage mummy masks were made to fit over the head of the wrapped mummy. They belong to the same tradition as mummy masks from the Middle Kingdom (see p. 117). This face, modeled in plaster, is bland and idealized, and represents the deceased transformed into a god. The gilding and glass inlays are quite dazzling. Yet the black hair emerging from beneath the headdress lends a human touch to this shining icon.

The traditional lappet headdress is painted with age-old funerary motifs. A winged sun disk with uraei, image of the celestial Horus, crowns the head like a diadem, and rows of seated deities, Anubis jackals, and solar uraei adorn the sides. The broad-collar is a kaleidoscope of rosettes and geometric patterns imitating rows of beads.

The scene on the chest depicts the resurrection of Osiris. The god reclines on a lion bier, with Isis in front of him and Nephthys behind him, gesticulating with grief and uttering magic spells to bring him back to life. Above him hovers a falcon holding in its talons the *shen*-ring of eternity and a feather fan. Below are the Red Crown, the Double Crown, and the White Crown — the emblems of his power. Magic seems to take effect before our eyes as the shrouded one, the great god Osiris — his flesh of Nile silt, ram's horns of divinity on his head — sits up in bed and turns to face his sister-wife. The god is reborn.

Painted and gilded cartonnage, inlaid glass
H. 57.2 cm (H. 22 ½ in.)
Gift of Lucien Viola, Horace L. and Florence E. Mayer Fund, Helen and Alice Colburn Fund, Marilyn M. Simpson Fund, William Francis Warden Fund, and William Stevenson Smith Fund
1993.555

Portrait mummy of a youth
Roman Period, about A.D. 50

An innovation of Roman times was the beautiful life-like portrait painted onto a wooden panel to be inserted into the mummy bandages. Such portrait mummies are contemporary with cartonnage mummy masks but present a very different appearance. Because the majority have been found in the cemeteries of the Faiyum, an oasis west of the Nile, about 80.5 kilometers (50 miles) south of Cairo, they are traditionally called "Faiyum portraits." But finds at other sites indicate that the practice was widespread. Portrait mummies were neither placed in coffins, nor were they even buried right away. Classical authors comment on the Egyptian practice of dining with the dead, and it appears that the wrapped mummies of relatives were kept in the home as cult objects for a generation or two before being consigned to burial.

Much attention has focused on the funerary panels as the only painted portraits in the Greco-Roman style to have survived from antiquity, especially as so many have been detached from their mummies and displayed independently. However, it is important not to lose sight of the mummy for which each funerary portrait was specifically made and of which it was an integral part. The complete ensemble consists of three parts: portrait, mummy, and footcase. The portrait presents a moving, if not haunting, and lifelike image of the deceased. The subject here is a young boy with round, dark eyes, and dark hair combed close to the scalp. A wisp of hair behind the right ear may represent a sidelock of youth. He wears a white tunic and a gold amulet case suspended by a black cord. The gilded lips are rare. The gold may symbolize the deceased's transformation into an *akh*, or blessed spirit, a being of light.

The mummy has been bound lengthwise in a rhomboid or diamond pattern approximately three layers deep with gilded stucco studs in the center of each rhombus. Bands of linen across the chest secure a strip of cartonnage with gilded studs. Plain linen bands, perhaps once holding a similar strip, gird the ankles. The wrapped feet are enclosed in a cartonnage footcase. The upper part of the footcase is modeled in relief with the sandaled feet of the deceased painted pink with gilded toes and resting on a checkered floor. The soles of the sandals on the underside of the footcase (not visible in the photograph) are painted with figures of bound prisoners, a motif borrowed from the royal sphere (see p. 165), and symbolic of the deceased's victory over opposing forces in the underworld.

Although the art of bandaging reached new heights in the Roman Period, mummification itself lagged behind, and the fancy wrapping conceals shoddy preservation of the body. Even x-rays have not allowed experts to determine whether the occupant was a boy or girl. However, the lack of any specifically female clothing or adornment may indicate that the coffin was intended for a boy.

Encaustic (colored wax)
on wood, linen, cartonnage,
and human remains
Faiyum, Hawara
H. 113 cm (H. 44 ½ in.)
Gift of the Egyptian
Research Account
11.2892

Funerary shroud of Tasherytwedjahor
Roman Period, first or second century A.D.

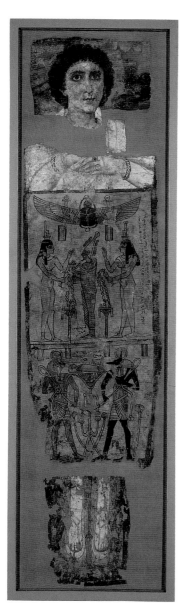

As an alternative to a portrait mummy or cartonnage mummy mask, one might opt for a full-length painted shroud like this one inscribed for Tasherytwedjahor. Roman Egypt was a multifaceted society, and death offered many possibilities for those who could afford a wealthy burial. Personal taste, local styles, the availability of artists and materials all factored into the decision. Bald juxtapositions that seem glaring to us today existed seamlessly side by side.

Arms, shoulders, and head here are depicted naturalistically in the Greco-Roman manner. Meticulously rendered details of skin tone, hair, and bone structure suggest a keen sense of the subject's individuality, and with it, an inevitable sense of mortality.

In contrast, the body is painted with funerary motifs rendered in the traditional Egyptian manner: highly schematic, with flat, even tones, and a combination of front and side views. In the upper register, beneath a winged scarab, the perennial mourners Isis (on the right) and Nephthys (on the left) pour libations to their brother Osiris, who stands, shrouded, in the center. Two vertical bands have not been filled in with hieroglyphic inscriptions. Rather, there are two inscriptions in Demotic script (used to write the Egyptian spoken at that time) — one by the feet of Osiris that gives the date of burial, year 4 (or 11) in the reign of an unnamed emperor; the other behind (and actually at right angles to) Nephthys, giving the name of the deceased, Tasherytwedjahor, and her husband (or father), a priest of Wepwawet, god of Asyut.

The lower register has a variation of the classic "unification of the Two Lands" (see p. 162) motif featuring the falcon-headed god Horus and the jackal-headed god Anubis. Here, however, instead of the sedge and the papyrus of Upper and Lower Egypt, each god tugs at a lotus, and instead of the hieroglyphic sign for "unite" in the center is a tall lotus plant. As ultimate symbol of rebirth, the blossom opens up to reveal a reclining mummy, like the sun god at the dawn of creation.

At the bottom of the shroud are the subject's sandaled feet, appearing as though dangling in air. To appreciate the scene, we must view it from the mummy's point of view, as the decoration was done for her benefit. Upside down, standing on a lotus between the feet is a goddess. With each hand she pours a libation to a human-headed bird perched on a lotus on the outer side of each foot. Both birds represent the *ba* or spirit of the deceased.

Tempera on linen

Asyut

H. 90.5 cm, w. 47 cm (H. 35⅝ in., w. 18½ in.)

Gift of the Class of the Museum of Fine Arts, Mrs. Arthur L. Devens, Chairman 54.993

Portrait stela of a woman

Roman Period, third to early fourth century A.D.

This life-size tomb stela is one of about twenty, mostly from the city cemetery of el-Bahnasa (Oxyrhynchus) in Middle Egypt. El-Bahnasa was a wealthy and thriving community in the Roman Period, and is now best known as the source of thousands of papyri that cast a flood of light upon the daily lives of its inhabitants. The richly clad figure is carved in such high relief that it might easily be mistaken for sculpture in the round, yet it was designed to fit into an architectural niche.

The educated elite of Oxyrhynchus considered themselves to be Hellenes, but they had lived in Egypt for generations and had become Egyptianized in spite of themselves. At first glace there seems nothing particularly Egyptian about the representation in this stela, but as with the painted funerary portraits, a Greco-Roman visual language was put in the service of Egyptian religious ideas about the afterlife. The deceased is assimilated with a deity — the corkscrew curls and knotted garment were attributes of Isis as well as other fertility goddesses such as Ge (Earth) and Euthenia (Abundance) for the Romans (see p. 189). In her left hand she holds a ritual vessel, perhaps a container for incense. As a work of art this stela is on the threshold where pagan blended into early Christian, for the same late antique visual language, reinterpreted in Christian terms, had a new life in the late Roman Period.

At first the Roman emperors supported the Egyptian temples but their patronage gradually died out. The last major building projects in Egypt were carried out in the mid-second century A.D. In the third century imperial support for the temples virtually ceased. Meanwhile Christianity was catching on rapidly. With the formal division of the Roman Empire into eastern (Byzantine) and western halves in 395 a new era began.

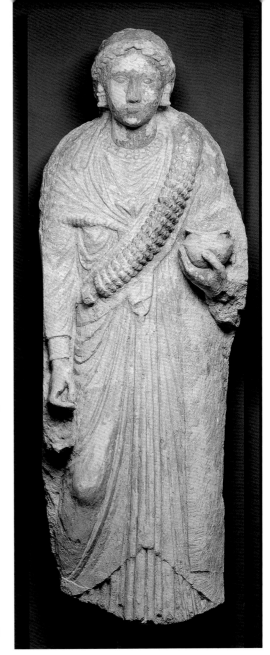

Limestone with traces of paint
El-Bahnasa (Oxyrhynchus)
H. 141 cm, w. 53 cm, d. 23 cm
(H. 55 ½ in., w. 20⅞ in., d. 9 1/16 in.)
Edward J. and Mary S. Holmes Fund 1972.875

Chronology of Ancient Egypt

There are many chronologies of ancient Egypt in use today. Most agree in the essentials, but all differ in certain details. This chronology is based on one devised by James P. Allen for the Metropolitan Museum of Art. The rulers named under each dynasty are those mentioned specifically in this book.

Predynastic Period, before 3850 B.C.– about 2960 B.C.

Badarian	4500 – 3800 B.C.
Naqada I	3850 – 3650 B.C.
Naqada II	3650 – 3300 B.C.
Naqada III	3300 – 2960 B.C.
DYNASTY 0	about 3100 – about 2960 B.C.

Early Dynastic Period, 2960 – 2649 B.C.

DYNASTY 1	2960 – 2770 B.C.
Djer	2926 – 2880 B.C.
Djet	2880 – 2873 B.C.
Den	2873 – 2859 B.C.
DYNASTY 2	about 2750 – 2649 B.C.
Khasekhemwy	2676 – 2649 B.C.

Old Kingdom, 2649 – about 2100 B.C.

DYNASTY 3	2649 – 2575 B.C.
Zanakht	2649 – 2630 B.C.
Djoser	2630 – 2611 B.C.
Sekhemkhet	2611 – 2605 B.C.
DYNASTY 4	2575 – 2465 B.C.
Sneferu	2575 – 2551 B.C.
Khufu	2551 – 2528 B.C.
Khafre	2520 – 2494 B.C
Menkaure	2490 – 2472 B.C.
DYNASTY 5	2465 – 2323 B.C.
Isesi	2381 – 2353 B.C.
Unis	2353 – 2323 B.C.
DYNASTY 6	2323 – 2150 B.C.
Teti	2323 – 2291 B.C.
Pepy II	2246 – 2152 B.C.
DYNASTY 7	2150 – about 2143 B.C.
DYNASTY 8	about 2143 – about 2100 B.C.

First Intermediate Period, about 2100 – 2040 B.C.

DYNASTIES 9 and 10	about 2100 – 2040 B.C.
DYNASTY 11 (first part)	2140 – 2040 B.C.
Mentuhotep II (pre-unification)	2061 – 2040 B.C.

Middle Kingdom, 2040 – about 1640 B.C.

DYNASTY 11 (second part)	2040 – 1991 B.C.
Mentuhotep II (post-unification)	2040 – 2010 B.C.
Mentuhotep III	2010 – 1998 B.C.
Mentuhotep IV	1998 – 1991 B.C.
DYNASTY 12	1991 – 1783 B.C.
Amenemhat I	1991 – 1961 B.C.
Senwosret I	1971 – 1926 B.C.
Amenemhat II	1929 – 1892 B.C.
Senwosret II	1897 – 1878 B.C.
Senwosret III	1878 – 1841 B.C.
Amenemhat III	1844 – 1797 B.C.
Nefrusobek	1787 – 1783 B.C.
DYNASTY 13	1783 – about 1640 B.C.

Second Intermediate Period, about 1640 – 1550 B.C.

DYNASTIES 14, 15 (Greater Hyksos) and DYNASTY 16 (Lesser Hyksos)	about 1640 – 1540 B.C.
DYNASTY 17	about 1640 – 1550 B.C.

New Kingdom, 1550 – 1070 B.C.

DYNASTY 18	1550 – 1295 B.C.
Ahmose	1550 – 1525 B.C.
Amenhotep I	1525 – 1504 B.C.
Thutmose I	1504 – 1492 B.C.
Thutmose II	1492 – 1479 B.C.
Thutmose III	1479 – 1425 B.C.
Hatshepsut	1473 – 1458 B.C.
Amenhotep II	1427 – 1400 B.C.
Thutmose IV	1400 – 1390 B.C.
Amenhotep III	1390 – 1352 B.C.
Amenhotep IV (Akhenaten)	1352 – 1336 B.C.
Tutankhamen	1336 – 1327 B.C.
Ay	1327 – 1323 B.C.
Horemheb	1323 – 1295 B.C.
DYNASTY 19	1295 – 1186 B.C.
Ramesses II	1279 – 1213 B.C.
Merneptah	1213 – 1203 B.C.
DYNASTY 20	1186 – 1070 B.C.
Ramesses III	1184 – 1153 B.C.
Ramesses IX	1126 – 1108 B.C.
Ramesses XI	1099 – 1070 B.C.

Third Intermediate Period, 1070 – 712 B.C.

DYNASTY 21	1070 – 945 B.C.
DYNASTY 22	945 – 712 B.C.
Shoshenq I	945 – 924 B.C.
Osorkon II	874 – 850 B.C.
DYNASTY 23	818 – about 700 B.C.
Neferkare Peftjawybast	740 – 725 B.C.
DYNASTY 24	724 – 712 B.C.

Late Period, about 760 – 332 B.C.

DYNASTY 25	about 760 – about 660 B.C.
Piye	743 – 712 B.C.
Shabaka	712 – 698 B.C.
DYNASTY 26	664 – 525 B.C.
Psammetichus I	664 – 610 B.C.
Amasis	570 – 526 B.C.
DYNASTY 27	525 – 404 B.C.
DYNASTY 28	522 – 399 B.C.
DYNASTY 29	399 – 380 B.C.
Achoris	393 – 380 B.C.
DYNASTY 30	380 – 332 B.C.
Nectanebo II	360 – 343 B.C.

Greco-Roman Period, 332 B.C. – A.D. 364

MACEDONIAN DYNASTY	332 – 305 B.C.
Alexander the Great	332 – 323 B.C.
PTOLEMAIC DYNASTY	305 – 30 B.C.
Ptolemy I	305 – 282 B.C.
Ptolemy II	284 – 246 B.C.
Ptolemy V	204 – 180 B.C.
Ptolemy VIII	170 – 116 B.C.
Cleopatra VII	51 – 30 B.C.
ROMAN PERIOD	30 B.C. – A.D. 364
Augustus (Octavian)	30 B.C. – A.D. 14
Tiberius	14 – 37
Claudius	41 – 54
Nero	54 – 68
Hadrian	117 – 138
Antoninus Pius	138 – 161
Diocletian	284 – 305
Constantine	306 – 337
BYZANTINE PERIOD	A.D. 364 – 476
Theodosius I	379 – 395

Glossary

Abydos: Center of worship of Osiris, and one of the most important religious sites in ancient Egypt. It was also the location of the royal tombs of Dynasty 1, cemeteries, cenotaphs, and several temples.

Amen: Theban god, known as "the Hidden One," who became the supreme state god of the New Kingdom. He was depicted as a man with a double-plumed crown or as a ram with curved horns.

ankh: Hieroglyphic sign and emblem meaning "life."

Anubis: Canine deity, guardian of the necropolis; associated with mummification.

ba: One of the spiritual components of an individual, represented as a human-headed bird, believed to travel to and from the tomb.

Blue Crown: Helmet-shaped crown known as the *khepresh*; originated in the Second Intermediate Period.

Book of the Dead: Funerary texts recited to help the deceased enter the afterlife through the invocation of **Re** and **Osiris**. Known by the Egyptians as the *Book of Going Forth by Day in the Afterworld*. Used for nonroyals beginning in Dynasty 18.

cartonnage: A material consisting of layers of linen and gesso that became popular in the Middle Kingdom. It was used for funerary masks, and in the Late and Greco-Roman periods, for mummy cases as well.

cartouche: An oval loop representing a coil of rope in which the name of a king or queen was written. Literally the hieroglyph for "to encircle," it signified rulership over all lands touched by the sun.

Coffin Texts: Spells carved on the interiors of wooden coffins to assist the deceased during the perilous journey to the afterlife, as well as during Osiris's judgement. Known primarily from the Middle Kingdom, they were later adapted and incorporated into the Book of the Dead.

Double Crown: Royal crown combining the White Crown of Upper Egypt and the Red Crown of Lower Egypt, worn to symbolize the unity of the two lands.

faience: Non-clay ceramic composed of quartz, lime, and alkali. When combined with water, it can be modeled by hand or shaped in a mold. Upon firing, it forms a reflective, vitreous glaze. Known to the ancients as "(that which is) dazzling," faience was used for decorative architectural elements, amulets, and jewelry.

false door: A mock doorway on the west wall of the tomb through which the spirit of the deceased could freely pass between this world and the next; a focal point for offerings.

Hathor: Goddess of love, music, and motherhood. Represented as a woman with a horned sun disk or as a cow.

hieroglyphs: Pictorial and sound signs composing early ancient Egyptian writing, used primarily in monumental inscriptions in stone.

Horus: Sun and sky god manifested in the reigning king, symbolized by a falcon or a falcon-headed man. The son of Osiris and Isis, Horus was awarded the throne of Egypt after a long struggle against Seth, his father's brother and murderer.

Isis: Goddess who was the wife of Osiris and the mother of Horus. She was represented in human form wearing a headdress with the throne hieroglyph or a horned sun disk.

ka: One of the spiritual components of an individual, written with the hieroglyphic sign of upraised arms. Sometimes translated as "life force," it was created at a person's birth and survived death, residing in the tomb as a recipient of the offerings left for the deceased.

khepresh: See **Blue Crown.**

kohl: Powdered mineral pigment used as eye makeup for both men and women.

Kush: Name used by the ancient Egyptians, Assyrians, and Hebrews for Nubia, Egypt's neighbor to the south, which encompassed the area between modern Aswan (Egypt) and Khartoum (Sudan).

Lower Egypt: Northern Egypt, including the Nile Delta. Called "Lower" because it lies at a lower altitude than southern Egypt. One of the two traditional geographical divisions of Egypt.

mastaba: Arabic word for "bench," used to refer to the rectangular stone or mudbrick superstructure of an Old Kingdom tomb, the top of which is typically flat, with slanted walls.

mortuary temple: Temple where rituals were celebrated for the cult of the king. In the Old and Middle Kingdoms they usually abutted the kings' pyramids. In the New Kingdom when pyramids were no longer built, they were independent structures called "temples of millions of years," built primarily on the west bank of the Nile at Thebes. The term is misleading, as the rites performed there were also carried out for the living king.

nemes: Royal headdress consisting of a striped headcloth with lappets in front and tied in the back.

Nephthys: Sister of Isis and fellow mourner of Osiris. She was represented in human form wearing a headdress comprised of the hieroglyphs that spell her name, a basket over a floorplan of a house.

nomarch: Governor of an administrative province, or **nome**. Often a hereditary position.

nome: An administrative province, headed by the nomarch.

Nubia: See **Kush.**

Osiris: God of the underworld, husband of Isis, and father of Horus. He was murdered by his brother Seth and resurrected with the help of Isis. He is commonly depicted as a man in a mummiform pose with black or green skin that represents life-giving Nile silt.

Pyramid Texts: The oldest surviving religious texts, they were carved and painted onto the pyramid chamber walls of Dynasty 5 and 6 rulers to protect the king from adversity, help him to reach the afterlife, and transform him into a deity.

Re: Creator/sun god of Heliopolis whose cult gained prominence beginning in Dynasty 4. Later, other gods enhanced their divinity by assimilating to this powerful deity.

Red Crown: The crown of Lower Egypt.

scarab: Sacred dung beetle, believed to possess the powers of self-creation and rejuvenation.

serdab: Arabic word for "storeroom," used to refer to the sealed statue chamber of an Old Kingdom tomb.

Seth: God of chaos and confusion. According to myth, he murdered his brother Osiris. He was represented as a fantastic doglike animal, with a long muzzle, pointed ears, and a forked tail.

shawabty: Mummiform figurine placed in the tomb to work as the representative of the deceased in the fields of the afterlife. Shawabtys were sometimes provided with model agricultural implements.

stela (pl. stelae): Inscribed rectangular or round-topped slab of stone or sometimes wood; stelae could be carved or painted or both. They could serve as funerary monuments in tombs, or as votive or commemorative monuments in temples.

Upper Egypt: Southern Egypt, from the Faiyum to Aswan. Called "Upper" because it lies at a higher altitude than northern Egypt. One of the two traditional geographical divisions of Egypt.

uraeus (pl. uraei): Protective device in the form of a rearing cobra with inflated hood; a symbol of kingship worn upon the king's brow.

Valley of the Kings: Ravine in the cliffs on the west bank of Thebes, chosen by kings of the New Kingdom for their rock-cut tombs.

wadjet **eye:** Stylized protective symbol representing the eye of Horus.

White Crown: Miter-shaped crown of Upper Egypt.

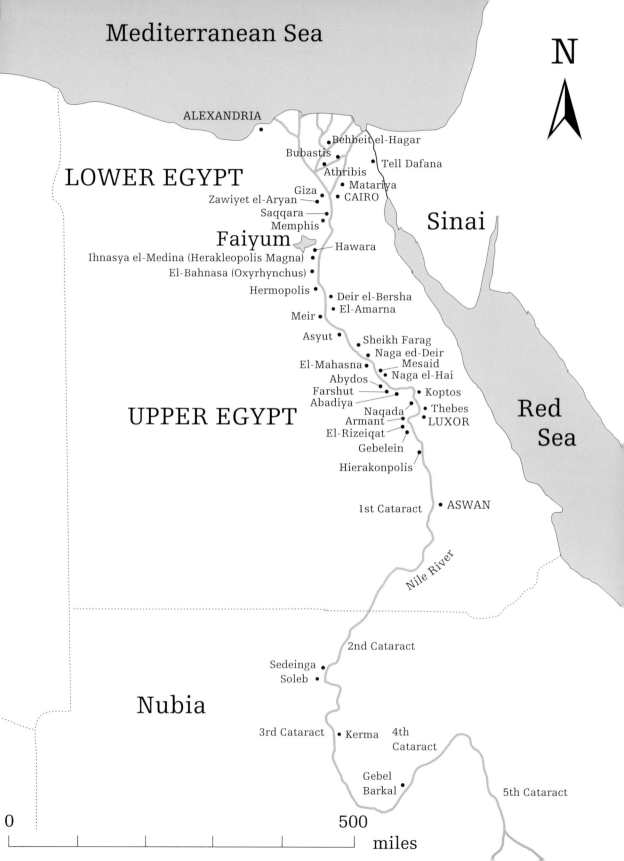

Index

*Page numbers in italics
indicate illustration captions.*

Abadiya, *39,* 40, *44, 46*
Abbott, Henry, 17, *17*
Abydos, 22, 40, 41, *41,* 51–53,
 52–53, 55, *55,* 57–58, *57–59,* 106,
 108, 122, 133, *133*
Achoris, 184, *184,* 187
Ahmose, 141
Akhenaten, 142, *158,* 158–160, *160,* 161
Alexander the Great, 171, 185
Alexandria, 12, 20, 184
Amasis, 180, *182*
Amen, 107, 142, 154, 169, 178, 187, *187*
Amenemhat I, 107
Amenemhat II, 108
Amenemhat III, 108, *130,* 130–131, 135, 163, 170
Amenhotep I, *141*
Amenhotep II, *141,* 169
Amenhotep III, 23, 142, 148, *148,* 152–156,
 152–156, 159, 160
Amenhotep IV (Akhenaten), 142, 154
American Oriental Society, 15
Antoninus Pius, 171
Anubis, 112, 135, 156, 192, 194
Armant, 115, *115*
Aswan, 12, 29, 132
Asyut, 22, *114, 116–117,* 126, *126,* 194, *194*
Athribis, 179, *179*
Atum, 149, 184
Augustus (Octavian), 11, 171, *171*
Ay, 162, *162*

Bastet, 132, *132, 163–164,* 173, *173,* 188
Behbeit el-Hagar, 187, *187*
Bonaparte, Napoleon (General and Emperor),
 12, 13–14, 25, 182

Bonaparte, Napoleon Joseph Charles Paul
 (Prince Plonplon), 77, 186
Bubastis, 22, 107, 132, *132,* 163, *163–164,*
 170, 173, *173*

Carter, Howard, 23, 161
Champollion, Jean-François, 13, 14, 16, 18
Claudius, 11
Cleopatra VII, 11, 12, 171, 189
Constantine, 171

Davis, Theodore M., 22–23
Deir el-Bersha, 119, *119–125*
Den, 40, 53, *53*
Dendara, 11, 14, 15
Dendur, 11
Denon, Dominique-Vivant, 14
Djer, 55, *55*
Djet, 57, *57*
Djoser, 41, 65
Dunham, Dows, 32, 34

Egypt Exploration Fund (EEF), 21–22,
 41, 173, 180
El-Amarna, 142, 158, *158–160,* 160–161
El-Bahnasa (Oxyrhynchus), 191, *191*
El Mahasna, *46*
El-Rizeiqat, 156, *157*
Euthenia, 195
Everett, Edward, 14, 16–17

Farshut, *112*

Gebel Barkal, 154–155, 155
Gebelein, *54, 111*

Giza, 23, 27–35, *65–66*, 66, *70–99*, 72–73, 75, 78, 80, 82, 90, 95–98, 182–183, *182–183*
Gleyre, Charles, *20*, 20–21, *155*
Gliddon, George R., 15

Hadrian, 171
Harsaphes, 22, 177, *177*, 188
Hathor, 14, 22, 28, 83, *83*, 85–86, 132, 149, 152, 154, 173, *173*
Hatshepsut, 21, 23, 141–142, *142*, 146–147, *146–147*
Hawara, 109, *193*
Hay, Robert, 18–19, 20
Hearst, Phoebe Apperson, 22, 23, 26
Hermopolis, 170
Herodotus, 170, 173
Hierakonpolis, 39, 40, 41
Horemheb, 161, 162, *162*
Horus, 85, 106, 112, 148, *154*, 155, 175, 184, 188, 192, 194

Ihnasya el-Medina (Herakleopolis Magna), 177, *177*
Imhotep, 65
Isesi, 95
Isis, *12*, 21, 148, 153, 156, 171, 173, 175, *175* 176, 182, 187, 189, 190, 194, 195

Kerma, *30*, 109, 126, *126*, 131, *131*, 135, *135*, 141
Khafre, *65*, 66, *66*, 75, *75*, 77, 78, *78*, 82
Khasekhemwy, 22, 41, *41*, 58–59, *58–59*
Khentiamentiu, 52, 57
Khentykhety, 179
Khnum, *170*, 188
Khufu, 32, 66, *70*, 70–75, *72–75*, 77, 78, 88, 182
Koptos, *171*, 190, *190*

Lannes, Jean (General), 183
Loring, Charles Greely (General), 21, 22
Lowell, John, Jr., 19–21, *20*, 154–155
Lythgoe, Albert M., 22, 23, 26

Mark Antony, 11, 12, 171
Maspero, Gaston, 29
Meir, 129, *129*
Memphis, 40, 41, 60, 178
Menkaure, 28–29, *28–29*, 66, 80–83, *80–88*, 85–86, 88, 152, 178, 182

Mentuhotep II, see Nebhepetre Mentuhotep II
Mentuhotep III, see Sankhkare Mentuhotep III
Mentuhotep IV, 106
Merenptah, 115, *115*, 164
Mesaid, *40, 43, 47, 49, 51*
Min, 190
Mohammed Ali Pasha, 13
Montu, 115

Naga el-Deir, 100, *100*
Naga el-Hai, *44–45, 49*
Naqada, 40, *40, 44–52*, 51, *58*
Naville, Edouard, 21
Nebhepetre Mentuhotep II, 105, 113, *113*
Nectanebo II, 22, *170*, 171, 184–185, *185*, 187
Neferhotep, 153, *153*
Neferkare Peftjawybast, 177, *177*
Nefrusobek, 109
Nekhbet, 145–146
Nekheny, 155
Nephthys, 156, 176, 192, 194
Nero, 11, 171, 190

Osiris, 35, *52*, 106, 112, *115*, 119, 122, 126, 133, 145, 148, 152, 156–157, 177, 182–183, *183*, 192, 194
Osorkon II, 22, 173, *173*

Peabody Essex Museum, 14
Pepy II, 67, 95, *99*
Petrie, Flinders, 22, 180
Philae, 11, 12, *12*, 20, 21, 171
Pickering, John, 15–17
Piye, 154
Psammetichus I, 170, 180
Ptolemy I, 171
Ptolemy V, 13
Ptolemy VIII, 190, *190*
Ptolemy XII, *12*

Ramesses II, 22, 143, *159*, 163–164, *163–164*, 173–174
Ramesses III, 21, 22, 143, 165, *165*
Ramesses IX, 169
Ramesses XI, 169
Re, 66, 135, 156–157, 184
Reisner, George Andrew, 11, 22, 23, *26*, 26–34, *28, 29, 33*, 75, 77, 81, 86, 90, 99

Robinson, Edward, 22
Rome, 12
Rowe, Alan, 31

Sams, Joseph, 16–17
Sankhkare Mentuhotep III, *115*
Saqqara, 22, 41, 57, 65–66, 98, *186*
Schiaparelli, Ernesto, 27
Sedeinga, 154, *154*
Sekhemkhet, 65
Sekhmet, 21
Sennuwy, 30, *30*, 126, *126*, 128
Senwosret I, *107*, 107–108
Senwosret II, 129, *129*
Senwosret III, 108, *109*, 129, *129*, 135
Seth, 43, 106, 148, 175
Shabaka, 170, 178
Sheikh Farag, *130*
Shoshenq I, 169
Simpson, William Kelly, 35
Smith, Joseph Lindon, 32, 81
Smith, William Stevenson, 34
Sneferu, 30, 32, 66, 70, *70*, 78
Soleb, 154, *155*
Steindorff, Georg, 27

Tell Dafana, 180, *180*
Thebes, 18, 20–21, 22, 105, 107, 113, *136*,
 141, *142*, 145, *145–147*, *150–152*, 152,
 160–161, *162*, 163–164, 169–170, *176*, *179*
Theodosius I, 171
Thutmose I, 23, 141, *146*, 147
Thutmose II, 141
Thutmose III, 141–142, 148, *148*
Thutmose IV, 23, *150–151*, 151
Tiberius, 171
Tutankhamen, 23, 142–143, 151, *161*,
 161–162, 169

Unis, *94*

Wadjyt, 145, 146
Warren, John Collins, 14
Way, Charles Granville, 18, 19
Way, Samuel Alds, 19
Wepwawet, 133, 194
Wheeler, Noel, 32, *32*

Young, William, 32

Zawiyet el-Aryan, 60, *60*

Additional Photo Credits

pages 2–3

Visitors to the MFA, 1910. The object on view: Seated statue of Ramesses II, Dynasty 19, reign of Ramesses II, 1279–1213 B.C., granodiorite, 205 x 54 x 104 cm (80 ¹¹⁄₁₆ x 21 ¼ x 40 ¹⁵⁄₁₆ in.), Gift of the Egypt Exploration Fund 87.111.

pages 5–6

Amphora with lid (details), see p. 160.

page 10

Egyptian mummies and coffins pending installation in the new MFA building on Huntington Avenue, 1909. At the far left and right are the box and lid of the outer coffin of Padihershef, presented to the city of Boston in 1823 (see p. 14) and now in the Springfield Museum in Springfield, Massachusetts.

pages 36–37

Jar with painted boats and boat model (detail), see pp. 50–51.

page 42

Stela of a woman (detail), see p. 55.

pages 62–63

Giza pyramids from canal bank, October 31, 1927. Harvard University-Museum of Fine Arts Expedition Photograph.

page 68

Reserve head (detail), see p. 75.

pages 102–3

Sphinx of Amenemhat III, reinscribed for Setnakht and Rameses III, Dynasty 12, reign of Amenemhat III, 1844–1797 B.C., granodiorite, from Tell Nabasha, 56 x 45.8 x 170 cm (22 x 18 x 67 in.), Gift of the Egypt Exploration Fund 88.747.

page 110

Relief of Nebhepetre Mentuhotep II (detail), see p. 113.

pages 138–39

J. P. Sébah, Egyptian, 1838–1890, *Temple of Karnak, general view*, about 1870, albumen print, 26.5 x 34.6 cm (10 ⁷⁄₁₆ x 13 ⅝ in.), Gift of Francis Lee Higginson 2001.484.

page 144

Head of King Tutankhamen (detail), see p. 161.

pages 166–67

Adolphe Braun, French, 1812–1877, Island of Philae, Nubia, about 1870, albumen print, 19.8 x 25.6 cm (7 ¹³⁄₁₆ x 10 ¹⁄₁₆ in.), Gift of Francis Lee Higginson 2001.533.

page 172

Aegis of Isis (detail), see p. 175.

pages 196–97

Old Kingdom sarcophagi and the sarcophagus of Kheperre after excavation at Giza, about 1930. Harvard University-Museum of Fine Arts Expedition Photograph.